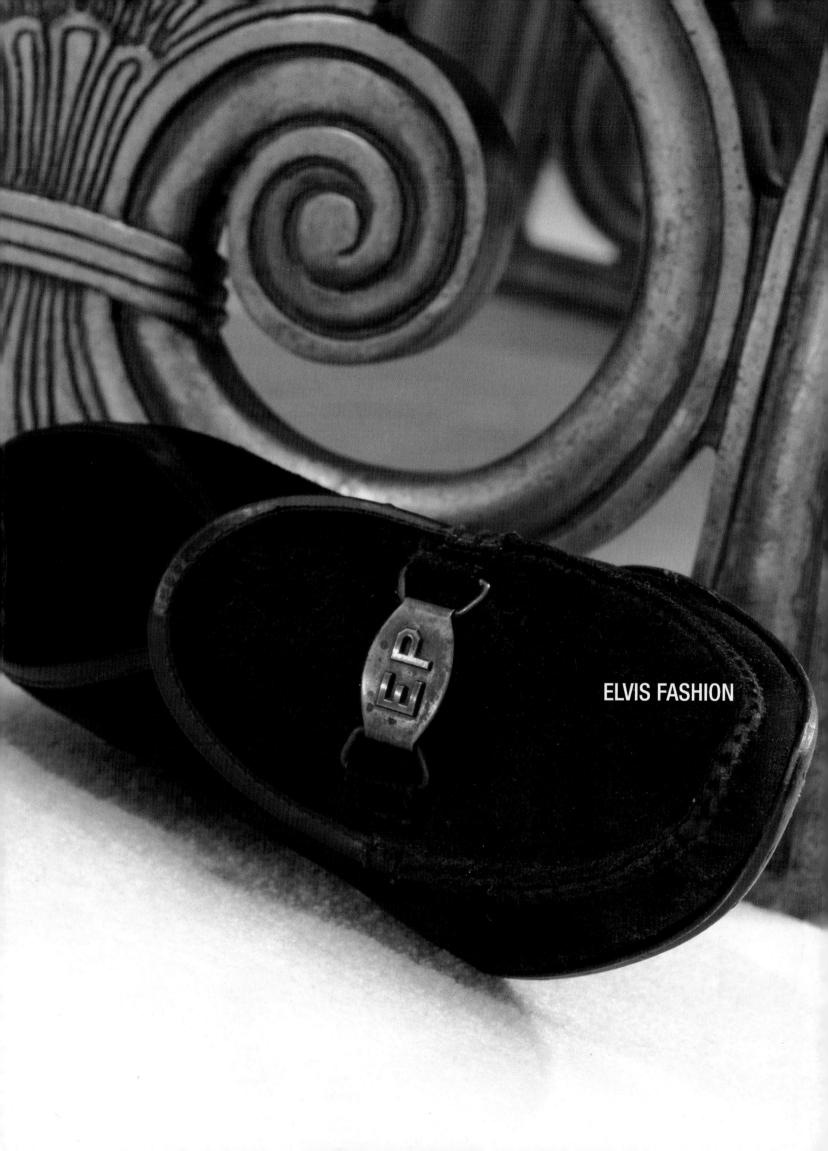

ELVIS FASHION

First published in the United States of America in 2003
by UNIVERSE PUBLISHING
A Division of Rizzoli International Publications, Inc.
300 Park Avenue South
New York, NY 10010

www.rizzoliusa.com

2003 2004 2005 2006 2007 / 10 9 8 7 6 5 4 3 2 1

Text by Julie Mundy

Design by Paul Guayante

New photography by Woody Woodliff

Printed in Belgium

ISBN: 0-7893-0987-4

Library of Congress Control Number: 2003110285

Photos © Alfred Wertheimer. All Rights Reserved
(cover, pages 12-15, 18-19, 25, 30-31, 33, 55, and 79)

Photos from the Bernard J. Lansky Collection
(pages 20 and 21)

Photos from the Sy Devore Collection
(pages 60 and 61)

ELVIS®FASHION: FROM MEMPHIS TO VEGAS

Julie Mundy in association with Graceland®

UNIVERSE

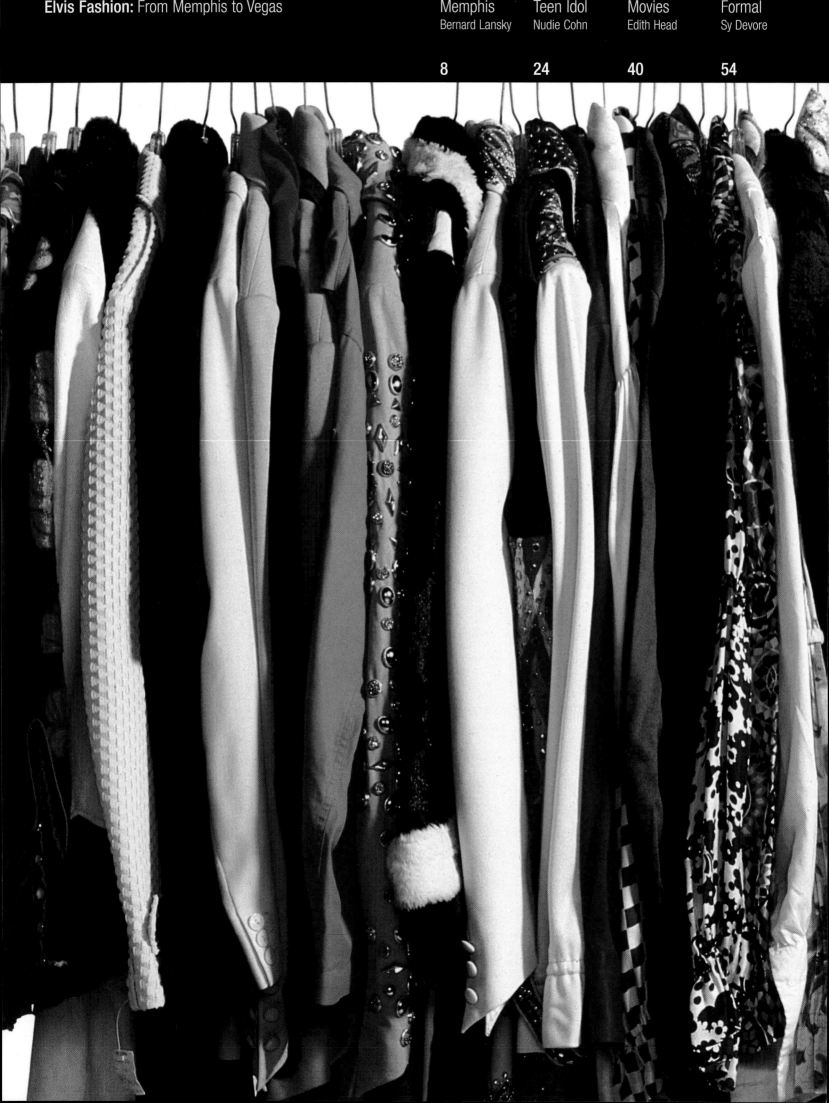

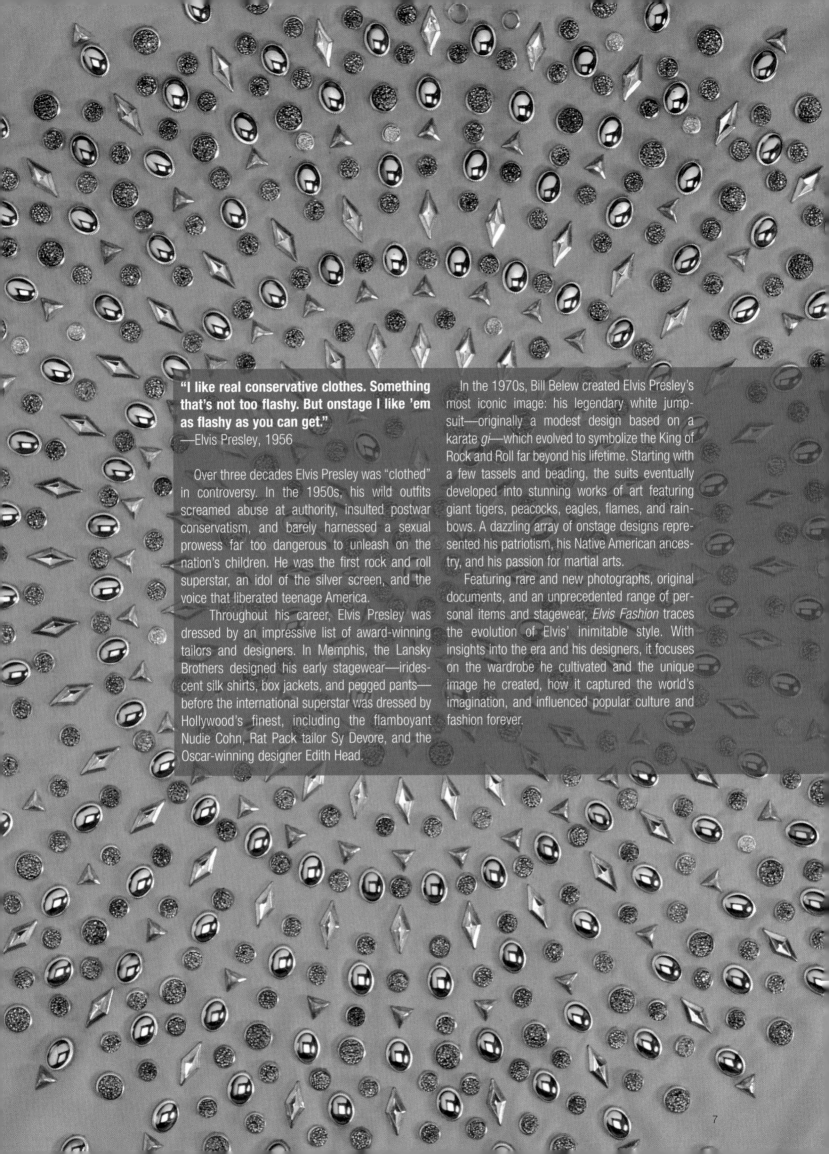

"I like real conservative clothes. Something that's not too flashy. But onstage I like 'em as flashy as you can get."
—Elvis Presley, 1956

Over three decades Elvis Presley was "clothed" in controversy. In the 1950s, his wild outfits screamed abuse at authority, insulted postwar conservatism, and barely harnessed a sexual prowess far too dangerous to unleash on the nation's children. He was the first rock and roll superstar, an idol of the silver screen, and the voice that liberated teenage America.

Throughout his career, Elvis Presley was dressed by an impressive list of award-winning tailors and designers. In Memphis, the Lansky Brothers designed his early stagewear—iridescent silk shirts, box jackets, and pegged pants—before the international superstar was dressed by Hollywood's finest, including the flamboyant Nudie Cohn, Rat Pack tailor Sy Devore, and the Oscar-winning designer Edith Head.

In the 1970s, Bill Belew created Elvis Presley's most iconic image: his legendary white jumpsuit—originally a modest design based on a karate *gi*—which evolved to symbolize the King of Rock and Roll far beyond his lifetime. Starting with a few tassels and beading, the suits eventually developed into stunning works of art featuring giant tigers, peacocks, eagles, flames, and rainbows. A dazzling array of onstage designs represented his patriotism, his Native American ancestry, and his passion for martial arts.

Featuring rare and new photographs, original documents, and an unprecedented range of personal items and stagewear, *Elvis Fashion* traces the evolution of Elvis' inimitable style. With insights into the era and his designers, it focuses on the wardrobe he cultivated and the unique image he created, how it captured the world's imagination, and influenced popular culture and fashion forever.

"ELVIS PRESLEY IS THE GREATEST CULTURAL FORCE IN THE 20TH CENTURY... HE INTRODUCED THE BEAT TO EVERYTHING AND HE CHANGED EVERYTHING- MUSIC, LANGUAGE, CLOTHES. IT'S A WHOLE NEW SOCIAL REVOLUTION."

—Leonard Bernstein

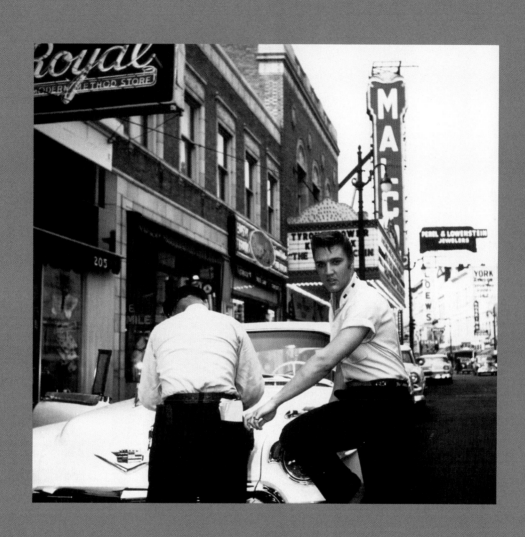

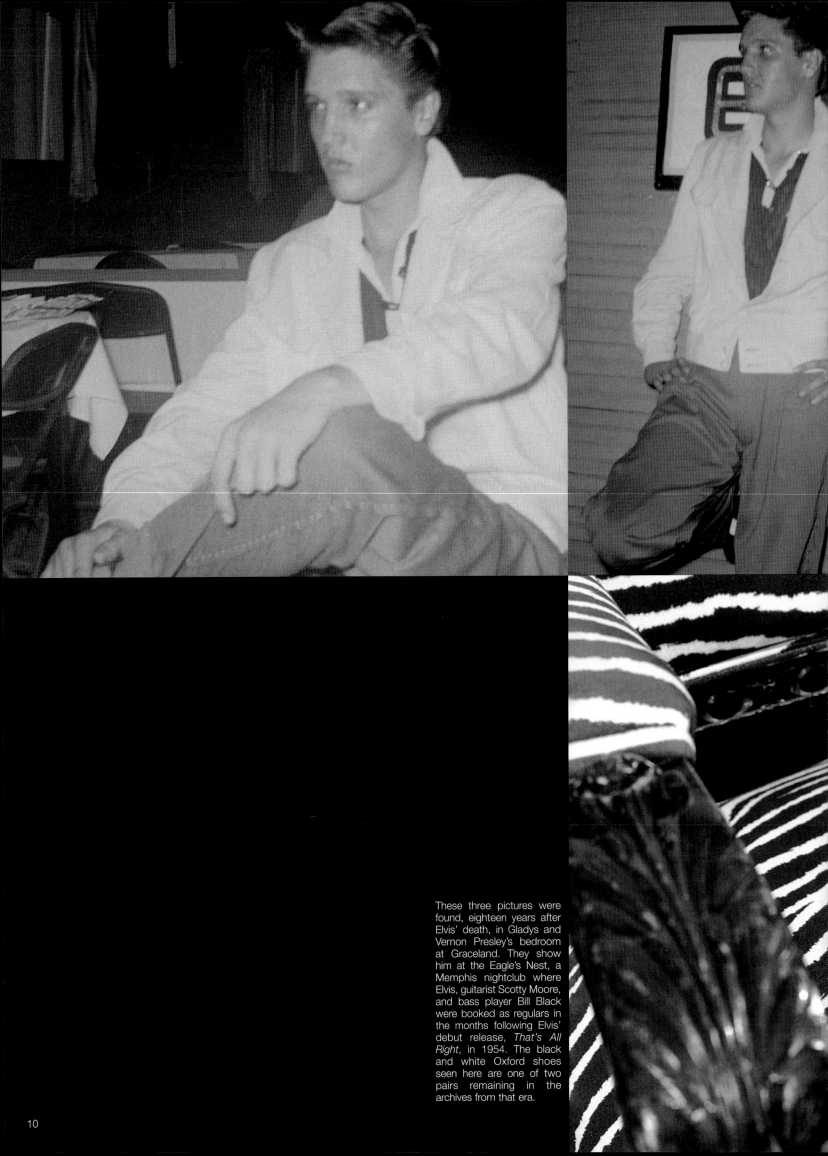

These three pictures were found, eighteen years after Elvis' death, in Gladys and Vernon Presley's bedroom at Graceland. They show him at the Eagle's Nest, a Memphis nightclub where Elvis, guitarist Scotty Moore, and bass player Bill Black were booked as regulars in the months following Elvis' debut release, *That's All Right*, in 1954. The black and white Oxford shoes seen here are one of two pairs remaining in the archives from that era.

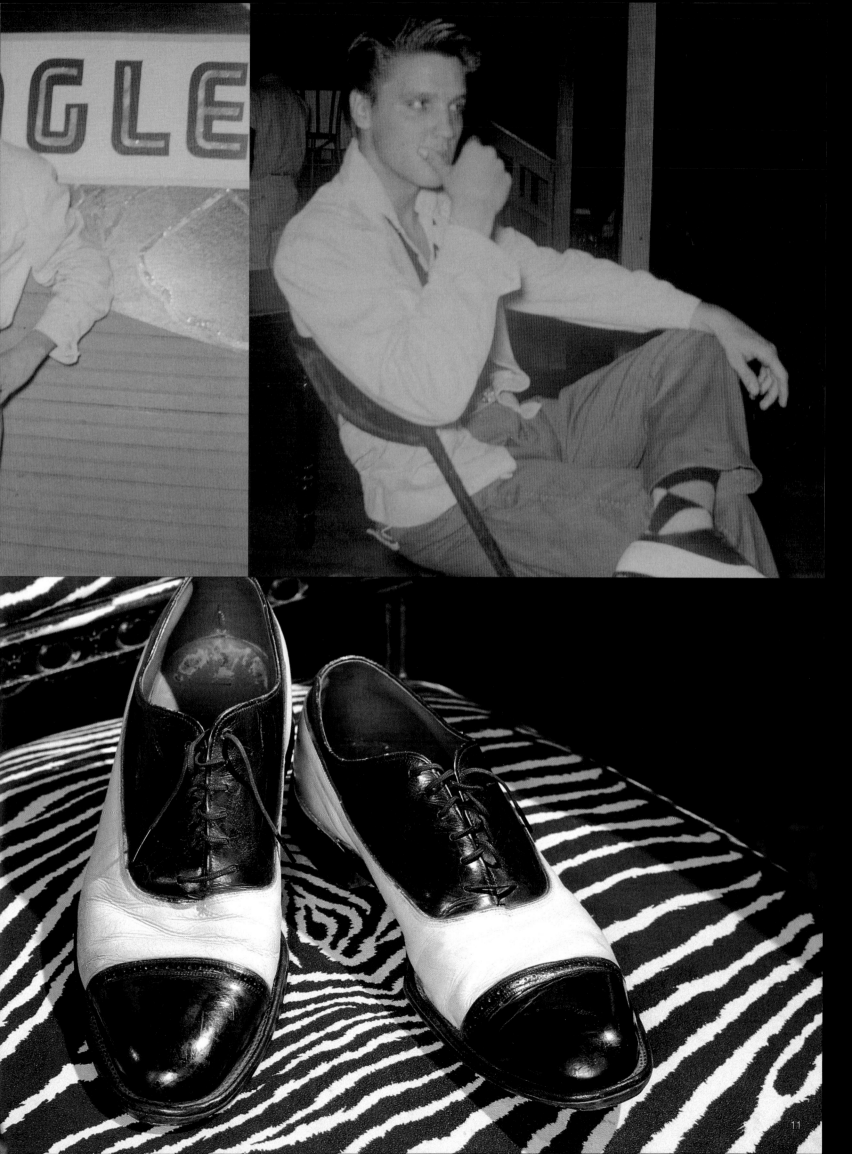

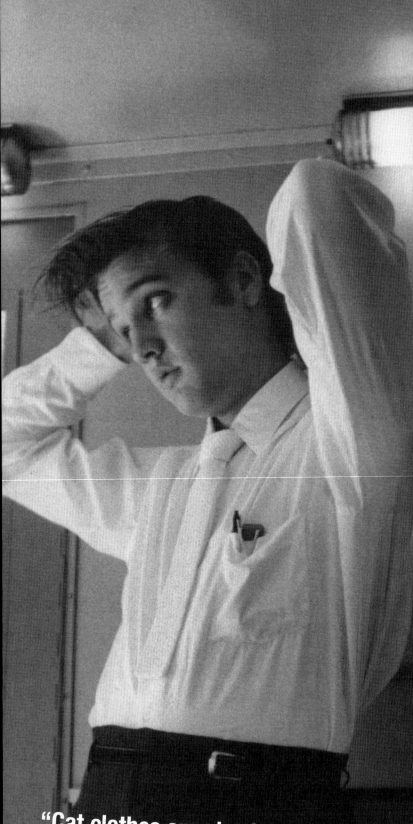

American gentlemen of the 1950s dressed modestly. Although the decade proved to be an era of economic growth and discovery, contemporary menswear remained cautious, steadfast, and dependable, like Sloan Wilson's *Man in the Gray Flannel Suit*.

This brave new world may have conquered two world wars, but new challengers came from within. As senators Joseph McCarthy and Estes Kefauver exploited the infancy of television to wage personal battles on communism and organized crime, a new menace started to ruffle the feathers of the great American Eagle—her very own children.

Teenager was the buzzword of the 1950s. Living in the richest nation on earth, American teens enjoyed their newfound affluence. Independent, with more leisure time and disposable income than ever before, they chose not to inherit their parents' fears, but rejected their conservatism instead; they were an all-new consumer group waiting for the opportunity to rebel.

Immortalized in celluloid—as Brando's Black Rebels in *The Wild One*, high school hoodlums in *Blackboard Jungle,* or fated juveniles in *Rebel without a Cause*—the teenage revolution had a darker side. The press described teen rebels as "hellion, unmanageable, rude, and primitive," fueled by rock and roll, with "a strange, moody, flesh-and-blood personality to symbolize it all—Elvis Presley."

Elvis' principal act of rebellion lay in the clothes he wore. His loud, eccentric outfits and long greased hair caused many fights in the schoolyard and no one could understand why he chose to be so different. By 1956, however, many teenagers in America wanted to dress like Elvis and some even tried to tear the clothes off his back.

"Cat clothes are absolutely a must as far as I'm concerned. My favorite hobby

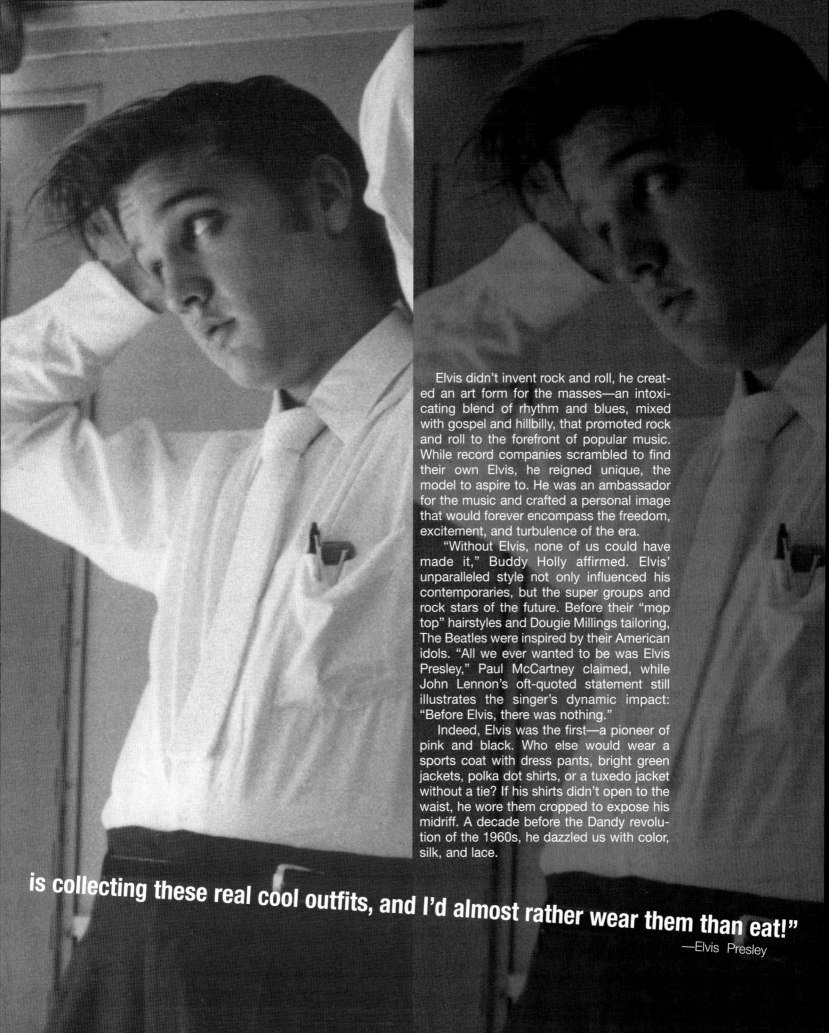

Elvis didn't invent rock and roll, he created an art form for the masses—an intoxicating blend of rhythm and blues, mixed with gospel and hillbilly, that promoted rock and roll to the forefront of popular music. While record companies scrambled to find their own Elvis, he reigned unique, the model to aspire to. He was an ambassador for the music and crafted a personal image that would forever encompass the freedom, excitement, and turbulence of the era.

"Without Elvis, none of us could have made it," Buddy Holly affirmed. Elvis' unparalleled style not only influenced his contemporaries, but the super groups and rock stars of the future. Before their "mop top" hairstyles and Dougie Millings tailoring, The Beatles were inspired by their American idols. "All we ever wanted to be was Elvis Presley," Paul McCartney claimed, while John Lennon's oft-quoted statement still illustrates the singer's dynamic impact: "Before Elvis, there was nothing."

Indeed, Elvis was the first—a pioneer of pink and black. Who else would wear a sports coat with dress pants, bright green jackets, polka dot shirts, or a tuxedo jacket without a tie? If his shirts didn't open to the waist, he wore them cropped to expose his midriff. A decade before the Dandy revolution of the 1960s, he dazzled us with color, silk, and lace.

is collecting these real cool outfits, and I'd almost rather wear them than eat!"

—Elvis Presley

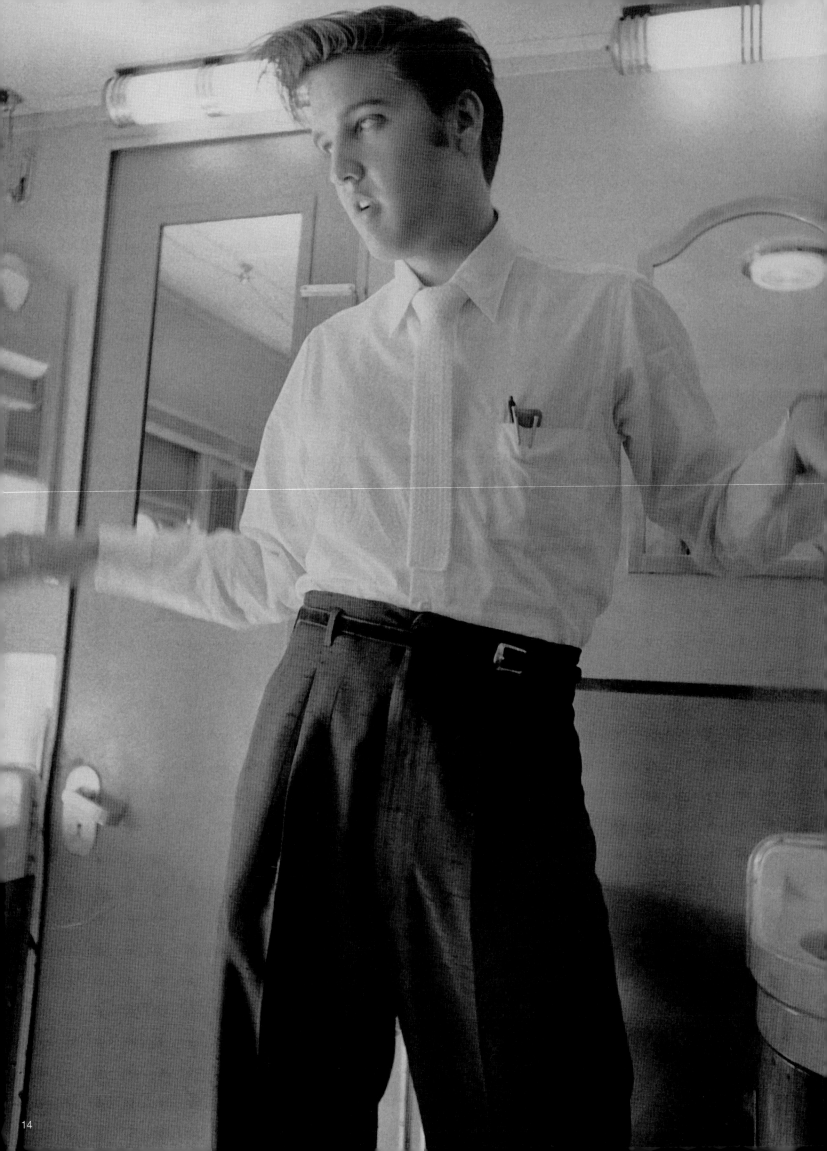

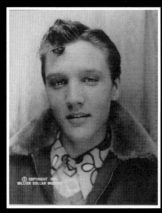

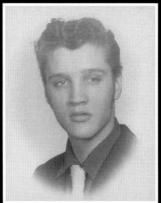

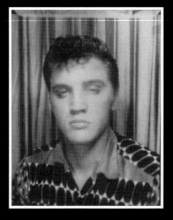

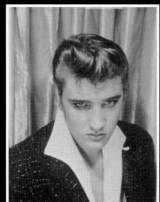

These pictures, taken at different times throughout Elvis' teenage years, reveal the evolution of the Hillbilly Cat. They highlight his increasing break from conformity and the development of his personal style and signature pompadour. In the last shot, taken from a series of pictures in a photo booth, saved by Gladys Presley, Elvis is wearing a wool jacket very similar to the one he would later wear on his national television debut in January 1956.

Photographed here with two friends, Elvis dominates the shot. In March 1953, when interviewed by the State Employment Security Office, Elvis was described as a "rather flashily dressed, playboy type." His unusual dress style would later lead to attacks from the media, with some even blaming him for his undue influence on rebellious teenagers, although Elvis was far from malevolent. God-fearing, hard-working, and respectful of parents and elders, Elvis was more of a Southern gentleman than a riotous troublemaker.

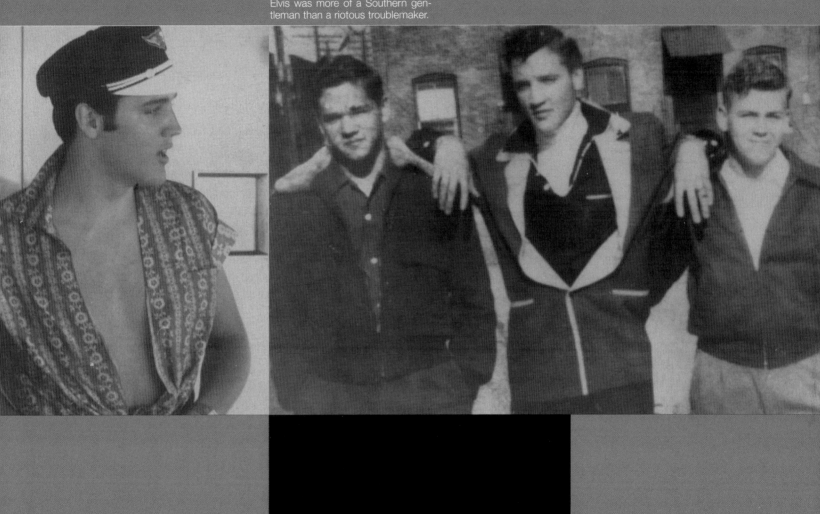

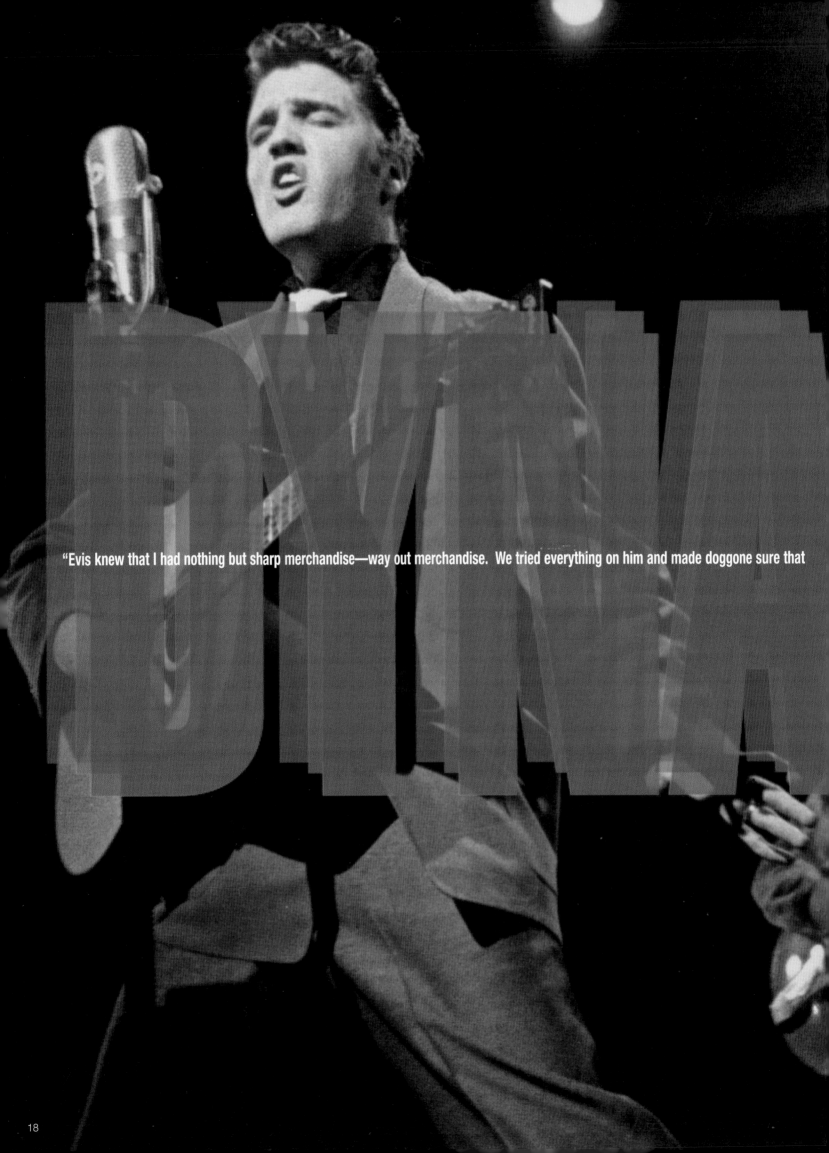

"Evis knew that I had nothing but sharp merchandise—way out merchandise. We tried everything on him and made doggone sure that

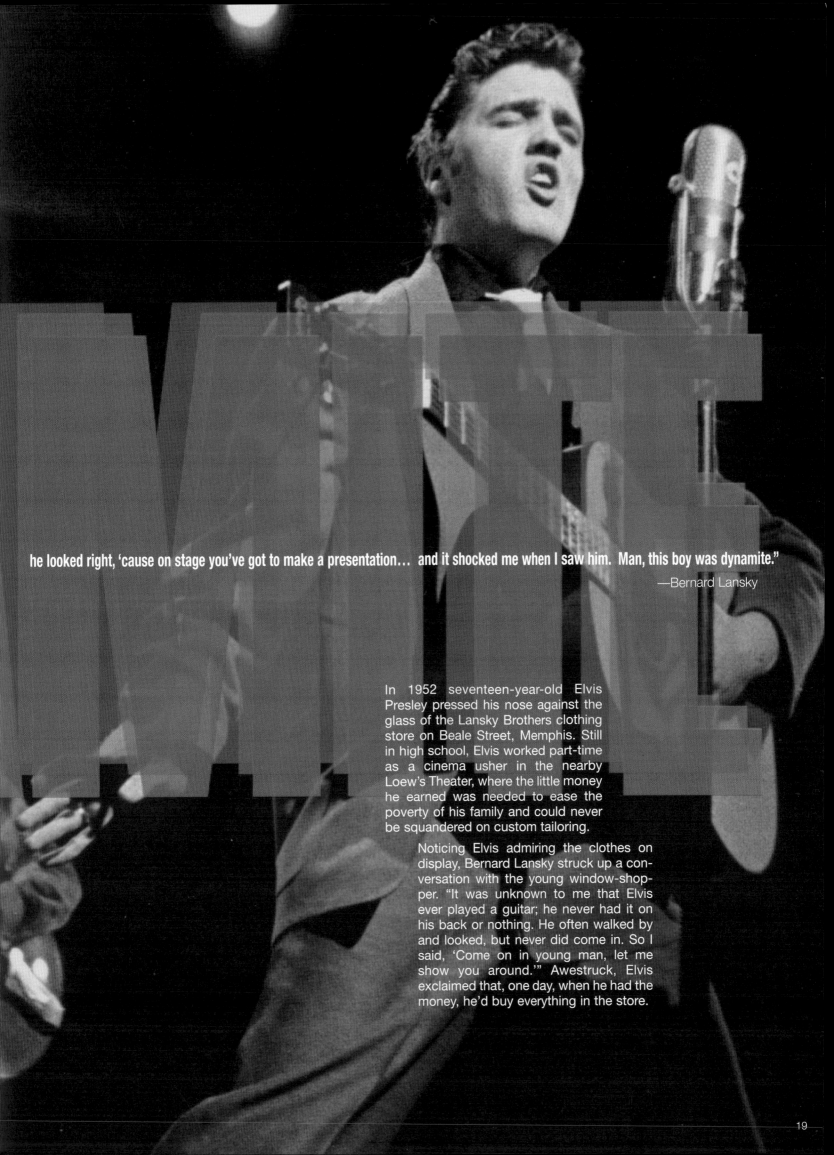

...he looked right, 'cause on stage you've got to make a presentation... and it shocked me when I saw him. Man, this boy was dynamite."

—Bernard Lansky

In 1952 seventeen-year-old Elvis Presley pressed his nose against the glass of the Lansky Brothers clothing store on Beale Street, Memphis. Still in high school, Elvis worked part-time as a cinema usher in the nearby Loew's Theater, where the little money he earned was needed to ease the poverty of his family and could never be squandered on custom tailoring.

Noticing Elvis admiring the clothes on display, Bernard Lansky struck up a conversation with the young window-shopper. "It was unknown to me that Elvis ever played a guitar; he never had it on his back or nothing. He often walked by and looked, but never did come in. So I said, 'Come on in young man, let me show you around.'" Awestruck, Elvis exclaimed that, one day, when he had the money, he'd buy everything in the store.

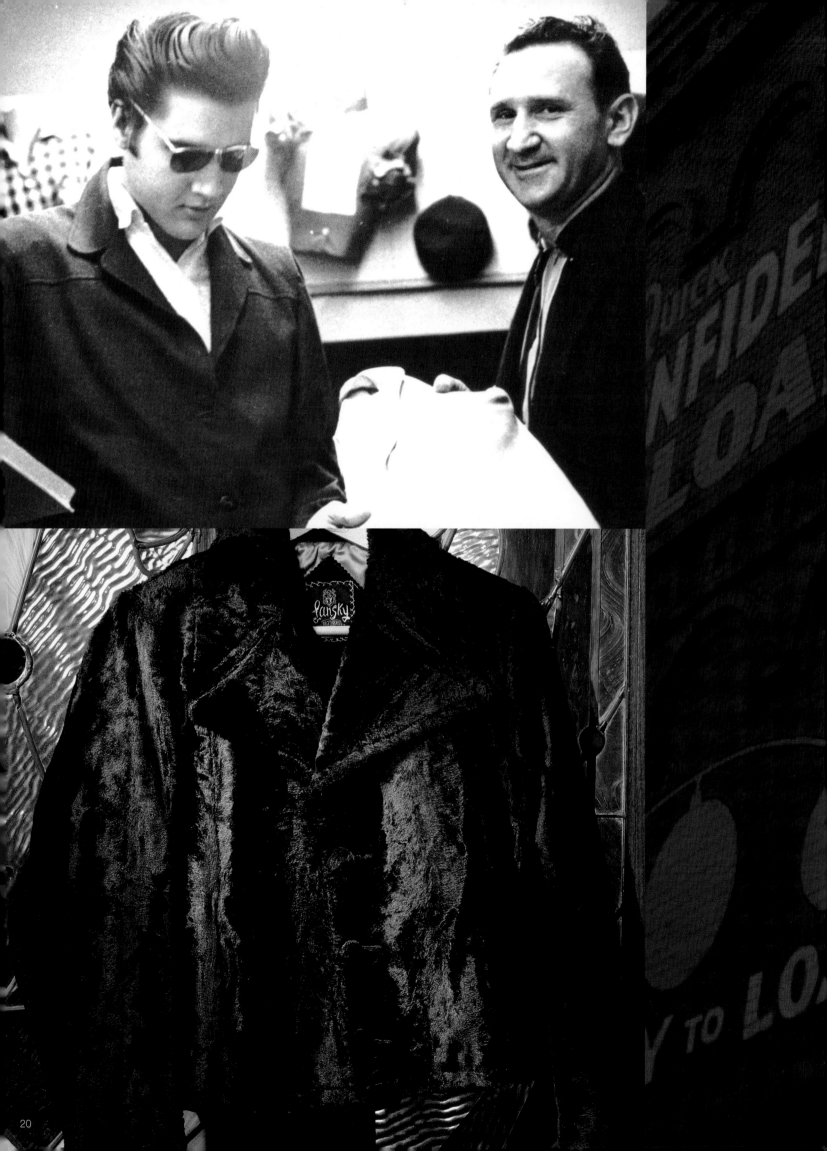

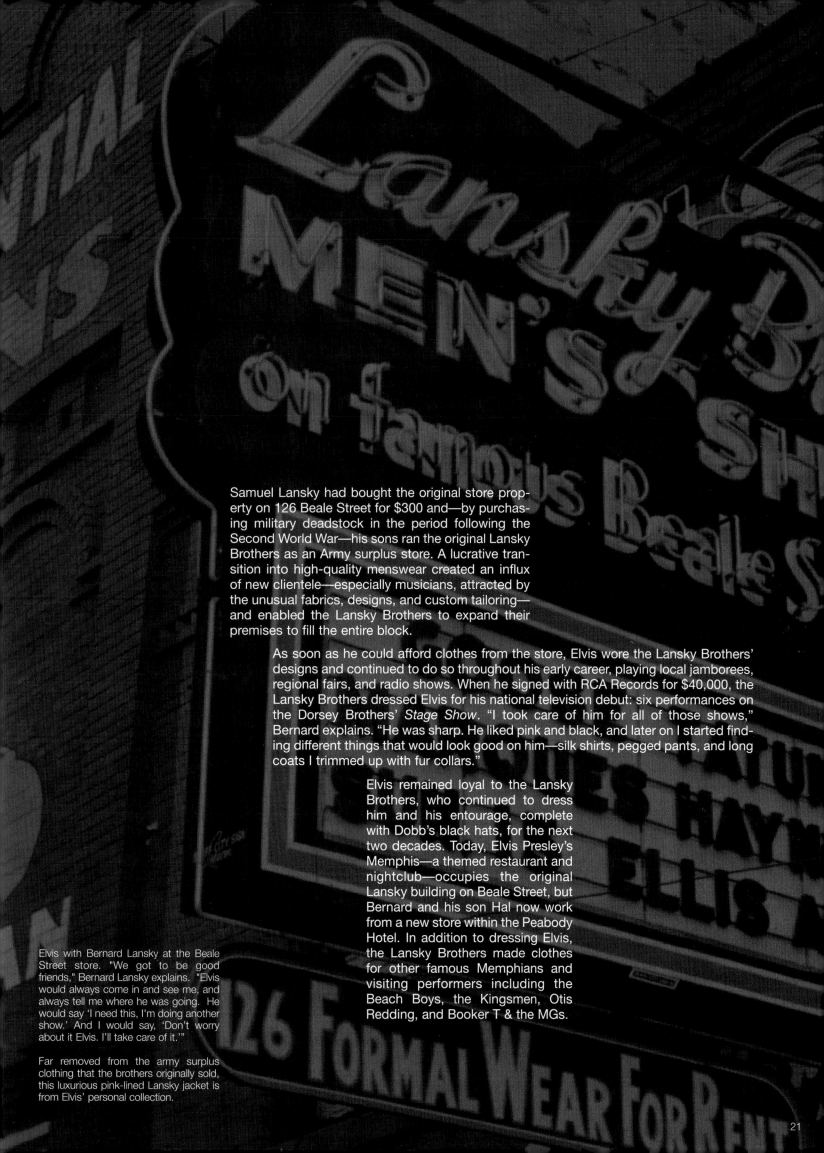

Samuel Lansky had bought the original store property on 126 Beale Street for $300 and—by purchasing military deadstock in the period following the Second World War—his sons ran the original Lansky Brothers as an Army surplus store. A lucrative transition into high-quality menswear created an influx of new clientele—especially musicians, attracted by the unusual fabrics, designs, and custom tailoring—and enabled the Lansky Brothers to expand their premises to fill the entire block.

As soon as he could afford clothes from the store, Elvis wore the Lansky Brothers' designs and continued to do so throughout his early career, playing local jamborees, regional fairs, and radio shows. When he signed with RCA Records for $40,000, the Lansky Brothers dressed Elvis for his national television debut: six performances on the Dorsey Brothers' *Stage Show*. "I took care of him for all of those shows," Bernard explains. "He was sharp. He liked pink and black, and later on I started finding different things that would look good on him—silk shirts, pegged pants, and long coats I trimmed up with fur collars."

Elvis remained loyal to the Lansky Brothers, who continued to dress him and his entourage, complete with Dobb's black hats, for the next two decades. Today, Elvis Presley's Memphis—a themed restaurant and nightclub—occupies the original Lansky building on Beale Street, but Bernard and his son Hal now work from a new store within the Peabody Hotel. In addition to dressing Elvis, the Lansky Brothers made clothes for other famous Memphians and visiting performers including the Beach Boys, the Kingsmen, Otis Redding, and Booker T & the MGs.

Elvis with Bernard Lansky at the Beale Street store. "We got to be good friends," Bernard Lansky explains. "Elvis would always come in and see me, and always tell me where he was going. He would say 'I need this, I'm doing another show.' And I would say, 'Don't worry about it Elvis. I'll take care of it.'"

Far removed from the army surplus clothing that the brothers originally sold, this luxurious pink-lined Lansky jacket is from Elvis' personal collection.

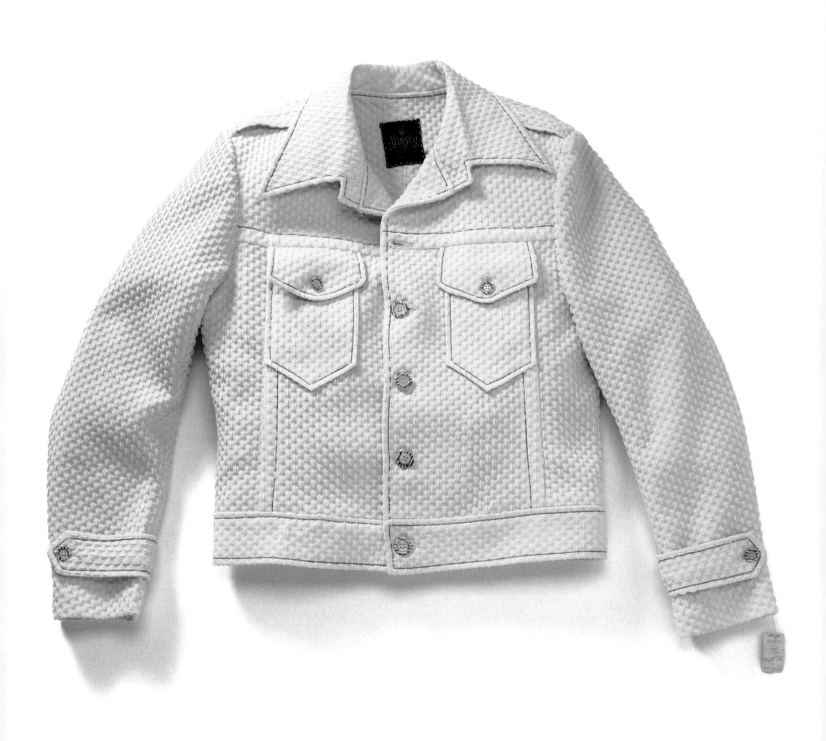

This unworn "Chanel-style" Lansky jacket from the Graceland archives still retains the $75 price tag.

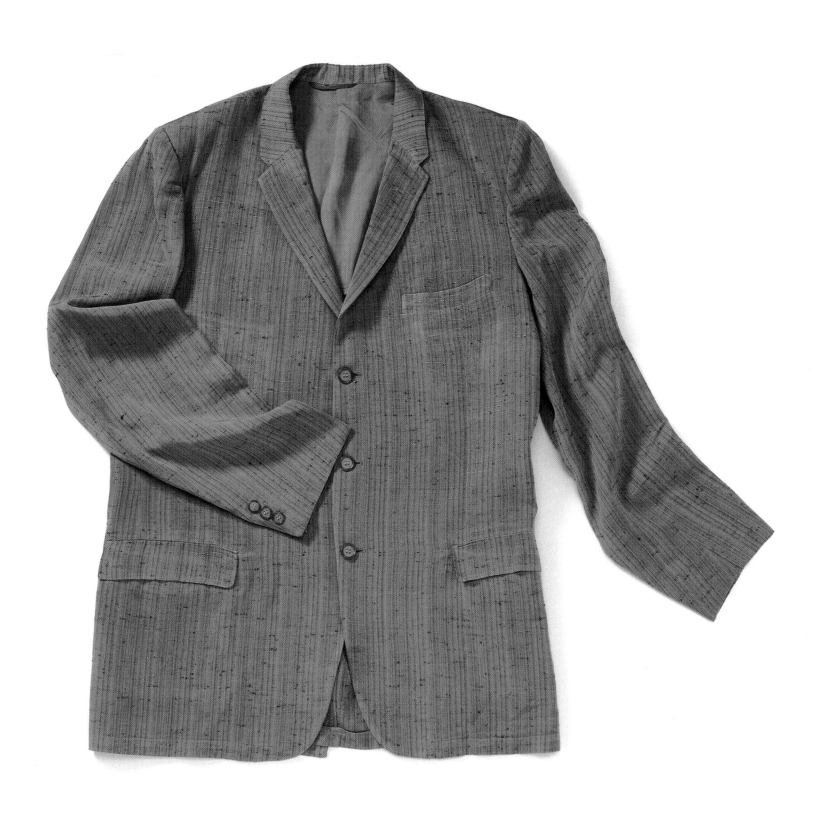

This gray jacket by the Lanskys was probably worn by Elvis during the 1950s. Despite the somewhat conservative color, the cut is typical of designs worn at the start of his career, particularly during the time of his television appearances with the Dorsey Brothers.

American teenagers dressed in denim for rebellion. Throughout the 1950s, clothing that represented manual labor, or cowboy pants, became the means to express rejection of their parents' aspirations. Not surprisingly, their new heroes wore jeans—and T-shirts. Once considered underwear, the simple white T-shirt was promoted to an outer garment by Marlon Brando, first in his portrayal of the impetuous Stanley Kowalski in *A Streetcar Named Desire*, then completing the look with a biker jacket and boots in *The Wild One*. Following closely, James Dean's *Rebel without a Cause* cemented the image. His denim jeans and white T-shirt, complete with knife wound, became the uniform for misunderstood youth who turned their jeans up high and flaunted the baggy, extravagant use of material denied to their forefathers.

"WE NEVER SAW ANYTHING LIKE ELVIS. YOUNG PEOPLE IN THOSE DAYS WOULD WEAR LEVI'S AND T-SHIRTS. THEN TO SEE ELVIS WITH ALL THOSE WILD CLOTHES, IT WAS VERY, VERY DIFFERENT."

—Joe Esposito

When Levi Strauss & Co. appealed to the teenage population with the tag line "Right for School," Elvis didn't conform. His image as a brooding young renegade in a white T-shirt and blue jeans is part of rock and roll folklore—it was never Elvis' true style. He rejected denim because such work-wear evoked the poverty of his youth. By the 1970s, however, denim was widely accepted as daywear, and Elvis' existing wardrobe includes some examples of Levi's and Wrangler shirts from that era. Elvis was rarely, if ever, photographed wearing these items, so it's possible that they belonged to friends or family who also lived at Graceland.

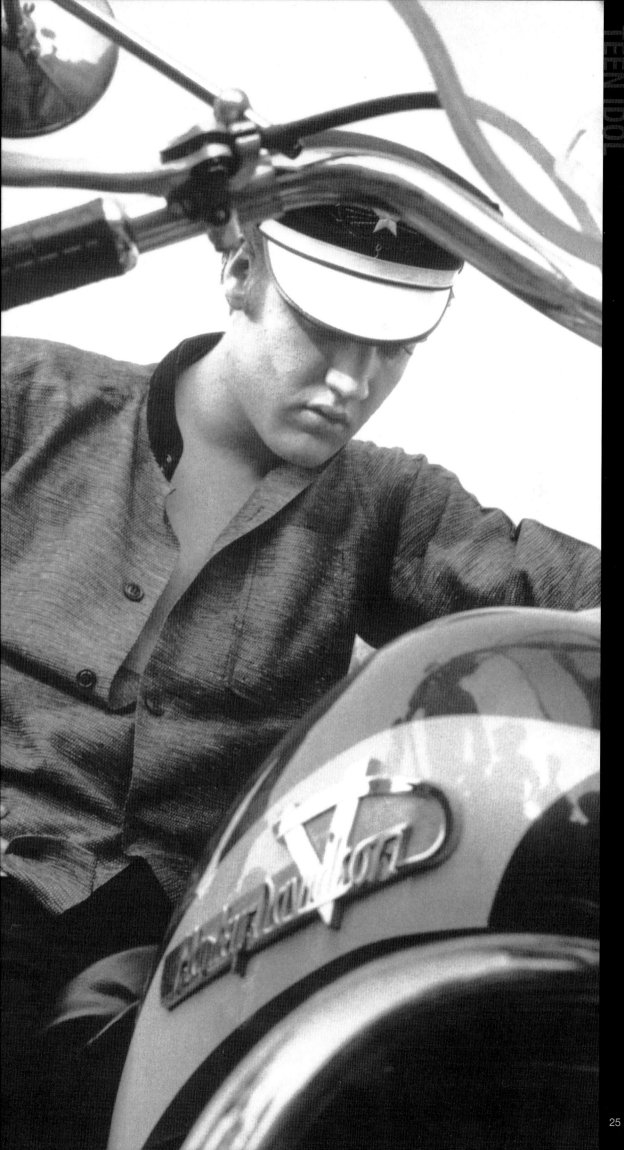

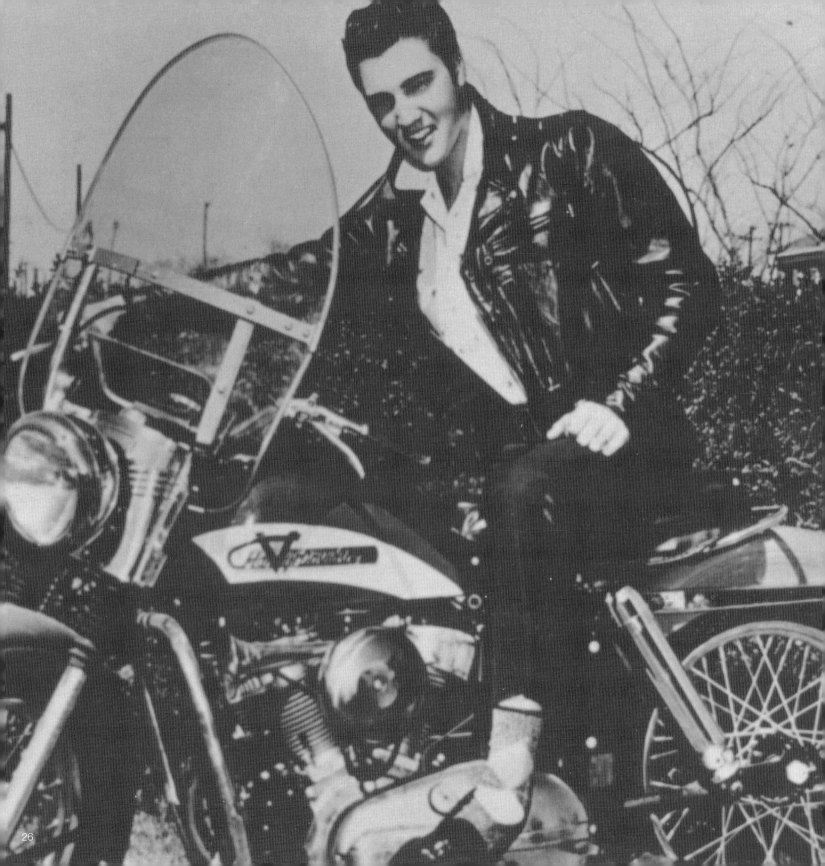

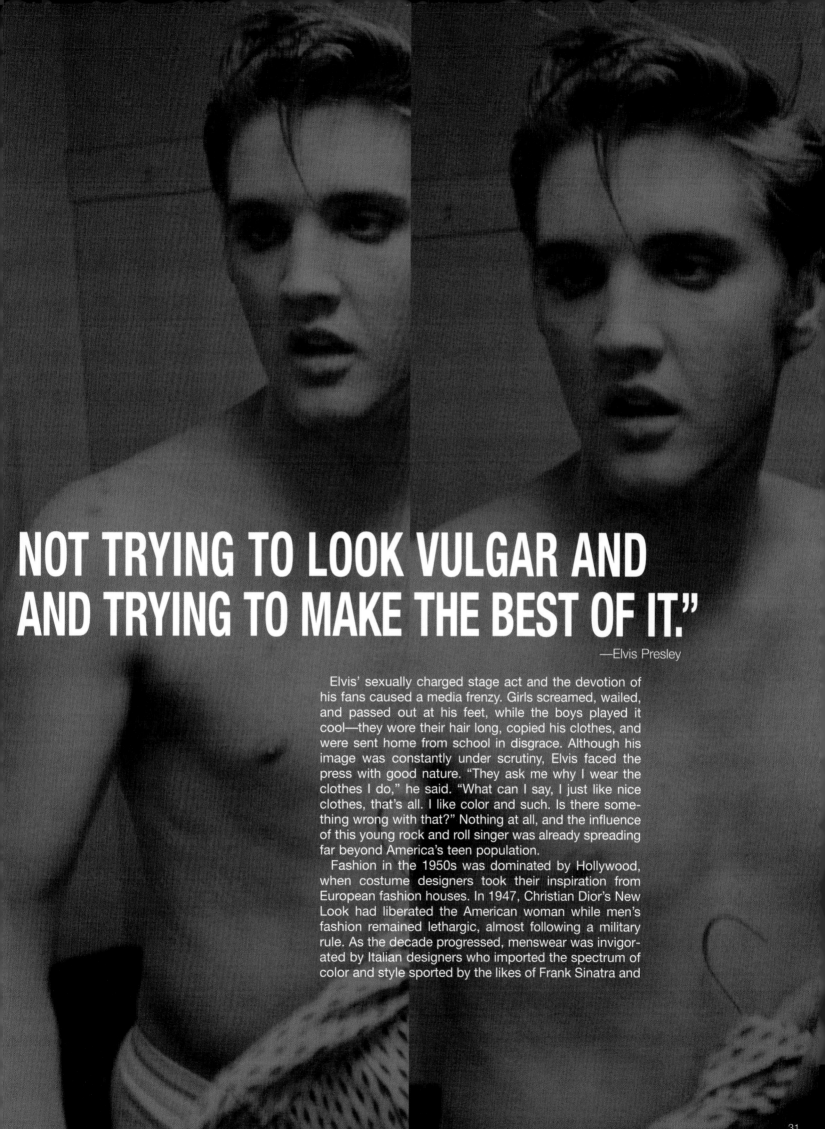

NOT TRYING TO LOOK VULGAR AND AND TRYING TO MAKE THE BEST OF IT."

—Elvis Presley

Elvis' sexually charged stage act and the devotion of his fans caused a media frenzy. Girls screamed, wailed, and passed out at his feet, while the boys played it cool—they wore their hair long, copied his clothes, and were sent home from school in disgrace. Although his image was constantly under scrutiny, Elvis faced the press with good nature. "They ask me why I wear the clothes I do," he said. "What can I say, I just like nice clothes, that's all. I like color and such. Is there something wrong with that?" Nothing at all, and the influence of this young rock and roll singer was already spreading far beyond America's teen population.

Fashion in the 1950s was dominated by Hollywood, when costume designers took their inspiration from European fashion houses. In 1947, Christian Dior's New Look had liberated the American woman while men's fashion remained lethargic, almost following a military rule. As the decade progressed, menswear was invigorated by Italian designers who imported the spectrum of color and style sported by the likes of Frank Sinatra and

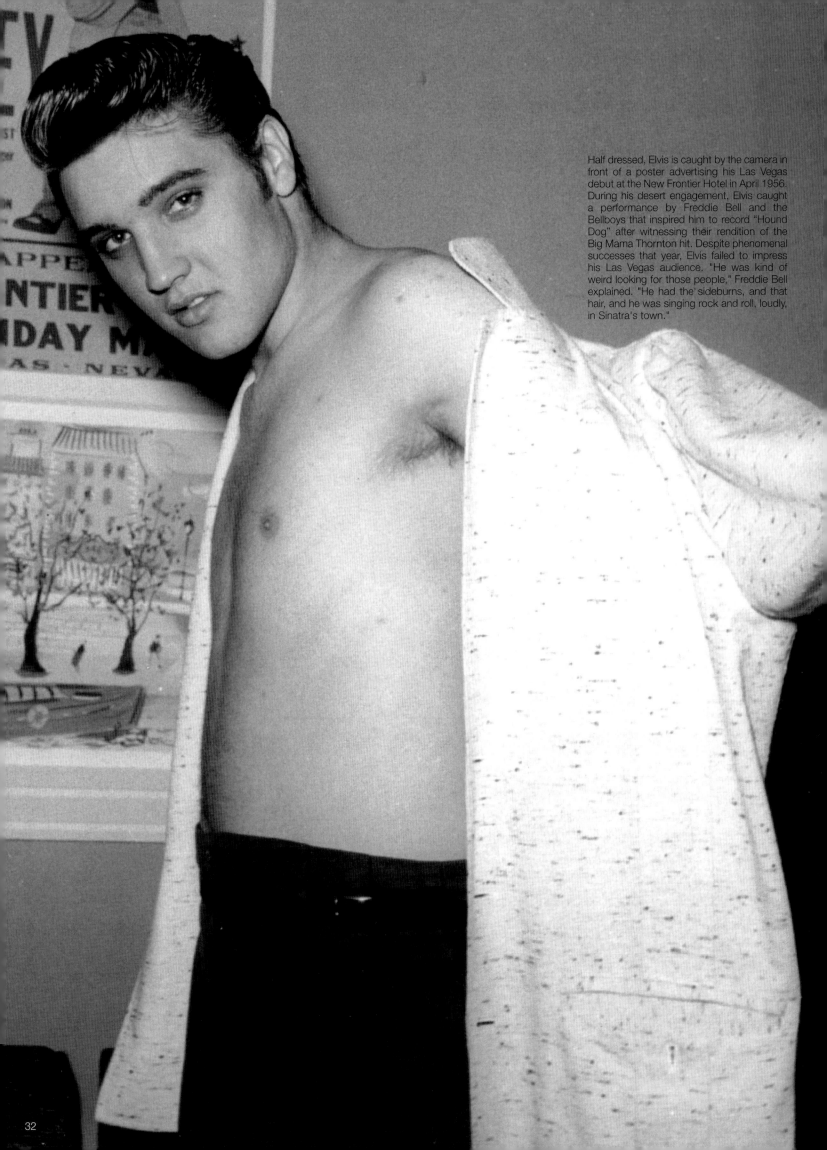

Half dressed, Elvis is caught by the camera in front of a poster advertising his Las Vegas debut at the New Frontier Hotel in April 1956. During his desert engagement, Elvis caught a performance by Freddie Bell and the Bellboys that inspired him to record "Hound Dog" after witnessing their rendition of the Big Mama Thornton hit. Despite phenomenal successes that year, Elvis failed to impress his Las Vegas audience. "He was kind of weird looking for those people," Freddie Bell explained. "He had the sideburns, and that hair, and he was singing rock and roll, loudly, in Sinatra's town."

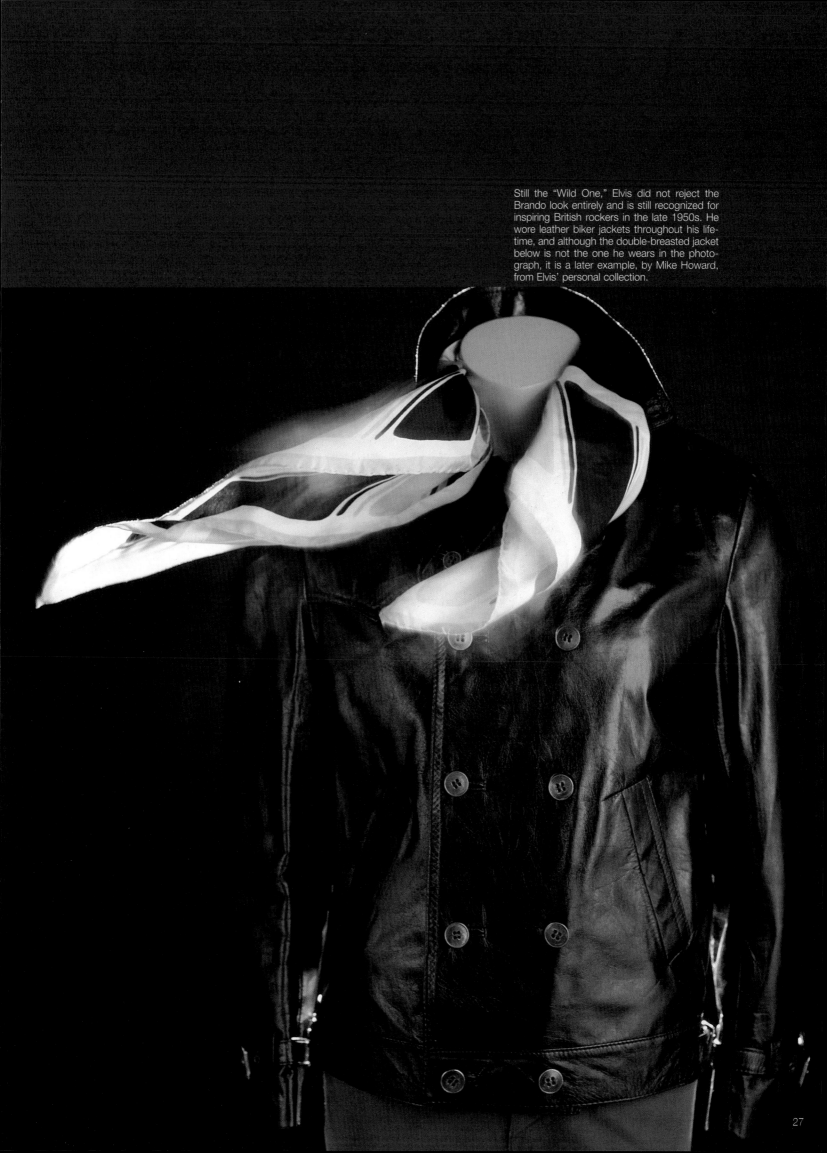

Still the "Wild One," Elvis did not reject the Brando look entirely and is still recognized for inspiring British rockers in the late 1950s. He wore leather biker jackets throughout his lifetime, and although the double-breasted jacket below is not the one he wears in the photograph, it is a later example, by Mike Howard, from Elvis' personal collection.

As Mike Edwards in the 1963 movie *It Happened at the World's Fair*, Elvis wore a leather jacket designed by Hollywood tailor Sy Devore and constructed to withstand Elvis' obligatory fight scenes. Devore later described this as the most expensive leather jacket he ever created.

Elvis' semi-biographical portrayal of Deke Rivers in *Loving You* is mainly responsible for his enduring denim look. Wearing a Levi's 507 jacket and jeans, Deke Rivers "plays" the local boy—endearing both real and fictional female fans with a look that would become synonymous with Elvis and a classic image for rock and roll.

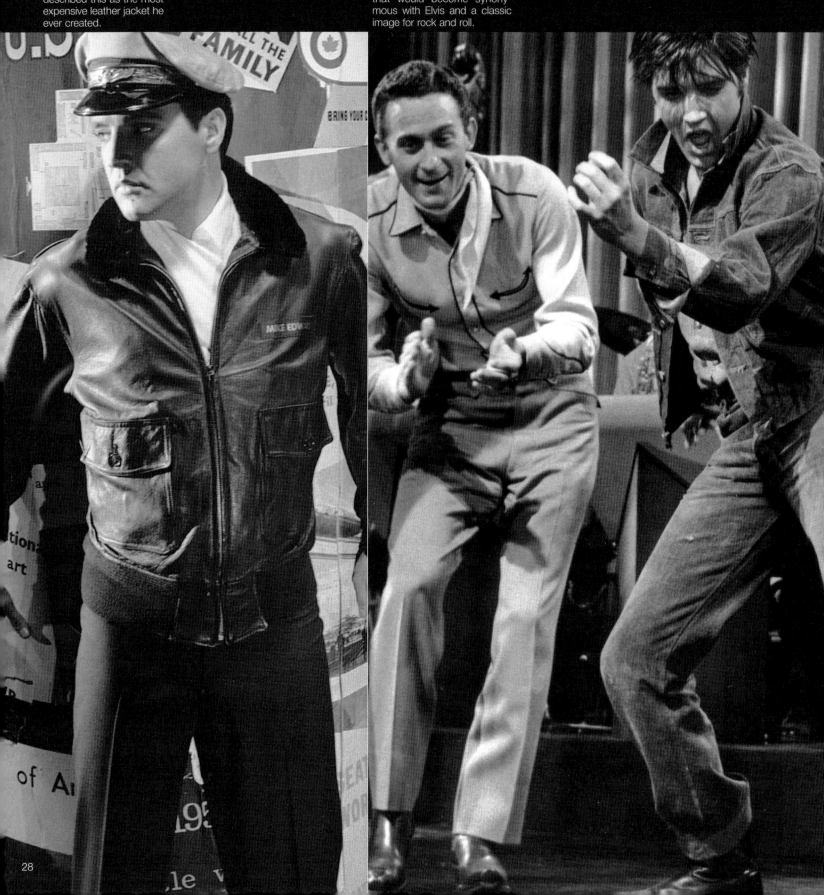

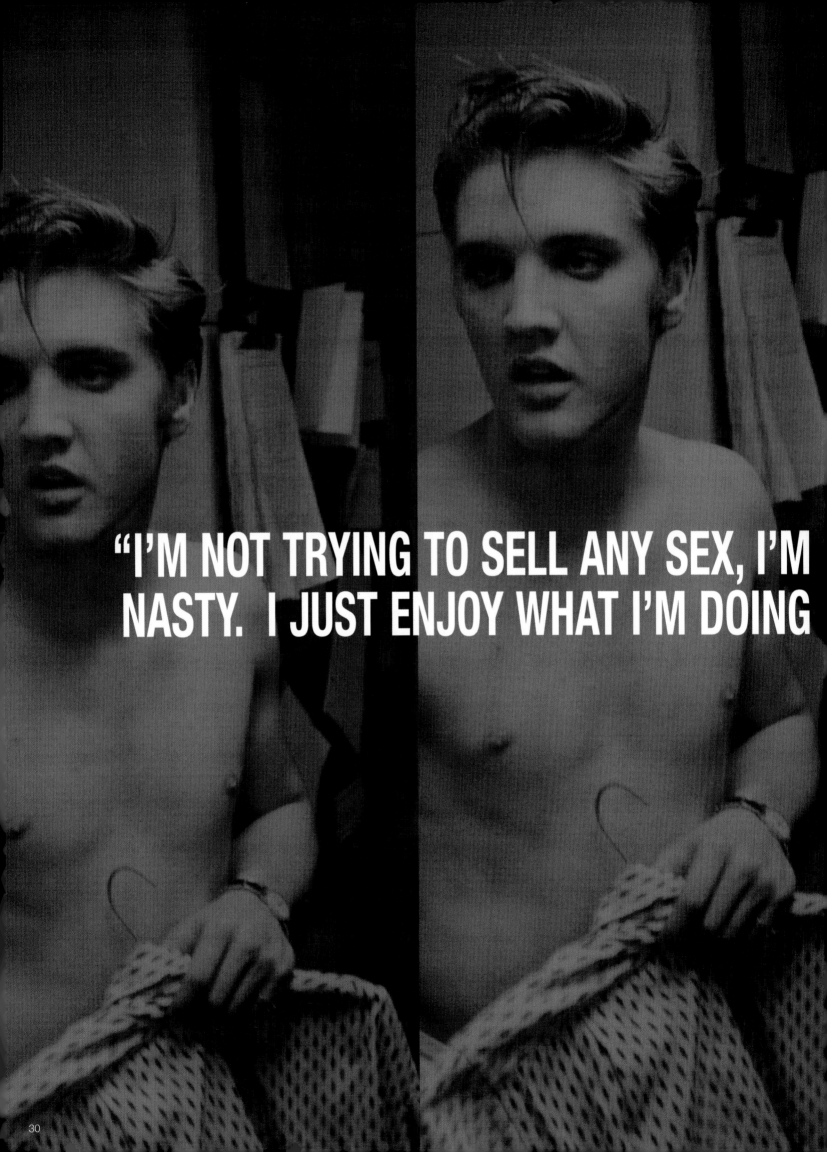

"I'M NOT TRYING TO SELL ANY SEX, I'M NASTY. I JUST ENJOY WHAT I'M DOING

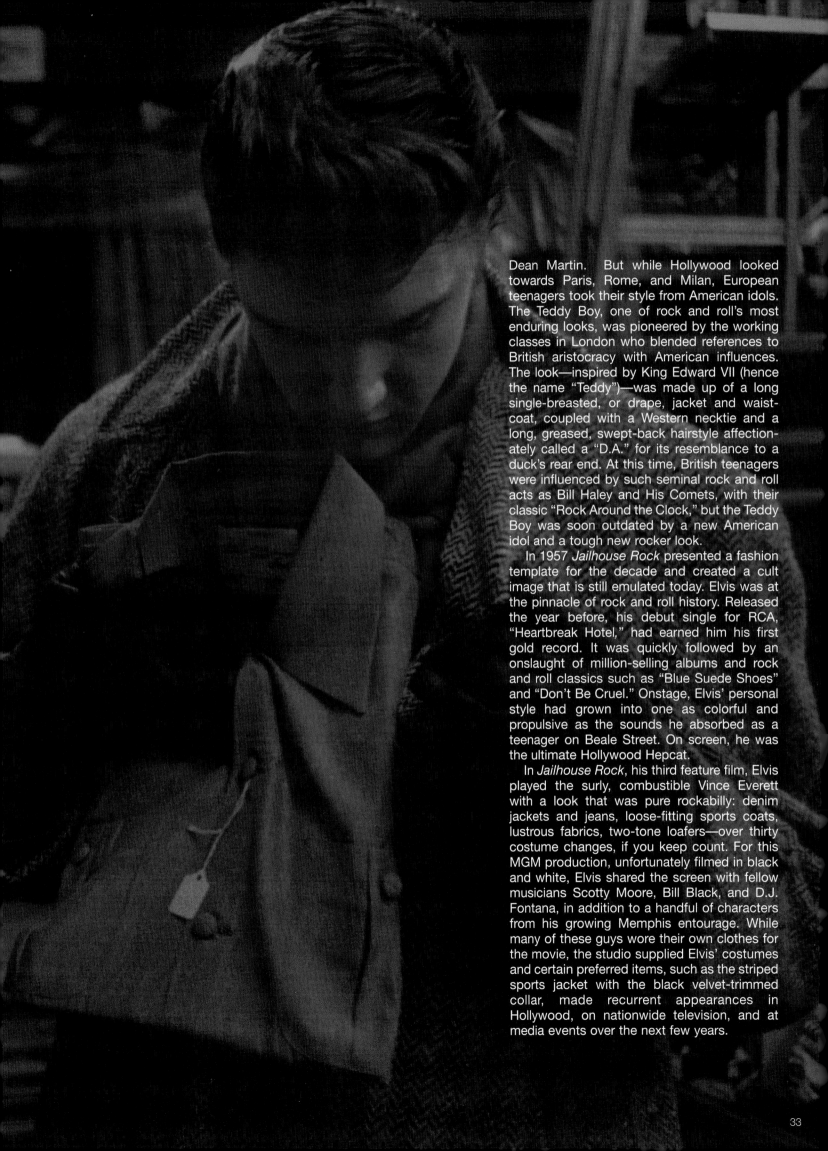

Dean Martin. But while Hollywood looked towards Paris, Rome, and Milan, European teenagers took their style from American idols. The Teddy Boy, one of rock and roll's most enduring looks, was pioneered by the working classes in London who blended references to British aristocracy with American influences. The look—inspired by King Edward VII (hence the name "Teddy")—was made up of a long single-breasted, or drape, jacket and waistcoat, coupled with a Western necktie and a long, greased, swept-back hairstyle affectionately called a "D.A." for its resemblance to a duck's rear end. At this time, British teenagers were influenced by such seminal rock and roll acts as Bill Haley and His Comets, with their classic "Rock Around the Clock," but the Teddy Boy was soon outdated by a new American idol and a tough new rocker look.

In 1957 *Jailhouse Rock* presented a fashion template for the decade and created a cult image that is still emulated today. Elvis was at the pinnacle of rock and roll history. Released the year before, his debut single for RCA, "Heartbreak Hotel," had earned him his first gold record. It was quickly followed by an onslaught of million-selling albums and rock and roll classics such as "Blue Suede Shoes" and "Don't Be Cruel." Onstage, Elvis' personal style had grown into one as colorful and propulsive as the sounds he absorbed as a teenager on Beale Street. On screen, he was the ultimate Hollywood Hepcat.

In *Jailhouse Rock*, his third feature film, Elvis played the surly, combustible Vince Everett with a look that was pure rockabilly: denim jackets and jeans, loose-fitting sports coats, lustrous fabrics, two-tone loafers—over thirty costume changes, if you keep count. For this MGM production, unfortunately filmed in black and white, Elvis shared the screen with fellow musicians Scotty Moore, Bill Black, and D.J. Fontana, in addition to a handful of characters from his growing Memphis entourage. While many of these guys wore their own clothes for the movie, the studio supplied Elvis' costumes and certain preferred items, such as the striped sports jacket with the black velvet-trimmed collar, made recurrent appearances in Hollywood, on nationwide television, and at media events over the next few years.

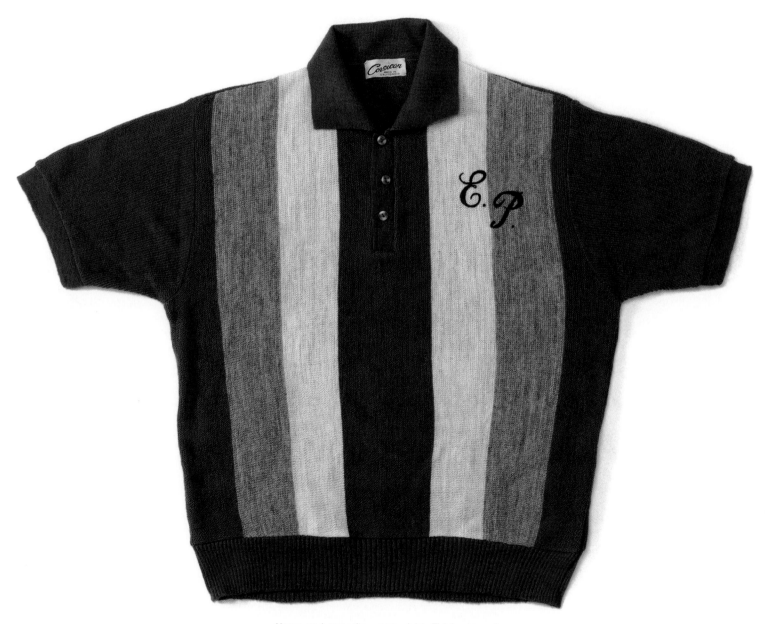

Above and opposite, upper right: Elvis' personal brand. His initials began appearing on his clothes in the 1950s and continued to adorn shirts, jackets, jewelry, and even sunglasses well into the 1970s.

Top: On the set of his first motion picture, *Love Me Tender*, in 1956, Elvis looked over his own range of merchandise. Devised by his enterprising manager, Colonel Tom Parker. Clothes bearing the "Elvis" brand included T-shirts, skirts, scarves, shoes, and hats, along with accessories ranging from vanity cases and portable record players to lipsticks and charm bracelets.

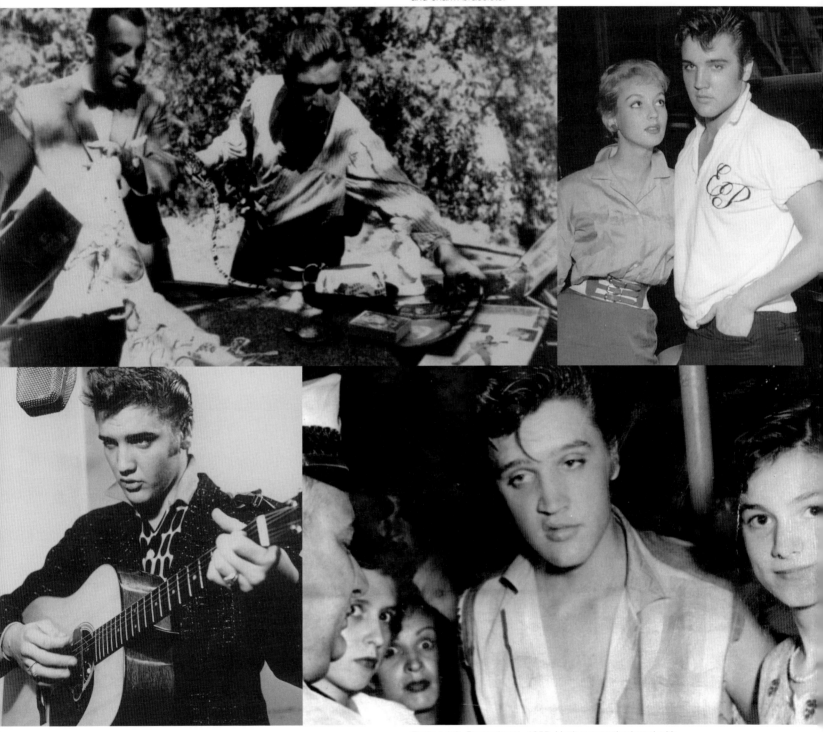

Bottom left: December 1, 1955. Having recently signed with RCA Victor, Elvis posed for a series of publicity photographs, some of which were used to promote his forthcoming television appearance with Jimmy and Tommy Dorsey on *Stage Show*. Jackie Gleason, who produced the show, described Elvis as "a guitar-playing Marlon Brando."

Bottom right: Under the watchful eye of a police officer, Elvis meets with his fans. On wilder occasions, they would tear at his clothes to reach him. "Elvis had a couple of shirts and a couple of sports jackets torn," his guitarist Scotty Moore remembers. "They wanted to talk to him, or get an autograph, or a kiss; they just didn't want him to go away. So there were a hundred hands reaching and grabbing."

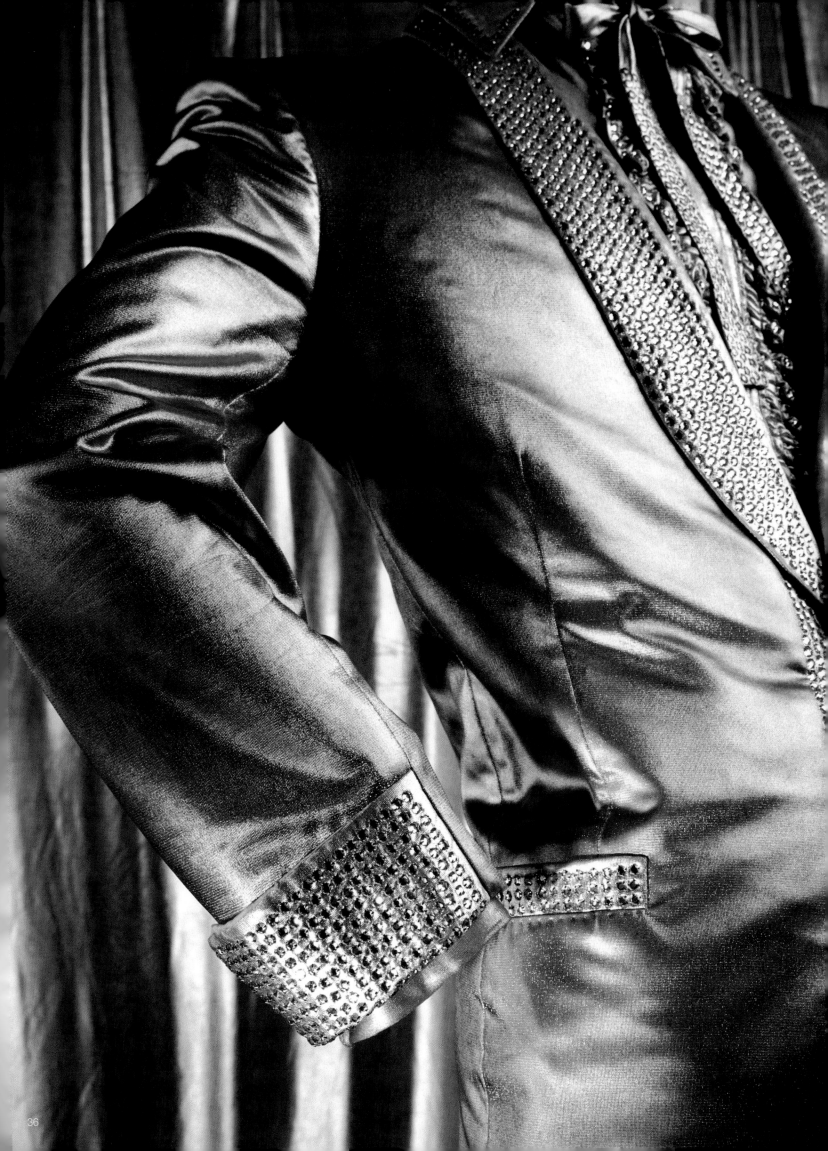

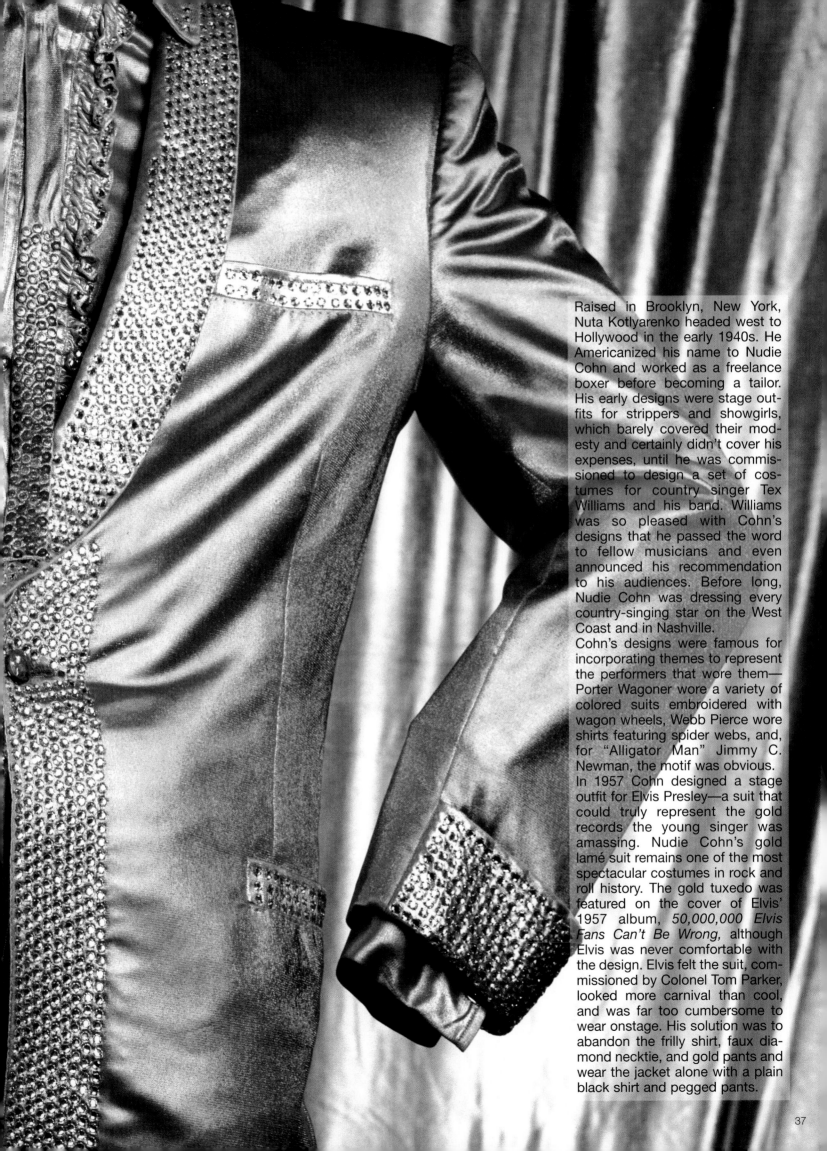

Raised in Brooklyn, New York, Nuta Kotlyarenko headed west to Hollywood in the early 1940s. He Americanized his name to Nudie Cohn and worked as a freelance boxer before becoming a tailor. His early designs were stage outfits for strippers and showgirls, which barely covered their modesty and certainly didn't cover his expenses, until he was commissioned to design a set of costumes for country singer Tex Williams and his band. Williams was so pleased with Cohn's designs that he passed the word to fellow musicians and even announced his recommendation to his audiences. Before long, Nudie Cohn was dressing every country-singing star on the West Coast and in Nashville.

Cohn's designs were famous for incorporating themes to represent the performers that wore them—Porter Wagoner wore a variety of colored suits embroidered with wagon wheels, Webb Pierce wore shirts featuring spider webs, and, for "Alligator Man" Jimmy C. Newman, the motif was obvious.

In 1957 Cohn designed a stage outfit for Elvis Presley—a suit that could truly represent the gold records the young singer was amassing. Nudie Cohn's gold lamé suit remains one of the most spectacular costumes in rock and roll history. The gold tuxedo was featured on the cover of Elvis' 1957 album, *50,000,000 Elvis Fans Can't Be Wrong,* although Elvis was never comfortable with the design. Elvis felt the suit, commissioned by Colonel Tom Parker, looked more carnival than cool, and was far too cumbersome to wear onstage. His solution was to abandon the frilly shirt, faux diamond necktie, and gold pants and wear the jacket alone with a plain black shirt and pegged pants.

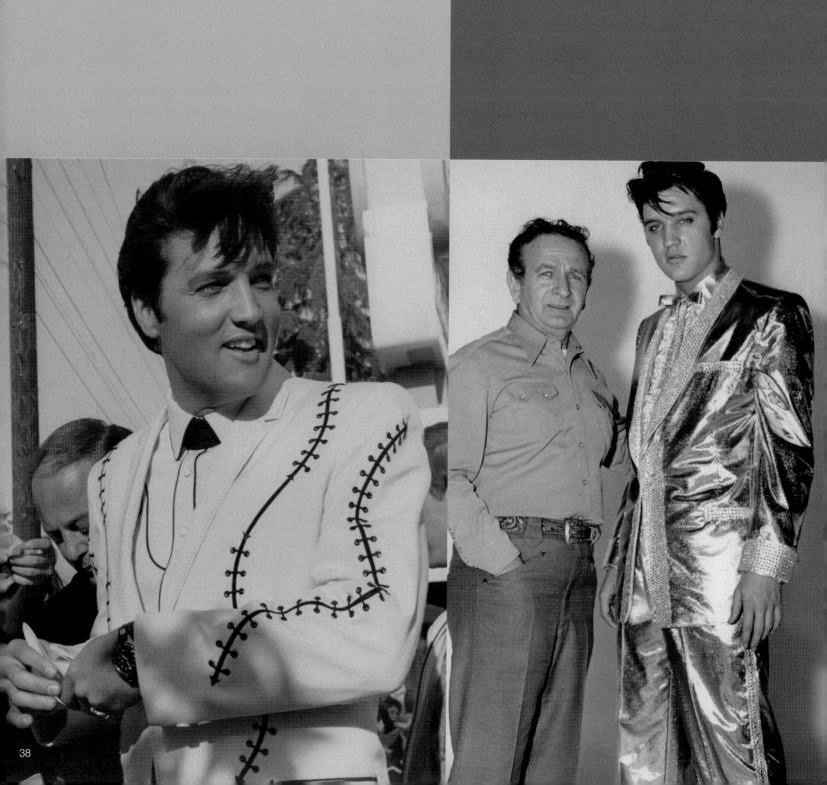

Also by Cohn, this white suit with black Frankenstein stitching was a classic Western design worn by Elvis in his 1967 movie, *Clambake*.

Cohn's granddaughter, Jamie Nudie Mendoza, recalls, "The Colonel and my grandfather wanted to do something spectacular for Elvis so they came up with the idea of the gold suit. Only my grandfather was involved, and it took several weeks of work. Today, we could never give you a price on what that would cost."

In *Loving You,* Elvis' character is presented with a stunning red and white embroidered Western suit with matching boots. Created by Nudie Cohn, this suit was featured in Elvis' performance of "Teddy Bear."

Cohn's gold lamé suit is trimmed in silver around the collar, upturned cuffs, and pockets, and set with rhinestones. The jewels continue down the pant legs and along the rear seam of the jacket, the front of which is fastened by a single button engraved with a flower design. Press reports state that the suit cost a record $10,000. Although the actual price was only a quarter of that, it was still an extravagant purchase for 1957. This suit was kept by Colonel Tom Parker until his collection was acquired by Graceland in 1990. It is currently on display in its Trophy Building.

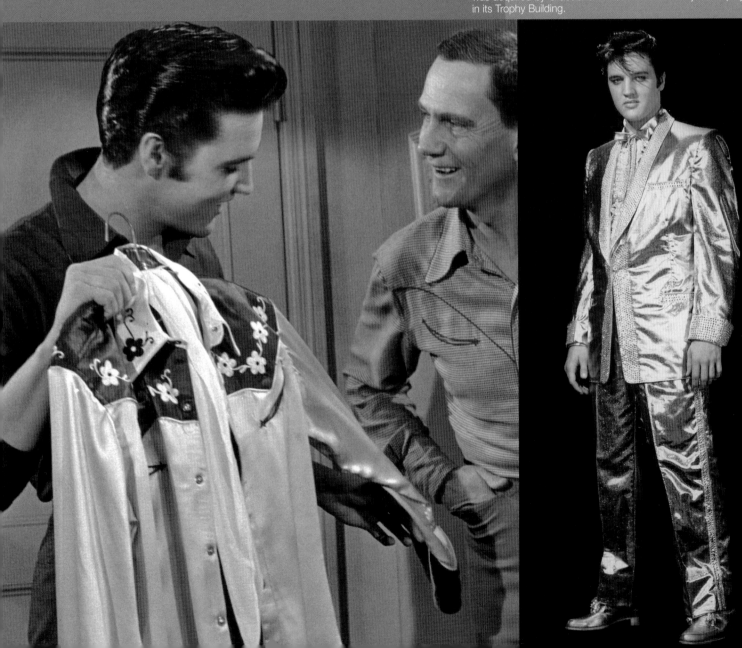

"Elvis started out as one of the bad boys. There was always this clean and squeaky kind of actor, or type, in high school, who had their hair parted to the side and combed very nicely, and they were very clean cut. Then there were always the rougher guys with longer hair and sideburns that wore their collars up. So Elvis would fit into that category.

He was much sexier in concept and far more dangerous than the all-American boy."

—Bob Mackie

Elvis in makeup, as a car mechanic turned boxer in the 1962 movie *Kid Galahad*. The makeup artist was Lynn F. Reynolds, whose credits include the television series *Gunsmoke* and *Little House on the Prairie,* as well as several movies. Elvis' hair is shorter than it was at the start of his movie career and the sideburns have been shaved off. His hair was styled for this feature by Alice Monte, fresh from grooming the Jets and Sharks in the 1961 movie *West Side Story*.

For Paramount pictures, Elvis' hair was styled by Nellie Manley, who worked on more than one hundred movies with an enviable portfolio of Hollywood masculinity, from Victor Mature in *Samson and Delilah* to Burt Lancaster in *The Rainmaker*.

The makeup artists primarily associated with Elvis' film career are MGM's William Tuttle and the Westmore family for Paramount Pictures. William Tuttle, who had been with MGM since the 1930s, began working with Elvis on *Jailhouse Rock* in 1957, followed by nine more pictures for the singer including *Viva Las Vegas, Spinout,* and *Stay Away Joe*. In 1965 he was awarded an honorary Academy Award for his work on *Seven Faces of Dr. Lao*.

A British-born wigmaker, George Westmore started work as a Hollywood makeup artist in 1917, where his family became leaders in their craft. For Paramount, his son Wally Westmore worked on ten Elvis movies from *Loving You* to *Easy Come Easy Go*, while two other sons, Frank and Bud Westmore, worked on *Tickle Me* and *Change of Habit*, respectively. Younger generations of the Westmore family have continued to join the profession and have made up an endless list of Hollywood stars from Clark Gable and Vivien Leigh in *Gone with the Wind* to Jim Carrey in *The Mask*, for which Pamela Westmore claimed the family's first Academy Award.

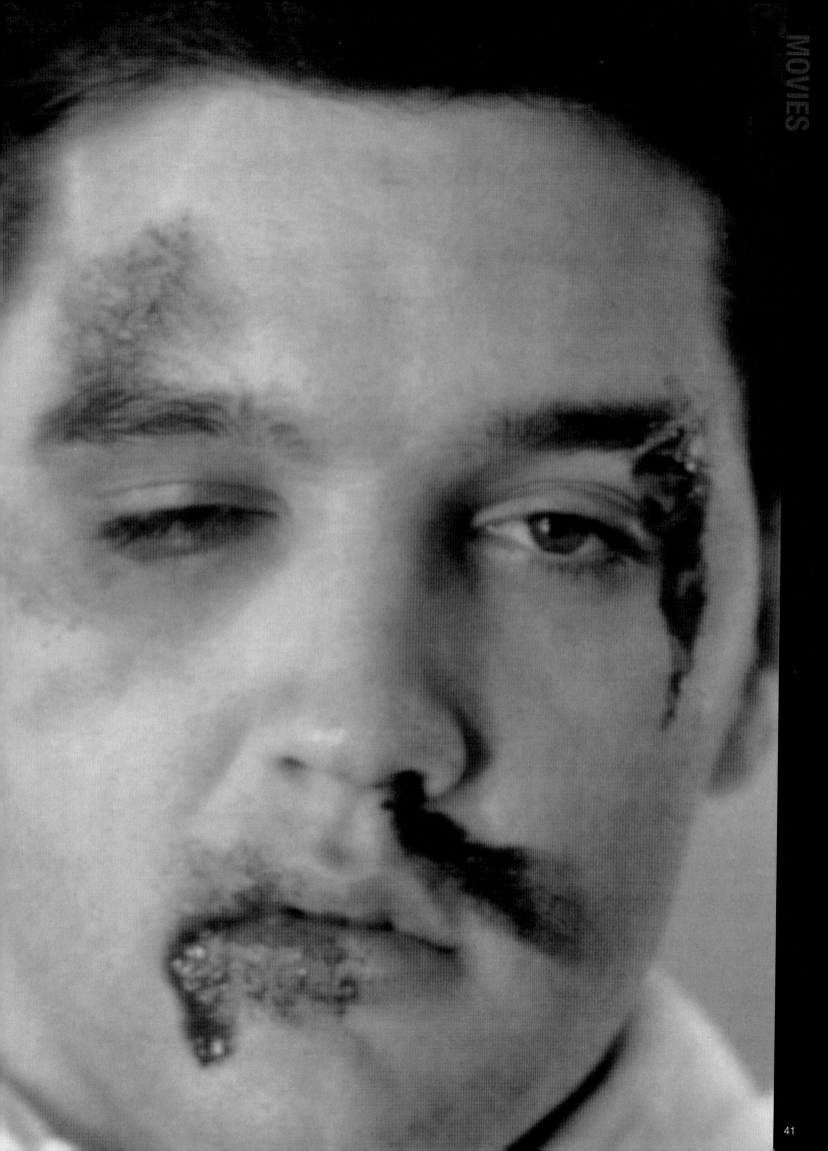

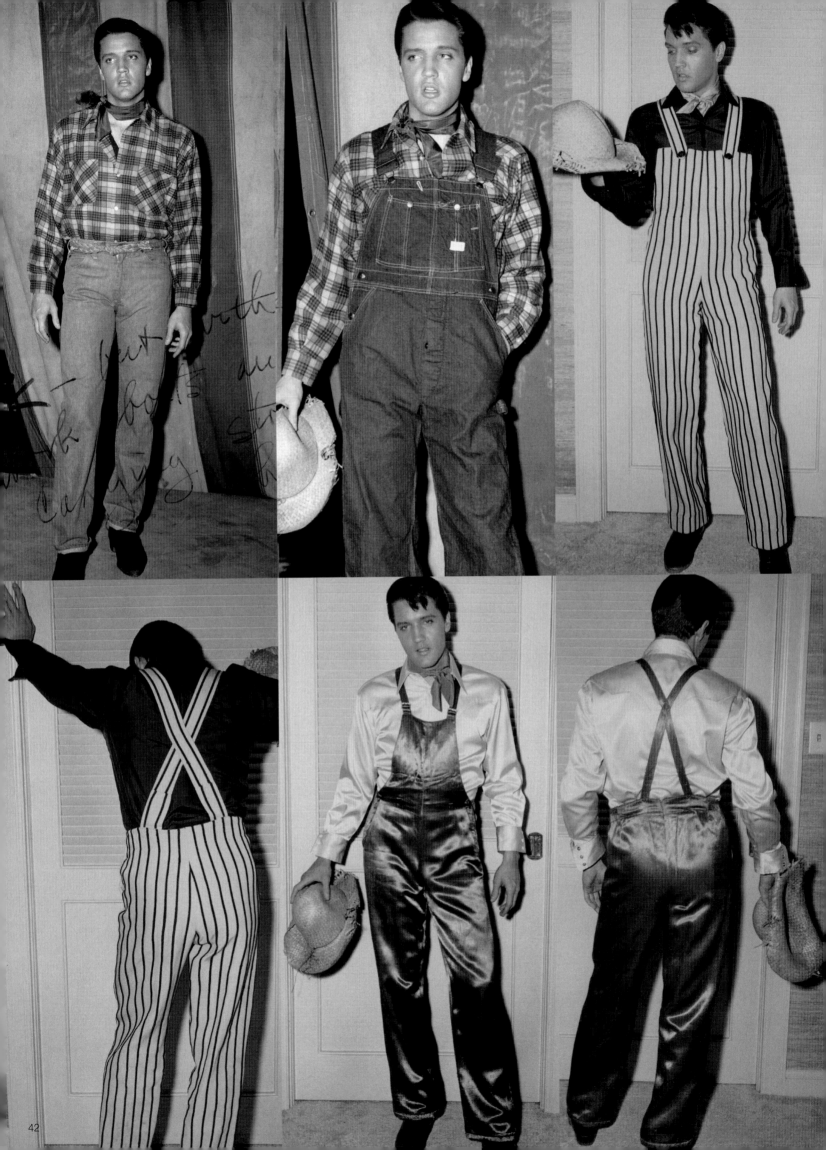

In August 1956, Elvis spoke candidly about his recording career, the criticism aimed at him, and his future ambitions. His message, on an intimate phonograph record, was released along with a 50-cent magazine entitled *Elvis Answers Back*. "All my life I've wanted to be an actor," he revealed. "Always sticking in the back of my head was the idea that somehow, someday, I'd like to get the chance to act."

His meteoric rise to stardom had already caught the attention of Hollywood, and only four short months after leaving Sun Records to sign with the big suits at RCA Victor, he was called for a screen test. Clutching a miniature prop guitar, Elvis mimed feverishly to "Blue Suede Shoes" in front of executives who were considering his future on the big screen. They were inspired to open the door for him and he became the star of thirty-one movies—the best-dressed GI, racecar driver, boxer, and tour guide ever to grace celluloid.

The clothes pictured in this series of costume tests for *Roustabout* did not actually make it into the movie, which credits Edith Head for wardrobe. As Paramount's Chief Costume Designer, she is listed on all of Elvis' movies for the studio, although the costume department employed a wide variety of personnel. Many of Elvis' clothes were bought off the rack by a costumer or stylist and viewed by the singer in a wardrobe sitting. "If Elvis didn't like something, he didn't have to wear it," recalls his friend Joe Esposito. "But he was very cooperative and figured, 'Hey, it's not me on stage, it's just a movie, so if that's what they want me to wear, I'll wear it.'"

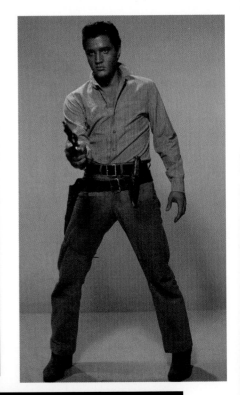

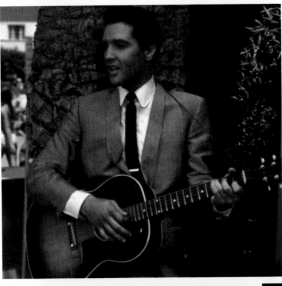

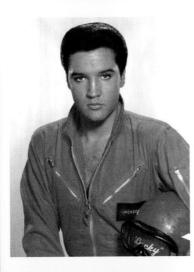

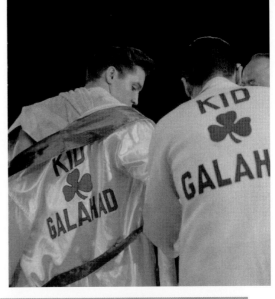

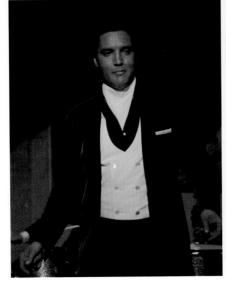

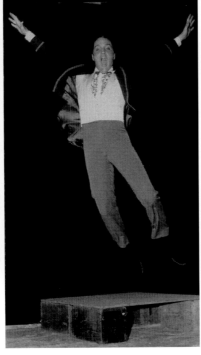

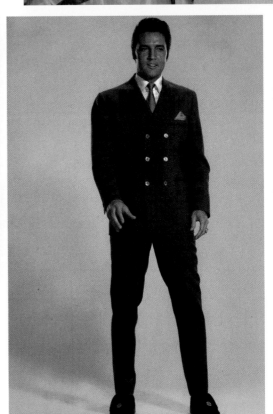

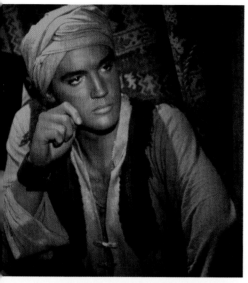
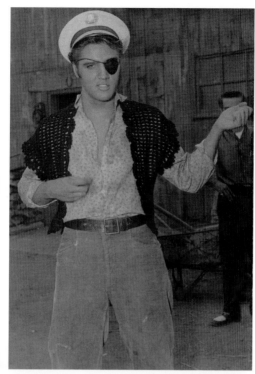
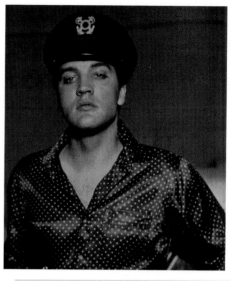
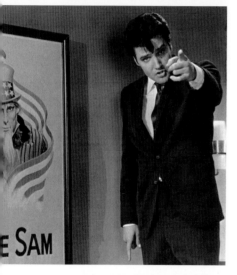
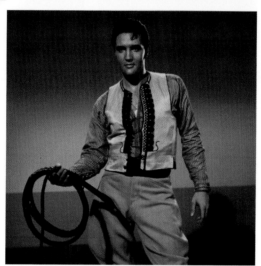
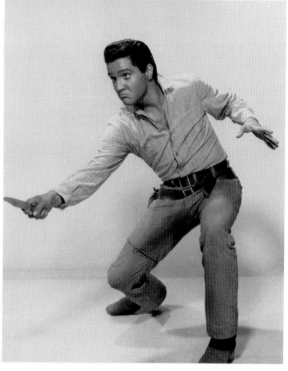

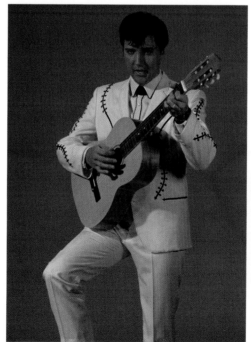
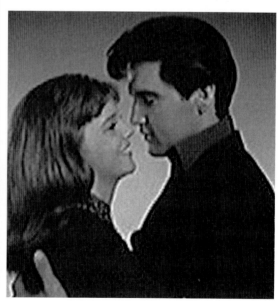

Pictured in a publicity shot with costar Judy Tyler, Elvis wears a Norfolk-style lounging jacket. This outfit appeared very briefly in *Jailhouse Rock*, when his character, rock and roll singer Vince Everett, signs autographs for his fans. For his new Hollywood image, Elvis had capped his teeth. When he accidentally inhaled one of the pearly whites while performing the energetic title track to the movie, he was forced to go to the hospital to remove the offending object from his lung.

When ex-jailbird Vince Everett discovers a talent for singing he teams up with Peggy Van Alden (played by Judy Tyler) to form Laurel Records. When his intentions move beyond a business association, she dismisses his amorous advances as cheap tactics, to which Elvis responds with the classic line, "That ain't tactics, honey… that's just the beast in me."

As Lucky Jackson in *Viva Las Vegas*, Elvis wears a variety of costumes, created by designer Don Feld, from mechanic's overalls to a waiter's uniform, shooting jacket, western clothes, swimming trucks, and a wedding suit. His character is in hot pursuit of Rusty Martin, a swimming instructor played by Ann-Margret.

In this remake of the 1937 classic (starring Edward G. Robinson and Humphrey Bogart), Elvis plays Walter Gulick, who abandons his role as a car mechanic to become the prizefighter Kid Galahad, in a role dressed by Bert Henrikson and Irene Caine.

"I don't want to copy anyone…. I'm trying to be myself

Stills from *Spinout* are often confused with *Girl Happy* (1964), as both movies feature very similar costumes and, although a costume designer is not credited for either movie, it's possible that the same costumer managed Elvis' wardrobe. In this picture Elvis is singing "I'll Be Back", his closing performance in *Spinout*.

Another sharp diversion for Elvis was portraying an ill-fated riverboat gambler in the 1966 movie *Frankie and Johnny*. Costume design is credited to Wes Jeffries for United Artists, and in this energetic studio shot the singer is wearing tuxedo tails supplied by the Western Costume Company, founded in 1912 and still the principal provider of movie wardrobes today.

MGM supplied a bountiful wardrobe for Elvis' role in *Live a Little, Love a Little*. As photographer Greg Nolan, his character has over twenty costume changes featuring a selection of very conservative but stylish outfits including two sets of pajamas—one for sleeping in, one for singing in.

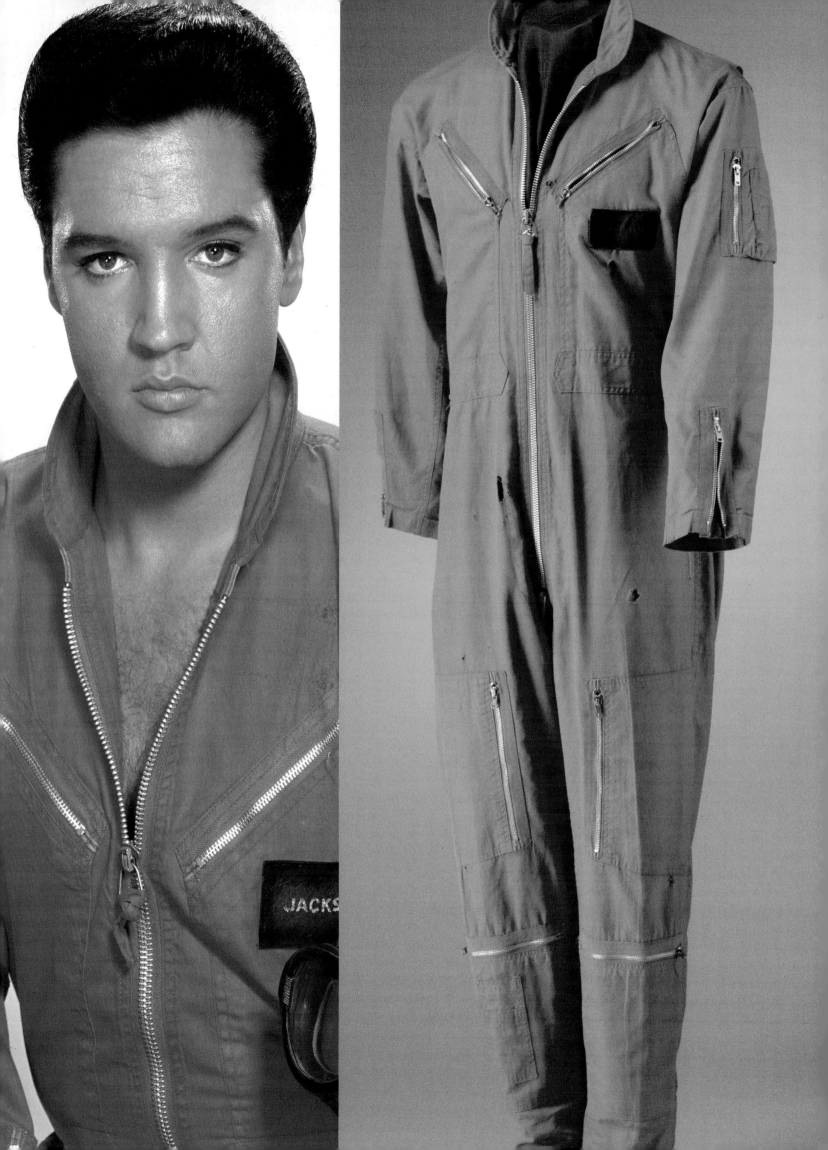

"I wasn't about to tamper with Elvis' image. In that sense, he was like a male version of Mae West—he knew the Elvis look."

—Edith Head

Below: Edith Head, Elvis, Marie Parker, and producer Hal Wallis on the set of *Blue Hawaii*. Head later named this her favorite Elvis movie. A male costumer usually managed Elvis' wardrobe although, as Chief Designer, Head worked closely with Wallis to ensure Elvis' box-office draw.

Trying on costumes for *Blue Hawaii*. Producer Hal Wallis always stated that he did not want the costumes to compete with the stars wearing them and, according to Priscilla Presley, Elvis felt the same way. In his clothes and Priscilla's, Elvis preferred solid colors and avoided large prints, which he felt were too distracting. The flamboyant wardrobe of *Blue Hawaii*, however, includes some of his most flattering movie costumes of the 1960s.

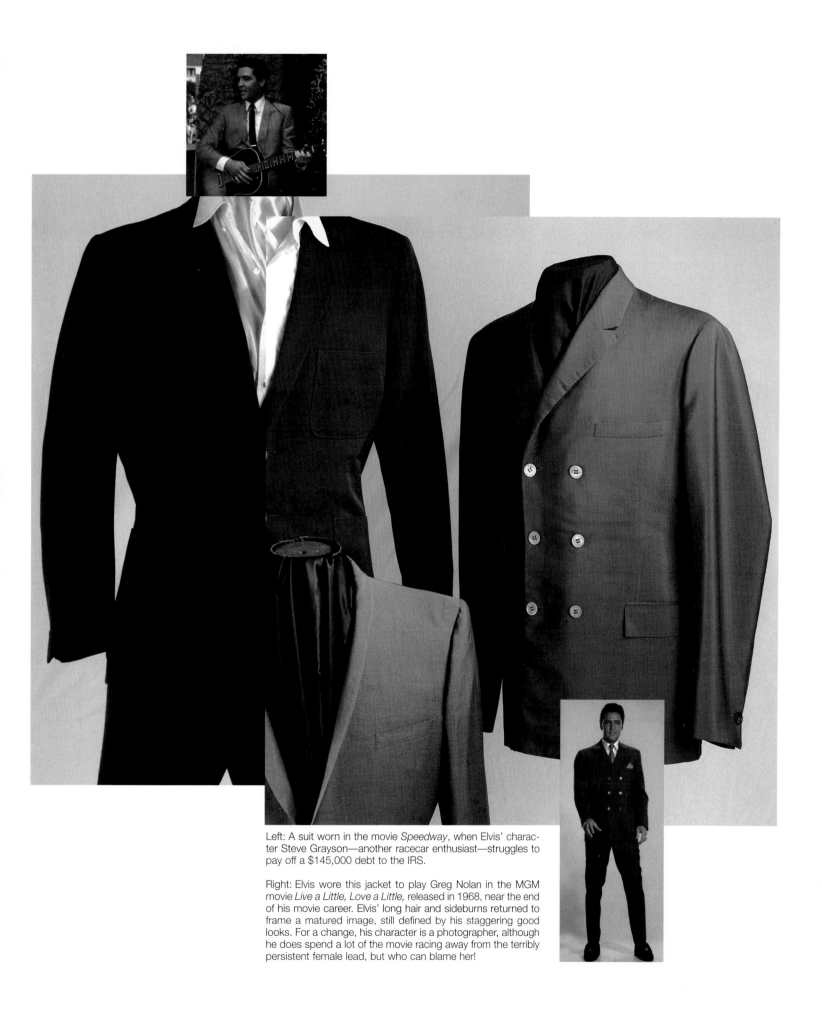

Left: A suit worn in the movie *Speedway*, when Elvis' character Steve Grayson—another racecar enthusiast—struggles to pay off a $145,000 debt to the IRS.

Right: Elvis wore this jacket to play Greg Nolan in the MGM movie *Live a Little, Love a Little,* released in 1968, near the end of his movie career. Elvis' long hair and sideburns returned to frame a matured image, still defined by his staggering good looks. For a change, his character is a photographer, although he does spend a lot of the movie racing away from the terribly persistent female lead, but who can blame her!

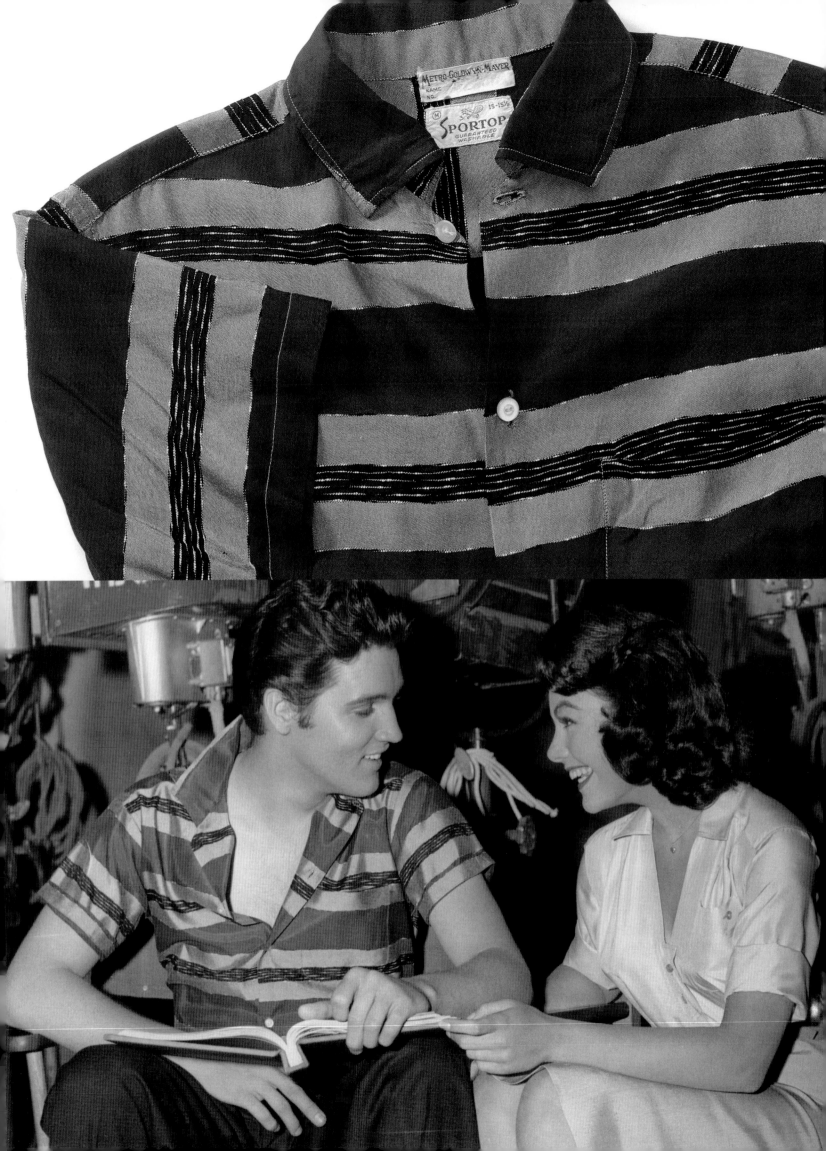

The endless list of films featuring Head's designs include such Hollywood classics as *A Farewell to Arms, Samson and Delilah, Sunset Boulevard, The Greatest Show on Earth, Roman Holiday, War of the Worlds, White Christmas, Breakfast at Tiffany's, The Sting, Butch Cassidy and the Sundance Kid,* Alfred Hitchcock's greatest thrillers including *To Catch a Thief* and *The Birds,* and numerous comedies featuring Bob Hope, Bing Crosby, Dean Martin, and Jerry Lewis.

Paramount's *Loving You* was the first Elvis movie to credit Edith Head as costume designer, followed by *King Creole,* in 1958, and another seven movies throughout the 1960s. It should be said, however, that as one of the last costume designers contracted by Paramount, Head would often receive the credit "Costumes by Edith Head" without having actually worked on the specific movie.

According to Bob Mackie, "A male costumer sourced Elvis' wardrobe." Now an acclaimed costume designer in his own right, Mackie originally worked with Head as a sketch artist in the early 1960s. "I don't think they used sketches for Elvis," he recalls, "and they weren't made by a designer, so nobody was trying to make a point. I guess they were just making him look like Elvis."

Working in Hollywood from its infancy, Edith Head began her partnership with Paramount Pictures in the 1920s after responding to an ad for sketch artists. Head, who was studying part-time at the Chounard Art College, later confessed that she used artwork by her classmates to create the portfolio that landed her the job.

Under the guidance of Paramount designer Travis Banton, Head advanced to Chief Designer in 1938. Soon to become a household name, Edith Head was the first woman to hold such a prestigious position in the industry. She received eight Academy Awards and thirty-five nominations. Her impressive career spanned more than fifty-eight years. Almost every starlet to grace the cinema screen during that period was dressed by Head. She wrapped *Jungle Princess* Dorothy Lamour in a sarong, adorned Grace Kelly in gold lamé, and was responsible, in 1951, for thousands of daisy-sprinkled prom queens, who copied Head's creation for Elizabeth Taylor in *A Place in the Sun.*

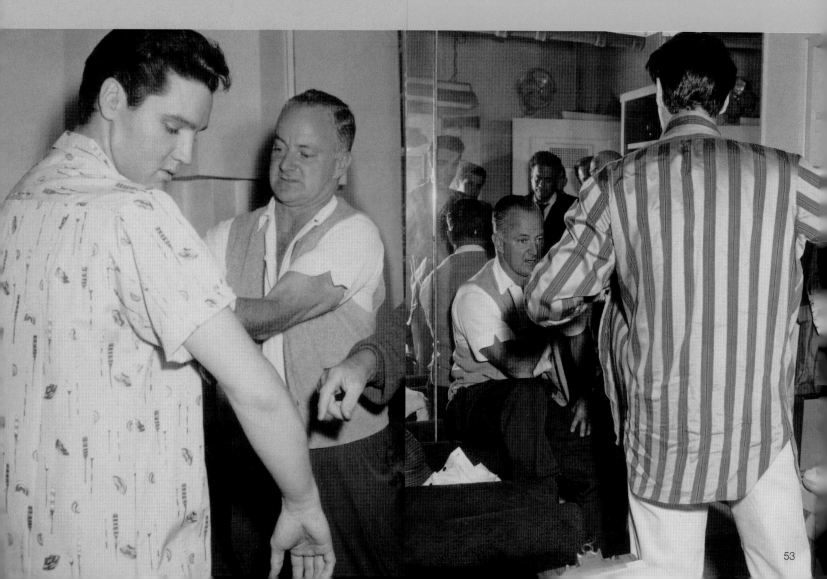

"THEY HAD ME DRESS IN A TUXEDO ON THE *STEVE ALLEN SHOW* AND STAND PERFECTLY STILL.

I COULDN'T MOVE

...I'M SINGING 'YOU AIN'T NOTHIN' BUT A HOUND DOG!' AND THE DOG'S LOOKING UP AT ME LIKE 'WHAT ARE YOU DOING? CALLING ME NAMES OR WHAT?'"
—Elvis Presley

Four years after Steve Allen forced Elvis into a tuxedo, he appeared formally dressed on the Frank Sinatra Show *Welcome Home, Elvis*. His friend Joe Esposito, who was present at the recording, remembers Elvis' dignified attire. "He had no problems putting the tuxedo on and I thought he looked great," he explains. "Elvis was a very cooperative person and, since it was Frank's show, he went along with it."

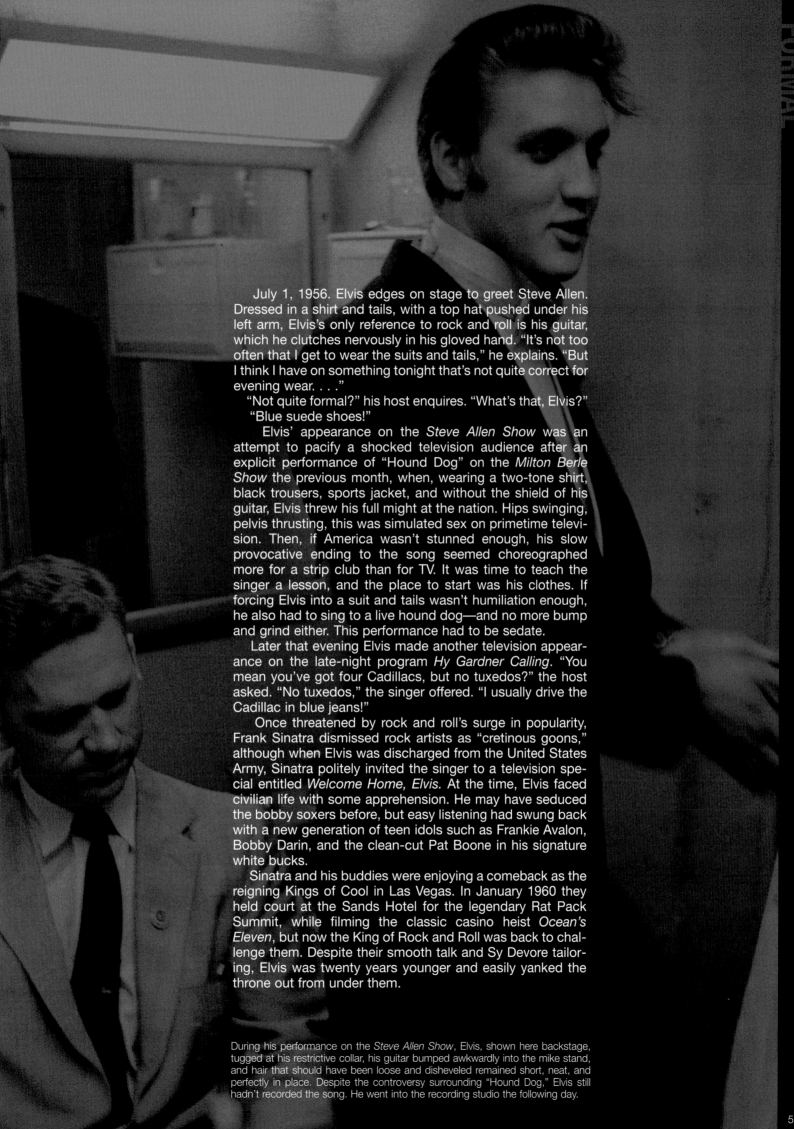

July 1, 1956. Elvis edges on stage to greet Steve Allen. Dressed in a shirt and tails, with a top hat pushed under his left arm, Elvis's only reference to rock and roll is his guitar, which he clutches nervously in his gloved hand. "It's not too often that I get to wear the suits and tails," he explains. "But I think I have on something tonight that's not quite correct for evening wear. . . ."

"Not quite formal?" his host enquires. "What's that, Elvis?"

"Blue suede shoes!"

Elvis' appearance on the *Steve Allen Show* was an attempt to pacify a shocked television audience after an explicit performance of "Hound Dog" on the *Milton Berle Show* the previous month, when, wearing a two-tone shirt, black trousers, sports jacket, and without the shield of his guitar, Elvis threw his full might at the nation. Hips swinging, pelvis thrusting, this was simulated sex on primetime television. Then, if America wasn't stunned enough, his slow provocative ending to the song seemed choreographed more for a strip club than for TV. It was time to teach the singer a lesson, and the place to start was his clothes. If forcing Elvis into a suit and tails wasn't humiliation enough, he also had to sing to a live hound dog—and no more bump and grind either. This performance had to be sedate.

Later that evening Elvis made another television appearance on the late-night program *Hy Gardner Calling*. "You mean you've got four Cadillacs, but no tuxedos?" the host asked. "No tuxedos," the singer offered. "I usually drive the Cadillac in blue jeans!"

Once threatened by rock and roll's surge in popularity, Frank Sinatra dismissed rock artists as "cretinous goons," although when Elvis was discharged from the United States Army, Sinatra politely invited the singer to a television special entitled *Welcome Home, Elvis.* At the time, Elvis faced civilian life with some apprehension. He may have seduced the bobby soxers before, but easy listening had swung back with a new generation of teen idols such as Frankie Avalon, Bobby Darin, and the clean-cut Pat Boone in his signature white bucks.

Sinatra and his buddies were enjoying a comeback as the reigning Kings of Cool in Las Vegas. In January 1960 they held court at the Sands Hotel for the legendary Rat Pack Summit, while filming the classic casino heist *Ocean's Eleven*, but now the King of Rock and Roll was back to challenge them. Despite their smooth talk and Sy Devore tailoring, Elvis was twenty years younger and easily yanked the throne out from under them.

During his performance on the *Steve Allen Show*, Elvis, shown here backstage, tugged at his restrictive collar, his guitar bumped awkwardly into the mike stand, and hair that should have been loose and disheveled remained short, neat, and perfectly in place. Despite the controversy surrounding "Hound Dog," Elvis still hadn't recorded the song. He went into the recording studio the following day.

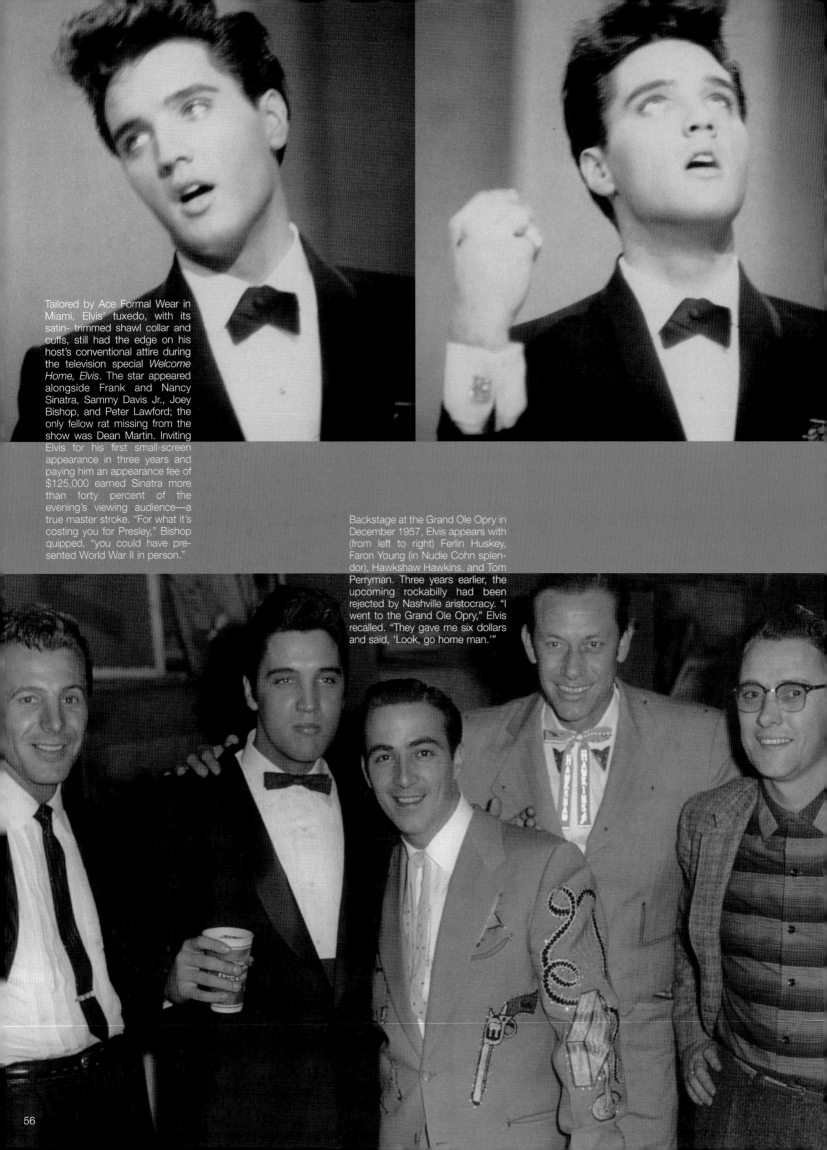

Tailored by Ace Formal Wear in Miami, Elvis' tuxedo, with its satin-trimmed shawl collar and cuffs, still had the edge on his host's conventional attire during the television special *Welcome Home, Elvis*. The star appeared alongside Frank and Nancy Sinatra, Sammy Davis Jr., Joey Bishop, and Peter Lawford; the only fellow rat missing from the show was Dean Martin. Inviting Elvis for his first small-screen appearance in three years and paying him an appearance fee of $125,000 earned Sinatra more than forty percent of the evening's viewing audience—a true master stroke. "For what it's costing you for Presley," Bishop quipped, "you could have presented World War II in person."

Backstage at the Grand Ole Opry in December 1957, Elvis appears with (from left to right) Ferlin Huskey, Faron Young (in Nudie Cohn splendor), Hawkshaw Hawkins, and Tom Perryman. Three years earlier, the upcoming rockabilly had been rejected by Nashville aristocracy. "I went to the Grand Ole Opry," Elvis recalled. "They gave me six dollars and said, 'Look, go home man.'"

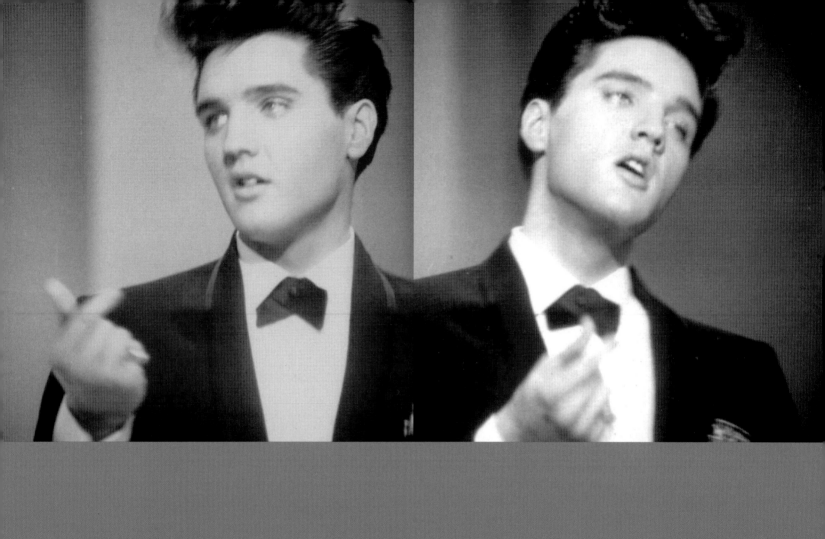

Elvis Presley Day, February 25, 1961. After a luncheon in his honor, Elvis performed two charity concerts at the Ellis Auditorium in Memphis. For Elvis, this was formal wear, a shawl-collared tuxedo and the personalized loafers seen on page 1.

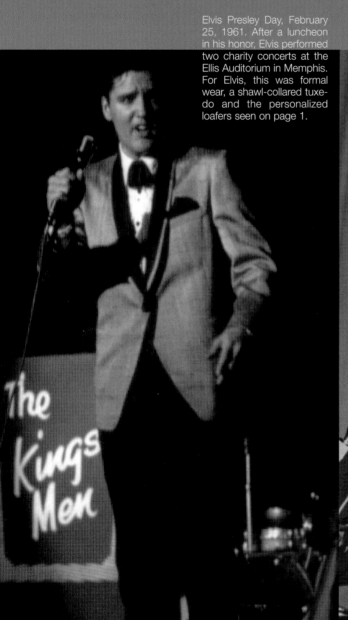

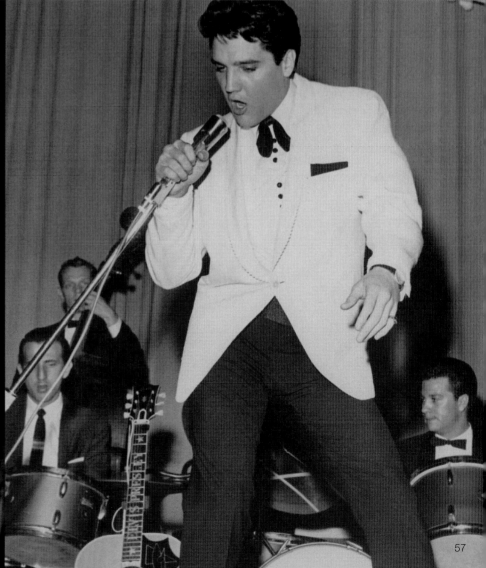

57

"DRESSING MALE STARS IS TRICKY—BUT OH, THAT

ELVIS!"

—Sy Devore

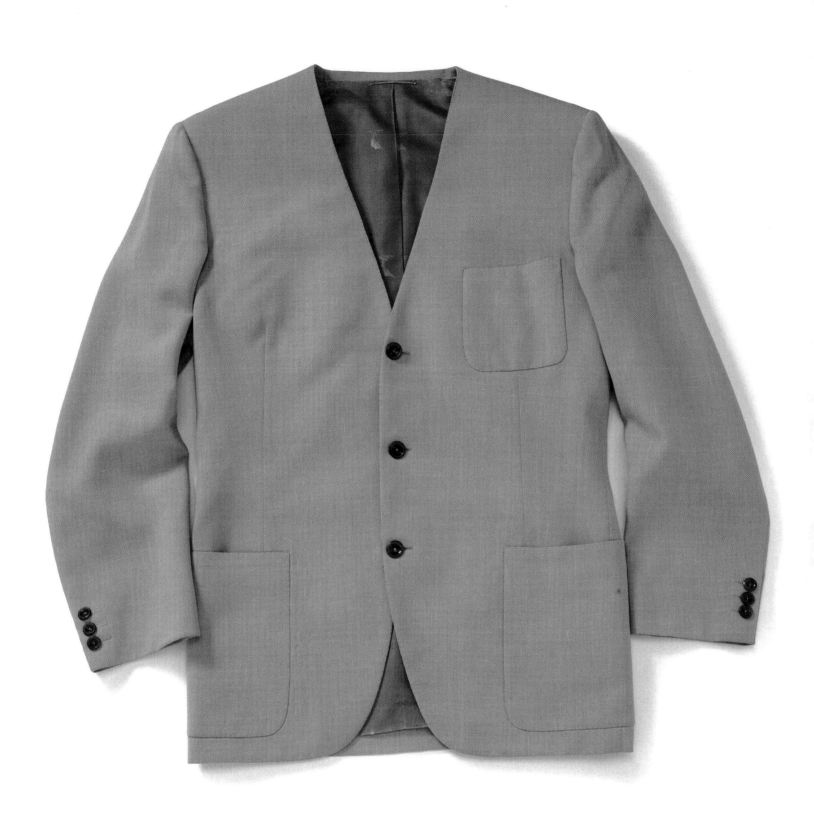

Dancing with Ann-Margret in the musical number "C'mon, Everybody," Elvis wore this Sy Devore jacket in the 1964 movie *Viva Las Vegas*. Beautifully tailored, its green silk lining features a pattern of embroidered gold swordfish.

Elvis with Sy Devore on an early visit to Devore's Vine Street store. The jacket worn by Elvis in this picture is typical of the short tailored jackets he wore in *King Creole*, rather than the loose sports coats he favored both in *Jailhouse Rock* and, off camera, for everyday style until his army induction in 1958.

Known as tailor to the stars, Sy Devore rubbed shoulders with showbiz royalty. His celebrity clientele included Frank Sinatra, Dean Martin, Jerry Lewis, Bob Hope, Desi Arnaz, Spencer Tracy, and Jack Benny. His prime Hollywood location placed Sy Devore at the hub of the entertainment business. ● "My Uncle Sy was a bachelor," his niece Marti explains. "The original Devore family store was in New York, where he hung out with a lot of musicians, like Count Basie, and that was really where he got his start. He was also the road manager for the Andrews sisters for a period of time, but was convinced that Hollywood was the place to move to. They started out right in the center of the entertainment industry, and right away he was known as tailor to the stars." ● Devore's passion for show business also led him into other ventures. According to Marti, "My father, Al Devore, was his partner, while Charlie, the third brother, wasn't involved in the clothes store but was a partner in another venture they had, a nightclub called Slapsy Maxie's." ● Located on Wilshire Boulevard, Slapsy Maxie's Café presented the West Coast debut of Dean Martin and Jerry Lewis to a celebrity audience that included Fred Astaire, Humphrey Bogart, Clark Gable, Gene Kelly, and Gary Cooper. The first of Elvis' movies that Devore provided a wardrobe for was *King Creole*. From his Vine Street store, Devore nervously watched six "bruisers"—as he described them—step out from a limousine and head toward him. He breathed a sigh of relief when he saw Elvis emerge from the vehicle. "You could make a Jimmy Cagney picture with this scene," he told Hollywood columnist James Bacon. "I was actually scared."

As tailor Leonard Freedman remembers, "We did a lot of wardrobe for most of the pictures that were directed by Norman Taurog. We made some Hawaiian shirts, sports coats, and leisure jacket suits—a short jacket with matching pants— for some of his movies. We had a more realistic approach to his wardrobe and actually showed him a little more dressed up than he normally would have been in regular presentations." The best example of Sy Devore's tailoring can be seen in the 1963 movie *It Happened at the World's Fair*, in which Devore created a new look for the star that Devore described as "conservative and stylish." Ranking him alongside Frank Sinatra, Peter Lawford, and John F. Kennedy, he told the press that Elvis "flipped when he saw the new clothes. He loved them." Devore continued, "What's more, Elvis has a natural flair for wearing them." ● Although Sy Devore passed away a few years later, in 1966, the family business continues to tailor for the entertainment industry from a new store in Studio City. Still retaining its loyal clientele, Sy Devore Menswear is also called upon for a variety of successful television programs including *The West Wing, ER,* and *The Young and the Restless.*

Who gets custody of Sy Devore? When the Martin and Lewis partnership ended in 1956, the press questioned the loyalty of their revered Hollywood tailor. When Elvis signed his contract with Paramount Pictures the same year, producer Hal Wallis briefly considered pairing the rock and roll singer with funnyman Jerry Lewis.

"When I was a child, ladies and

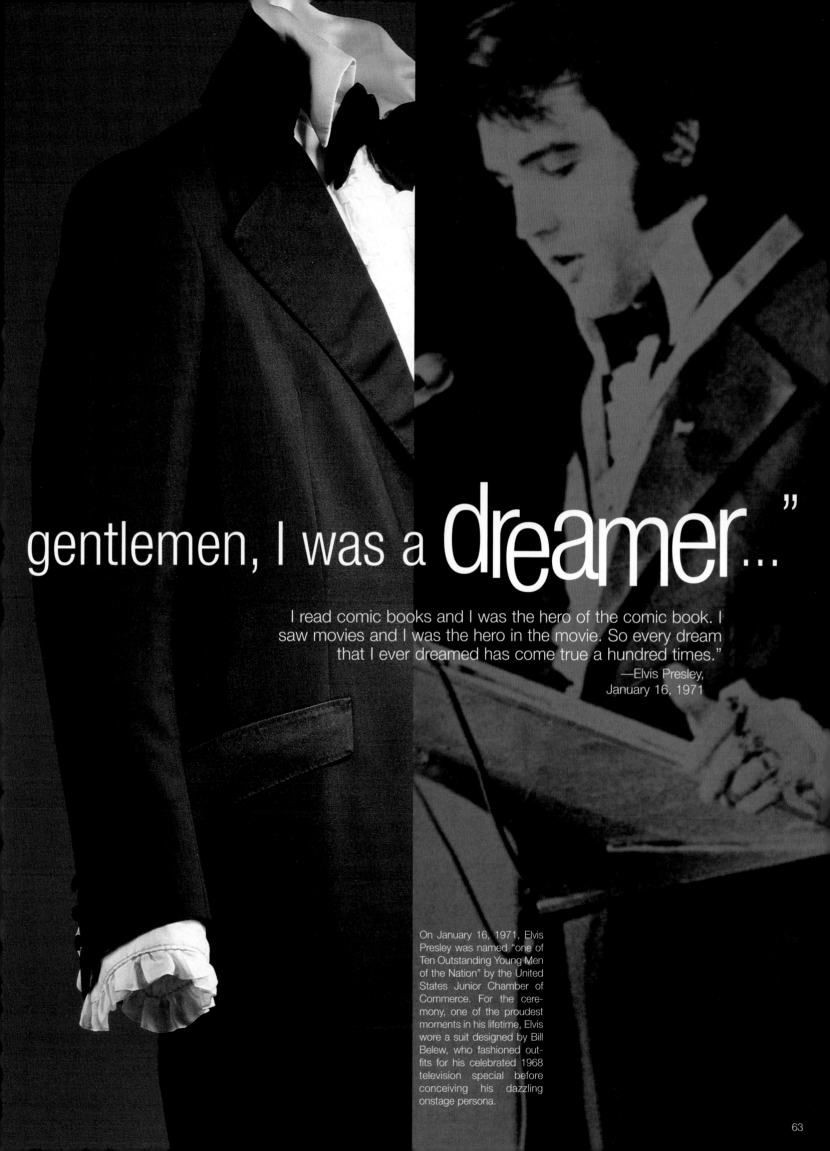

gentlemen, I was a dreamer..."

I read comic books and I was the hero of the comic book. I saw movies and I was the hero in the movie. So every dream that I ever dreamed has come true a hundred times."
—Elvis Presley,
January 16, 1971

On January 16, 1971, Elvis Presley was named "one of Ten Outstanding Young Men of the Nation" by the United States Junior Chamber of Commerce. For the ceremony, one of the proudest moments in his lifetime, Elvis wore a suit designed by Bill Belew, who fashioned outfits for his celebrated 1968 television special before conceiving his dazzling onstage persona.

YOU CAN'T FIGHT 'EM

"The only thing I can say is to play it straight and do your best because you can't fight 'em. If you're going to try and be an individual, or try to be different, you're gonna go through two years of misery!"

—Elvis Presley

"Boy, is this one a shorty," Elvis laughed as he rubbed his hands through his G.I. buzz-cut. For a sixty-five cent barber's fee, the U.S. Army stripped Elvis of his trademark coif and provided the world's media with a million dollars' worth of news footage.

64

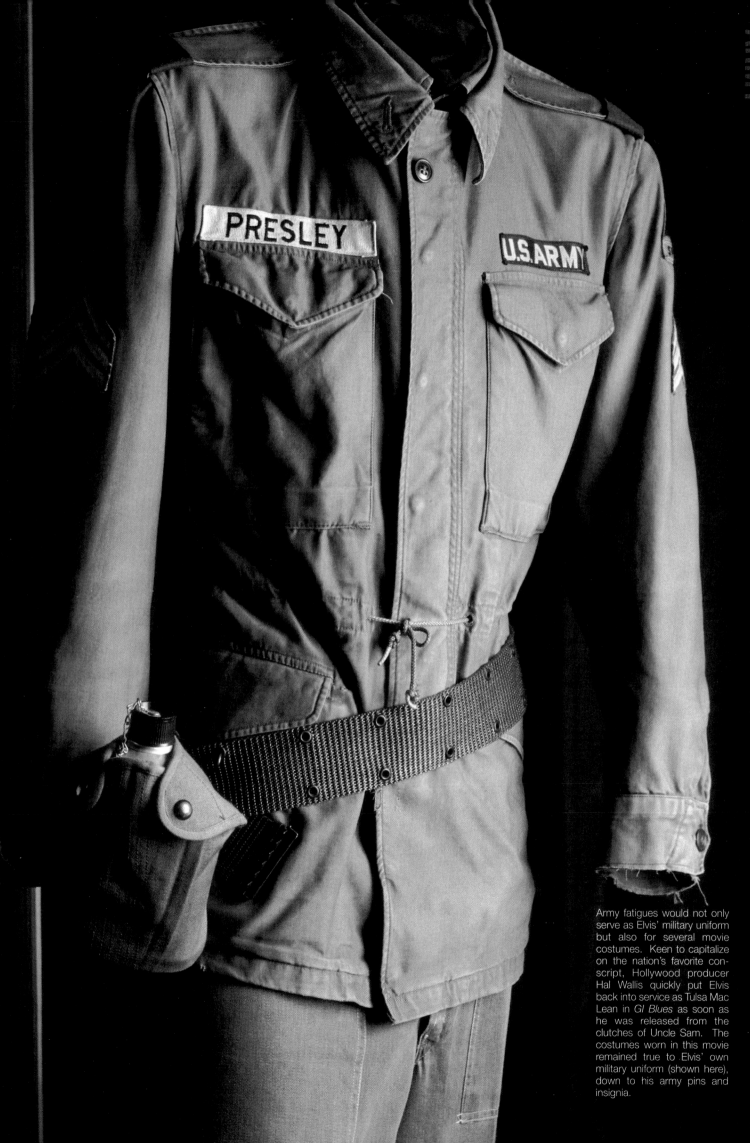

Army fatigues would not only serve as Elvis' military uniform but also for several movie costumes. Keen to capitalize on the nation's favorite conscript, Hollywood producer Hal Wallis quickly put Elvis back into service as Tulsa Mac Lean in *GI Blues* as soon as he was released from the clutches of Uncle Sam. The costumes worn in this movie remained true to Elvis' own military uniform (shown here), down to his army pins and insignia.

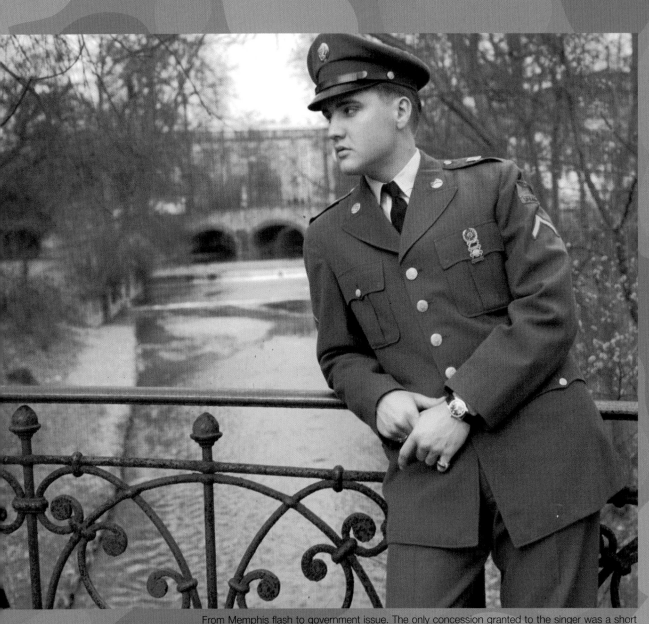

From Memphis flash to government issue. The only concession granted to the singer was a short postponement of his service in order to complete his fourth movie, *King Creole*.
Elvis was promoted to sergeant just one month before his official discharge. His full army stripes were awarded on February 11, 1960.

Fort Chaffee, March 1958; the press buzzed around him. The kid with the sideburns, under squealing protest from the female population, was about to lose his movie-star locks. Elvis started growing his hair long as a teenager, when his peers still sported crew cuts. "Everybody to their own taste," he shrugged. "I always wanted to have hair to comb."

The stark transformation began on March 24, when Elvis reported to the draft board in Memphis, where his famous name, so recently screamed from the lips of teenagers, was reduced to number "53 310 761." Despite the hair and salary cut, Elvis looked forward to the anonymity the army could provide. When asked how he felt about his enlistment, the singer replied, "Frankly, it'll be a relief." It was also a good time to break from rock and roll. Critics who once labeled the genre a passing fad were proved right when the music diminished in popularity by the end of the decade and easy-listening began to dominate the charts again.

But although parents of teenagers may have been relieved that their kids could now forget about Elvis, they had no such luck. Colonel Parker ensured that even when Elvis was stationed in Germany, the flow of music releases was unrelenting. Tracks including "Hard-Headed Woman," "A Big Hunk of Love," and the sultry "One Night" secured his ongoing presence in the *Billboard* charts.

In 1960, when Elvis was discharged from active duty in the U.S. army, the press was quick to question his comeback, although Elvis had already adapted his personal and singing style. "The only thing I can say is I'm gonna try," he told reporters. "I'll be in there fighting." His new, post-army look was more mature and more tailored, reflecting the European fashions of the time, while his music moved away from rock and roll and rivaled the competition with ballads such as "Fame and Fortune" and "Soldier Boy."

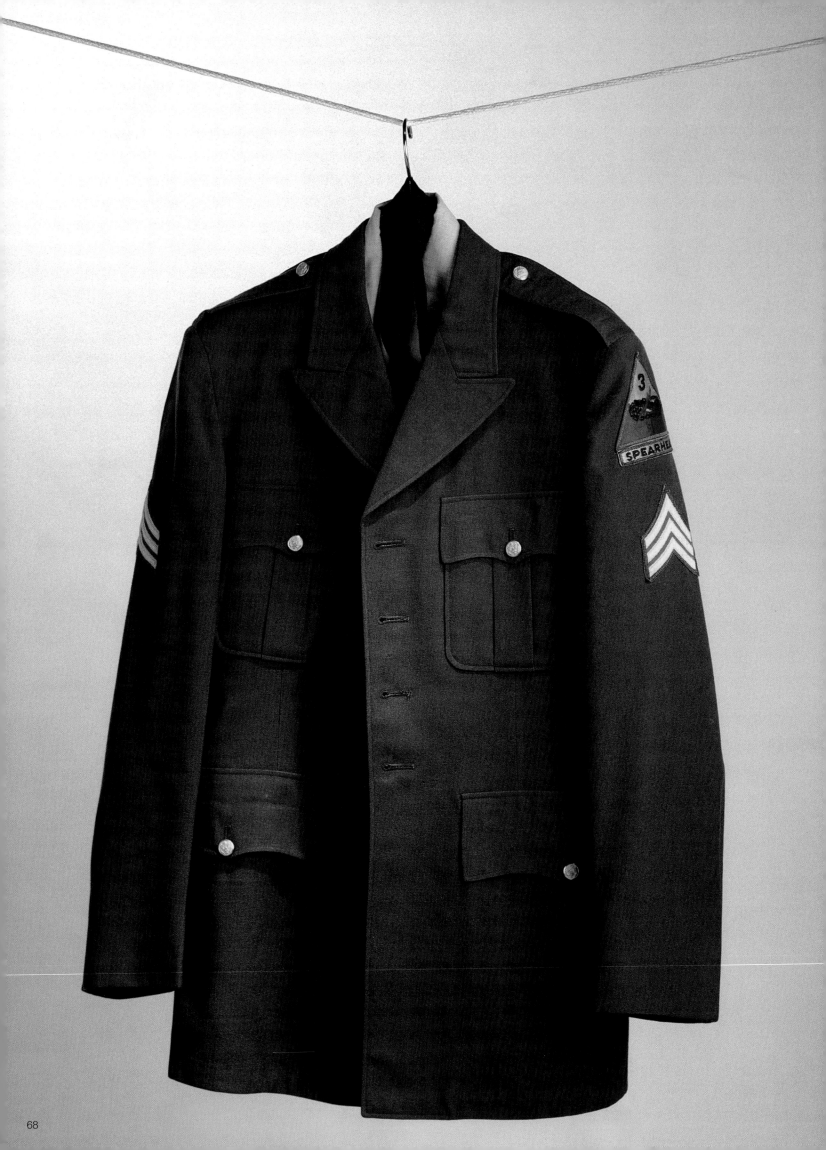

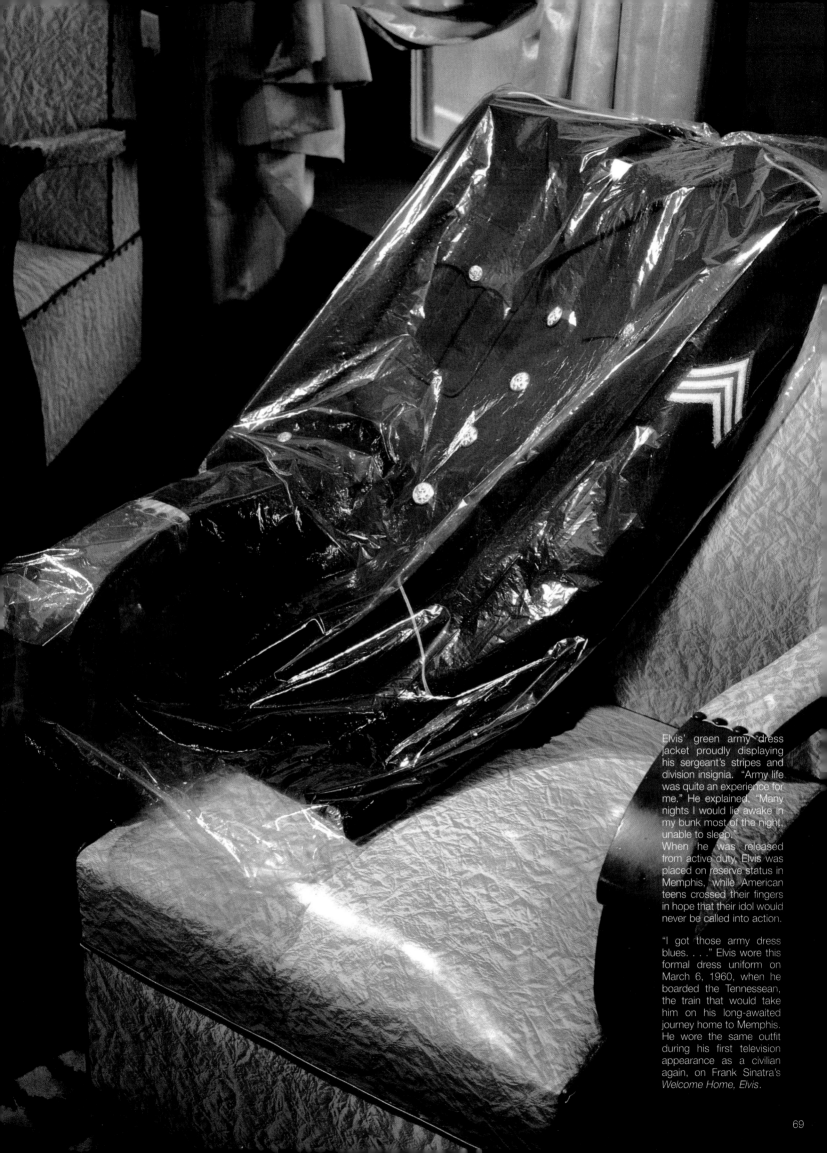

Elvis' green army dress jacket proudly displaying his sergeant's stripes and division insignia. "Army life was quite an experience for me." He explained, "Many nights I would lie awake in my bunk most of the night, unable to sleep."
When he was released from active duty, Elvis was placed on reserve status in Memphis, while American teens crossed their fingers in hope that their idol would never be called into action.

"I got those army dress blues. . . ." Elvis wore this formal dress uniform on March 6, 1960, when he boarded the Tennessean, the train that would take him on his long-awaited journey home to Memphis. He wore the same outfit during his first television appearance as a civilian again, on Frank Sinatra's *Welcome Home, Elvis.*

As you step beyond the legendary gates to Graceland, you are met with a potent cocktail of rock and roll extravagance chased with pure Southern hospitality. The superstar purchased the mansion for just over $100,000 in 1957, making the thirteen-and-three-quarter wooded acres his beloved home for the rest of his life.

Inside, Graceland is as stylish and excessive as its owner; it glitters with superstardom, Hollywood glamour, and Las Vegas indulgence. Its luxurious upholstery, gilded fixtures, sparkling chandeliers, exotic feathers, and fur details make it not only a splendid spectacle, but also a very personal home whose hospitality embraced an ever more extended family.

GRACELAND

Elvis first moved in with his parents, Vernon and Gladys Presley, and grandmother, Minnie Mae, but he was later joined by a close-knit circle of friends. The latter had torn across Hollywood as "El's Angels" before refining their look with mohair suits, dark glasses, and hats to earn the group a new title: "The Memphis Mafia." The group's *consigliere*, Joe Esposito, explains, "We looked like a bunch of hoodlums. We would all get out of the limousine one by one in our black suits and ties, and then Elvis would get out, so a reporter named us the Memphis Mafia."

Joe experienced Elvis' stylish sensibility firsthand, away from the public eye. "Elvis had a very bizarre imagination in clothes. He felt that he was onstage all the time and would make sure that he dressed well, even if it was just to go shopping."

In 1962 Priscilla Beaulieu arrived at Graceland. She and Elvis had met during his army service in Germany and, on his return, the dark-haired beauty seen waving him goodbye was quickly dubbed "the girl he left behind." He dismissed the press' allegations. "It was no big romance," he shrugged, but within a few years, Priscilla would be honored with a diamond engagement ring—3.5 carats that made her the future Mrs. Presley, to the envy of every teenage girl in America.

"He never acted for anybody. . . . He was always the same: same at home, same as a father, same very large presence in my life. I've never met anyone who could ever compare to that."

—Lisa Marie Presley

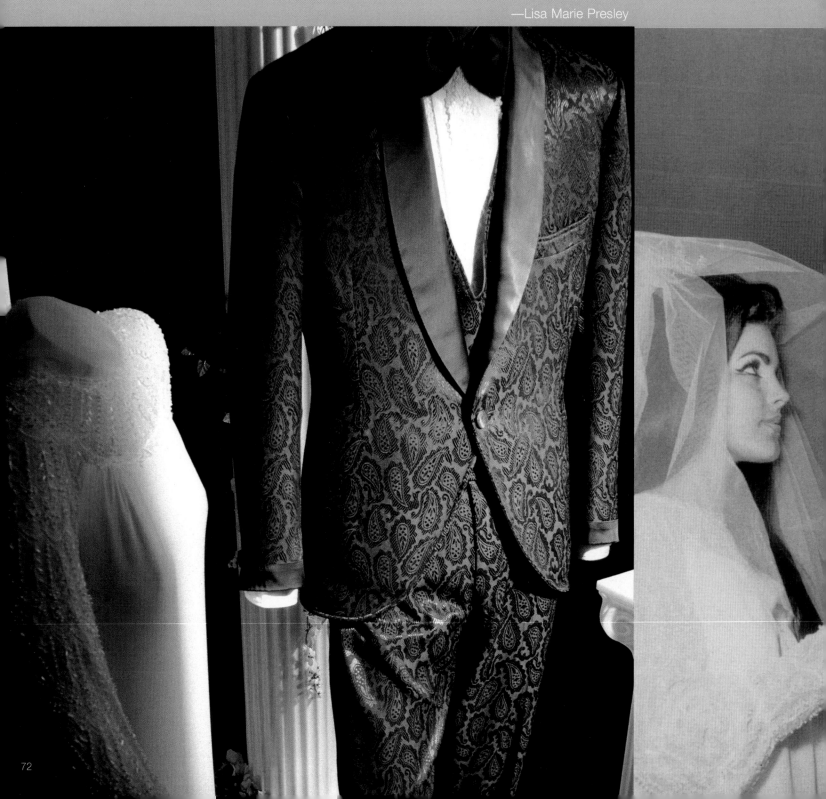

On May 1, 1967, Elvis and Priscilla were married at the year-old Aladdin Hotel in Las Vegas. Elvis' wedding suit was custom tailored, a gleaming black tuxedo with a paisley design that only became apparent in the glare of the flashbulbs. He wore it over a lace-trimmed white shirt with a bow tie. Instead of the looser pegged pants of ten years before, Elvis wore stovepipes—the leading cut of the 1960s—to his wedding. Afraid that she might be recognized, Priscilla simply bought her dress from a Los Angeles boutique. "It wasn't extravagant," she wrote in her 1985 autobiography. "It was simple and, to me, beautiful."

Exactly nine months after their wedding day, Priscilla gave birth to their daughter, Lisa Marie. Accustomed to the public eye, Priscilla put on thick black mascara and teased her hair before rushing to the hospital. This family portrait was taken in December 1970, when Lisa was not quite three years old.

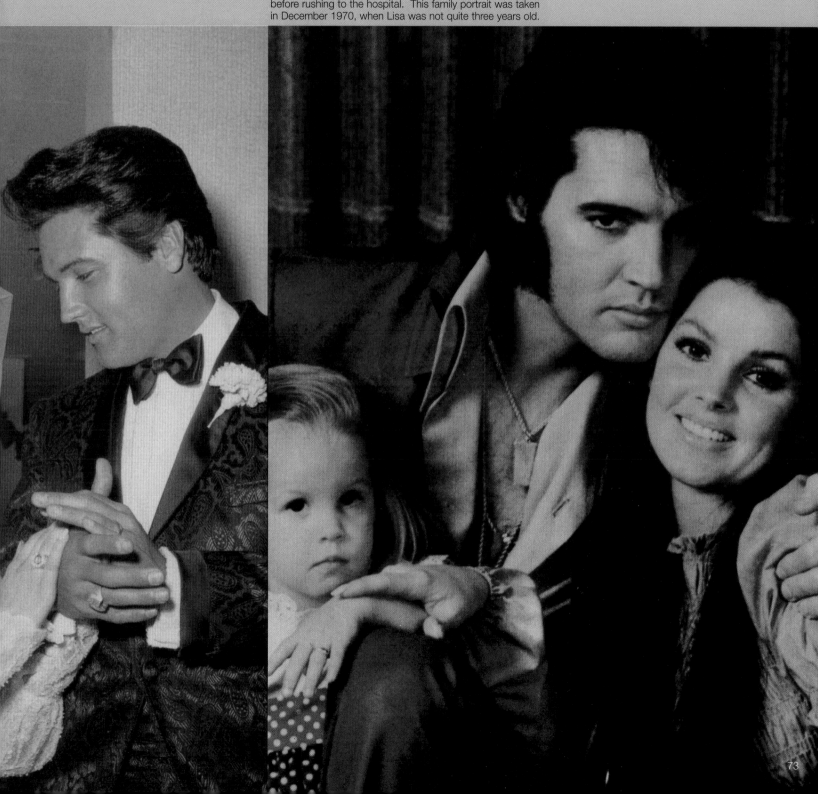

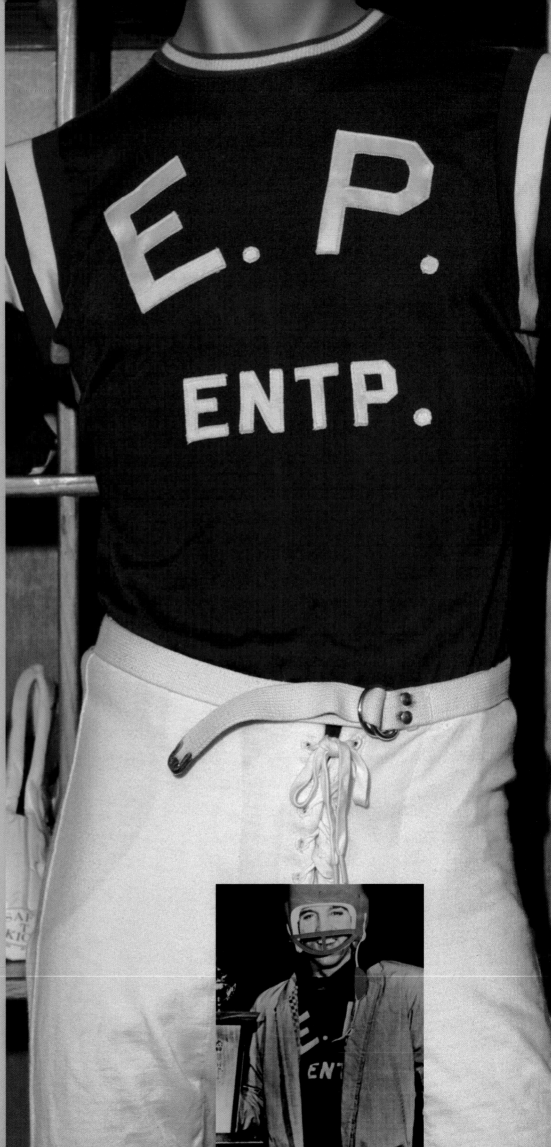

Elvis was as physical offstage as he was on. He rented a roller-skating rink for a perilous game of whip and challenged his buddies in football, baseball, and racquetball—a sport he took so seriously that he considered creating his own chain of Presley Center Courts.

From his local McKellar Lake to an island retreat in Hawaii, Elvis also loved water sports and even owned basic scuba diving equipment. An avid collector of cars and bikes, his collection of toys included speedboats, snowmobiles, and golf carts, although golf was one sport his friends could not tempt him with.

Elvis' ultimate indulgence was the *Lisa Marie* airplane, a Convair 880, purchased in 1975 and known as "the flying Graceland." Elvis spent $800,000 outfitting it with lavish furnishings in blue and green velvet with brass and gold fixtures, most notably in the bathrooms, where he installed 24-carat washbasins with ornate Spanish fittings.

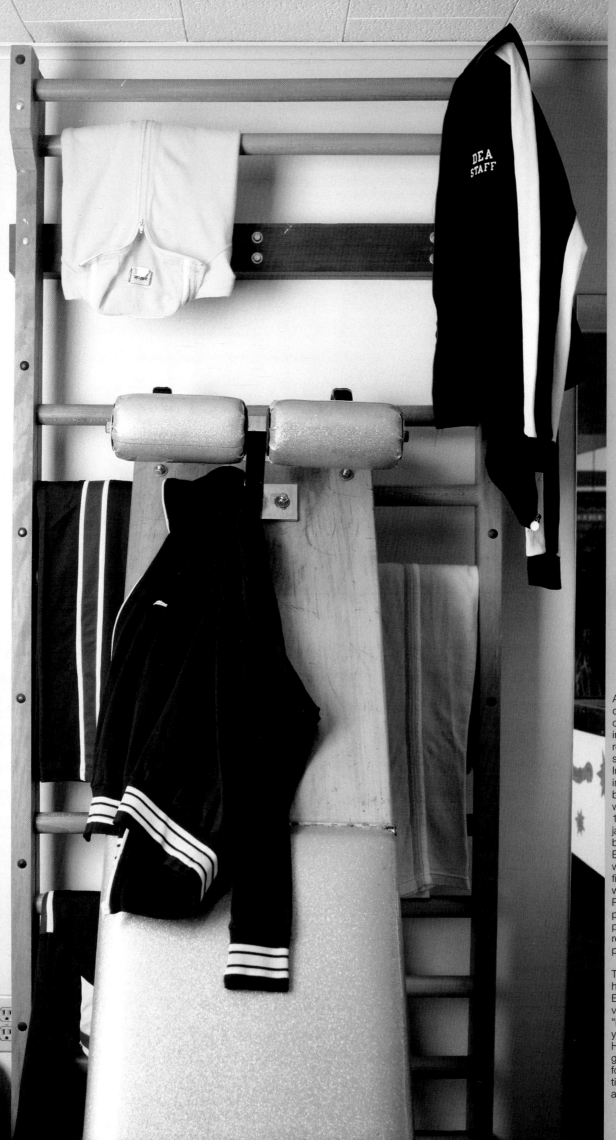

A collection of jogging suits displayed here in Elvis' racquetball building, which also included a fitness room, rooftop running track, three showers, and a Jacuzzi. Intended to prevent muscle injuries, the warm-up suit became fashion attire when it was popularized in the late 1960s. The blue and white jacket to the right of the sit-up bench, features a DEA (Drug Enforcement Agency) logo and was one of the last casual outfits that Elvis would be pictured wearing. On June 26 1977, RCA presented him with a plaque at the Indianapolis airport, marking the two-billionth record produced in the city's pressing plant.

This T-shirt was designed for his football team, Elvis Presley Enterprises. In a 1962 interview, Jack Bentley asked Elvis, "Looking back at it all, would you do anything differently?" His response was, "I wanted to go to college, I wanted to play football. I have a great ambition to play football. I have had and still have, believe it or not."

When Elvis relaxed he did so in splendor. This kaftan, trimmed with gold embroidery and beading, is one of at least two that he owned. What he wore underneath remains a burning question, though, curiously, his personal items include an infinite collection of identical blue pajamas. "When Elvis bought things he would buy ten or twelve at a time," Joe Esposito recalls. "You don't wear out pajamas. Just Elvis and his girlfriends wore them." Scotty Moore offered his own explanation. "Maybe Elvis had a lot of slumber parties," he laughed.

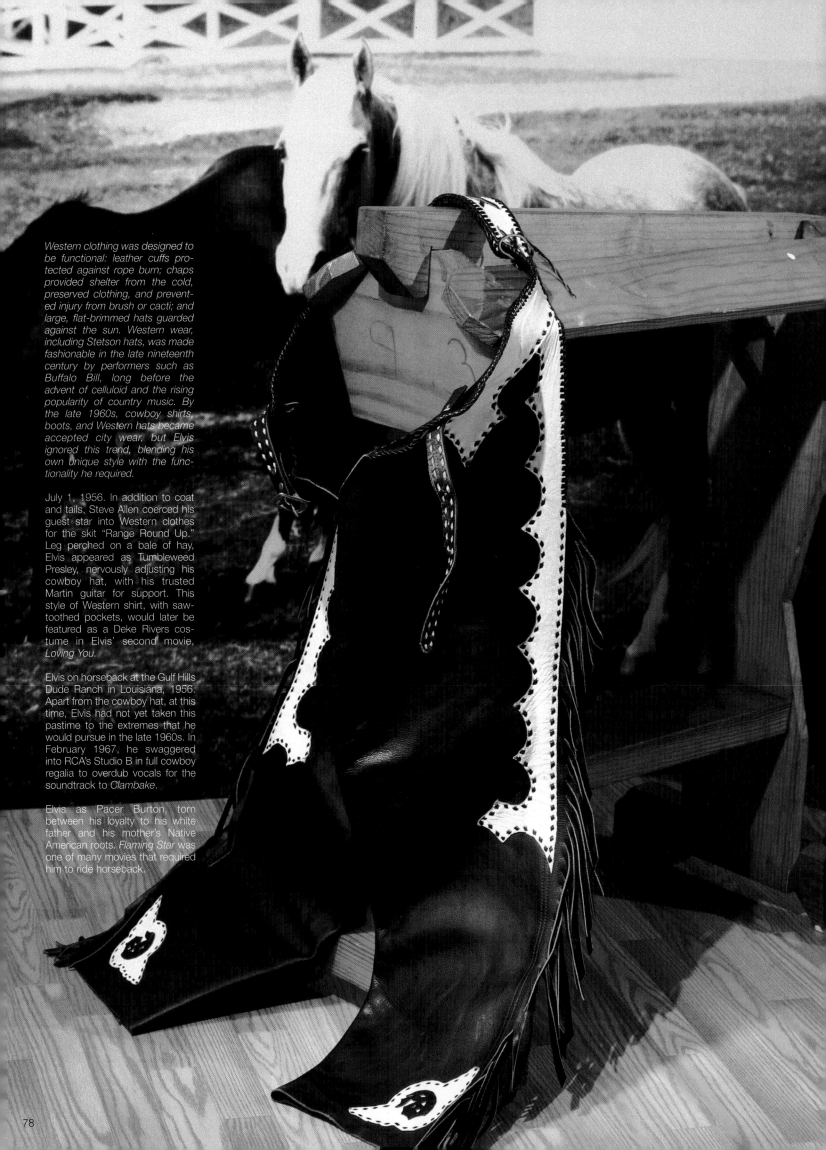

Western clothing was designed to be functional: leather cuffs protected against rope burn; chaps provided shelter from the cold, preserved clothing, and prevented injury from brush or cacti; and large, flat-brimmed hats guarded against the sun. Western wear, including Stetson hats, was made fashionable in the late nineteenth century by performers such as Buffalo Bill, long before the advent of celluloid and the rising popularity of country music. By the late 1960s, cowboy shirts, boots, and Western hats became accepted city wear, but Elvis ignored this trend, blending his own unique style with the functionality he required.

July 1, 1956. In addition to coat and tails, Steve Allen coerced his guest star into Western clothes for the skit "Range Round Up." Leg perched on a bale of hay, Elvis appeared as Tumbleweed Presley, nervously adjusting his cowboy hat, with his trusted Martin guitar for support. This style of Western shirt, with saw-toothed pockets, would later be featured as a Deke Rivers costume in Elvis' second movie, *Loving You*.

Elvis on horseback at the Gulf Hills Dude Ranch in Louisiana, 1956. Apart from the cowboy hat, at this time, Elvis had not yet taken this pastime to the extremes that he would pursue in the late 1960s. In February 1967, he swaggered into RCA's Studio B in full cowboy regalia to overdub vocals for the soundtrack to *Clambake*.

Elvis as Pacer Burton, torn between his loyalty to his white father and his mother's Native American roots. *Flaming Star* was one of many movies that required him to ride horseback.

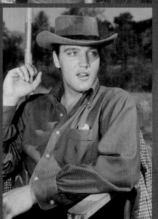

Aloft his prized palomino, Elvis would gallop down to the gates of Graceland to meet his fans. A confident horseman, his interest was rekindled by riding Priscilla's horse, Domino, and, in true Elvis style, it soon grew into a complete infatuation. Since the 1950s, horse riding had been an occasional recreation for Elvis. He also rode horseback in a number of his movies, including *Love Me Tender*, *Flaming Star, Blue Hawaii*, and most notably, the 1969 Western *Charro*.

His newfound passion for horse riding culminated with the Circle G, a 163-acre Mississippi ranch that he purchased in February 1967 in the midst of a spending spree. After buying his palomino quarter-horse, Rising Sun, the month before, he purchased more horses and equipment to house in a renovated barn on the grounds of Graceland. "We bought the finest saddles, blankets, halters, bits, reins, and feeding buckets," Priscilla wrote in *Elvis and Me*. "Anything that had to do with a horse, we bought." Then, as Elvis started to buy horses for his friends and family, he soon outgrew his Graceland stable and moved his entourage to the Circle G.

Circle G's ranch house soon proved too small, so Elvis bought mobile homes to accommodate his friends, ensuring that everyone owned horses, tackle, and their own pickup trucks. Furthermore, the residents of his dude ranch had to be fitted in matching Western wear. "We were all cowboys!" Joe Esposito laughed. "Everybody bought different clothes, then Elvis bought a lot of us jackets, so we all looked the same. We would go to a Western store and buy saddles, then we'd start picking up jackets and putting those on. Basically, it was just buy, buy, buy!"

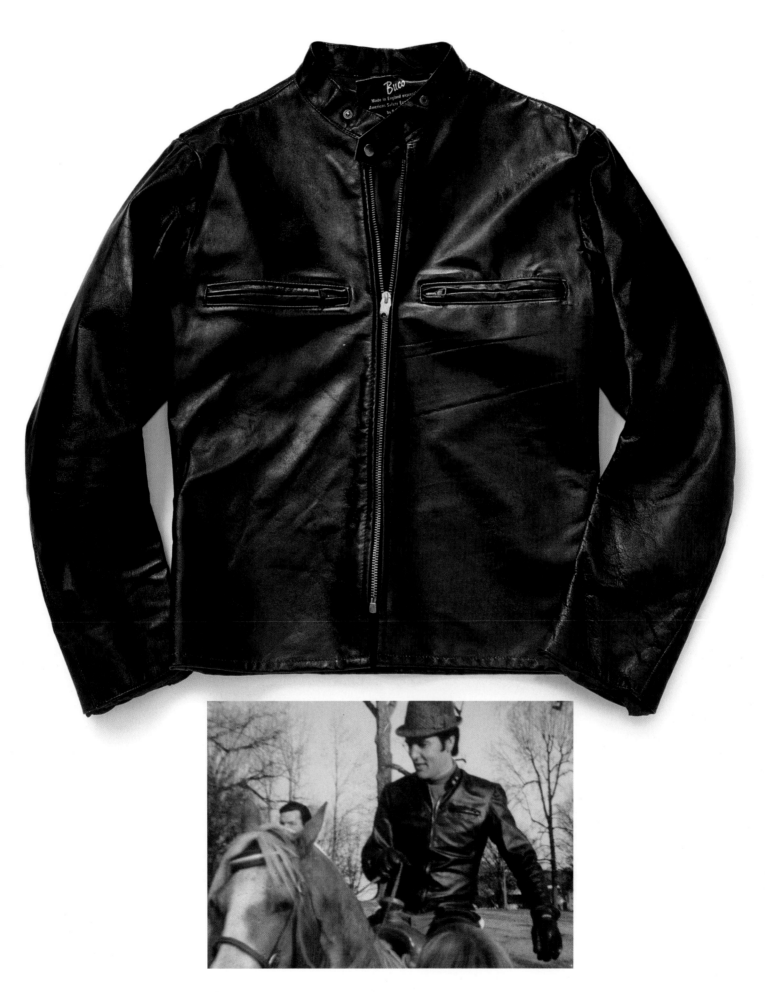

Despite excessive purchases of horse-riding equipment and clothes, Elvis is shown here in casual mode, wearing a collarless leather jacket made by Buco (also seen above). Elvis also wears a wool tweed hat in a style known as a Rex Harrison, after the actor who made it fashionable in the movie *My Fair Lady*.

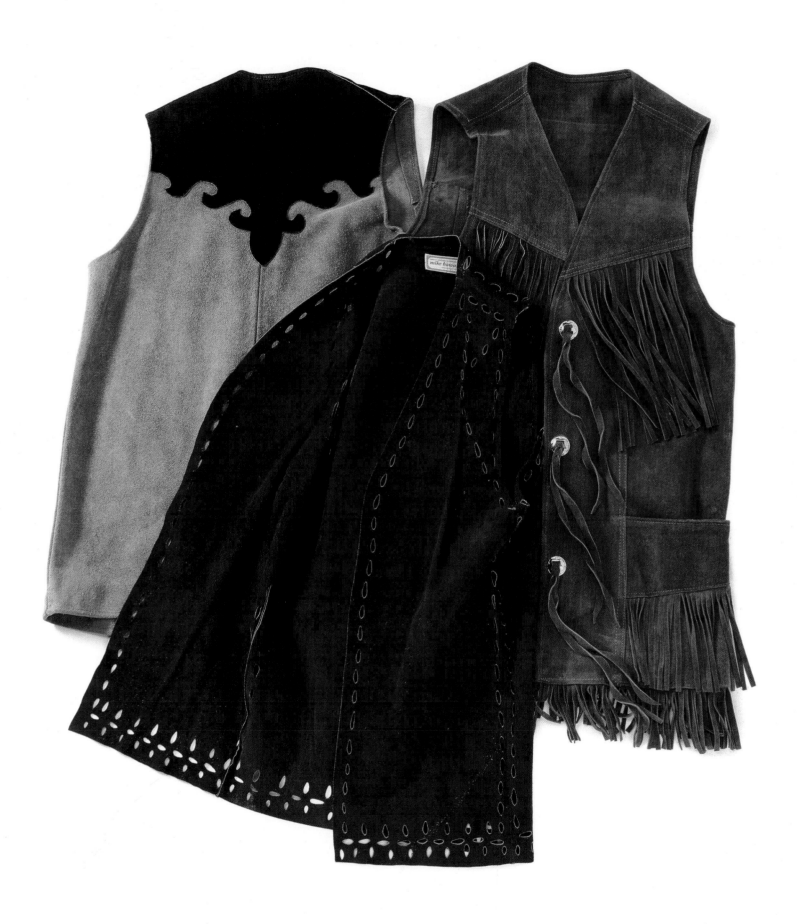

Although the designer of these three suede vests is unknown, similar items in Elvis' personal collection were made by Mike Howard, Fred Segal, and Mike McGregor, whose talent in creating stunning leatherwork earned him a life-long friendship with the singer.

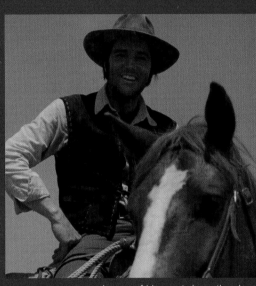

In one of his most dramatic roles, Elvis appeared as the outcast Jess Wade in *Charro*—a movie that broke from the mold with a single song, the title track, which was sung off-camera over the opening credits. For the first time in his career, Elvis also appeared in a full beard, although in this candid shot he is clean-shaven. The costume shown here is the only one worn throughout the movie.

Hollywood has long associations with the fashion industry, particularly in Western clothing. The Western Costume Company that supplied wardrobe items for a number of Elvis movies is famed as the largest costume maker in the world. It was founded by L.L. Burns, an enterprising Indian trader who felt that the costumes in the first silent Westerns did not seem authentic.

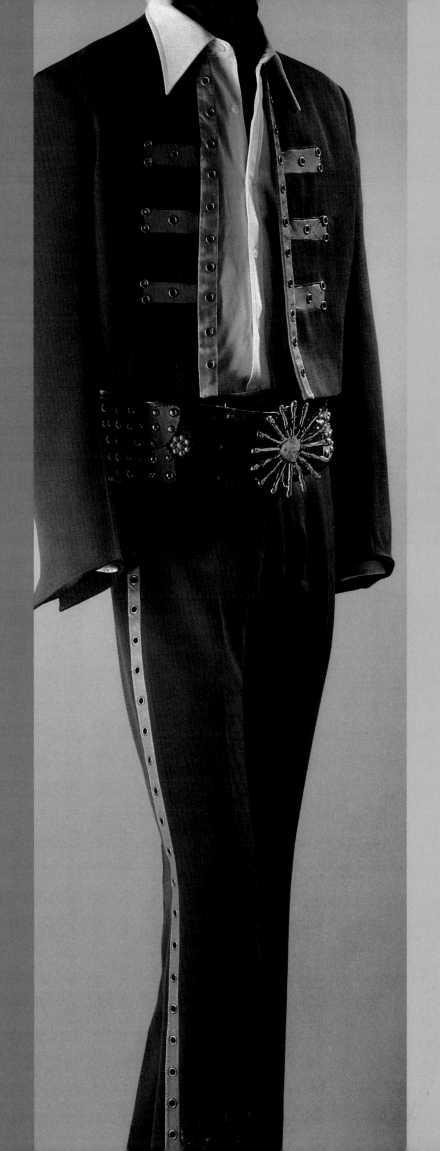

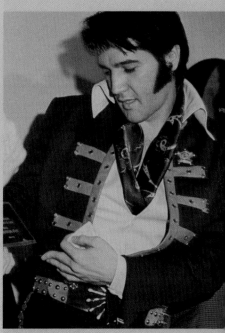

At a press conference, following six performances at the Houston Astrodome in 1970, Elvis was presented with five gold records, a limited-edition Stetson, a Rolex watch, and a gold badge proclaiming him deputy sheriff. This Western-inspired outfit, designed by Bill Belew, features brass and leather trimmings over a belt made of overlapping leather leaves that lead to a brass starburst in the center. This belt is from the collection of Kelly Diakonis.

Elvis was a tiger—fierce, stealthy, and athletic. His mastery was demonstrated onstage, where his sharp karate kicks pierced the air, gave the band direction, and left his audience spellbound. He first studied the martial art in Germany and earned his black belt in 1960. The same year, he was inspired by the technique of Ed Parker, a pioneer of Kenpo Karate and one of the first to bring the form to the United States. Ed Parker later became Elvis' *sensei*, along with master Kang Rhee, who trained the singer in Memphis.

"I'M THE KING OF THE JUNGLE, THEY CALL ME TIGER MAN."

Kang Rhee would give his students animal names, looking at their body shape, form, and technique. He decided that Elvis should be a tiger—a title the star loved. Elvis proudly displayed his predatory designate on his training clothes and personal wardrobe. Elvis had his suits customized with tiger designs, the TCB (Taking Care of Business) logo, and other features such as flared pants. In fact, the karate *gi* was in many ways the predecessor of Elvis' jumpsuits of the 1970s.

—as sung by Elvis, from the lyrics of "Tiger Man"

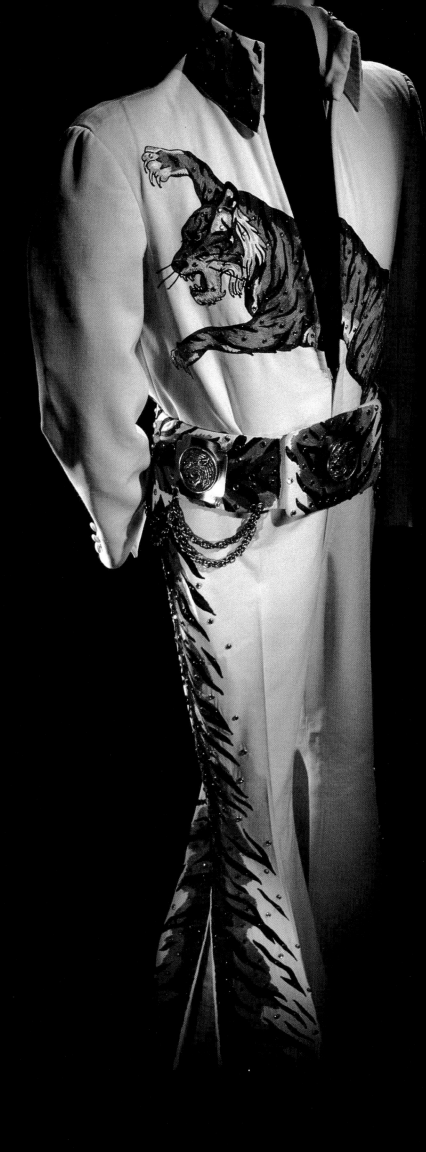

This impressive suit was created by costume designer Bill Belew and worn onstage in 1974. The leaping tiger wrapped around the torso is matched by brilliant orange and black stripes that run down the pant legs and across the belt.

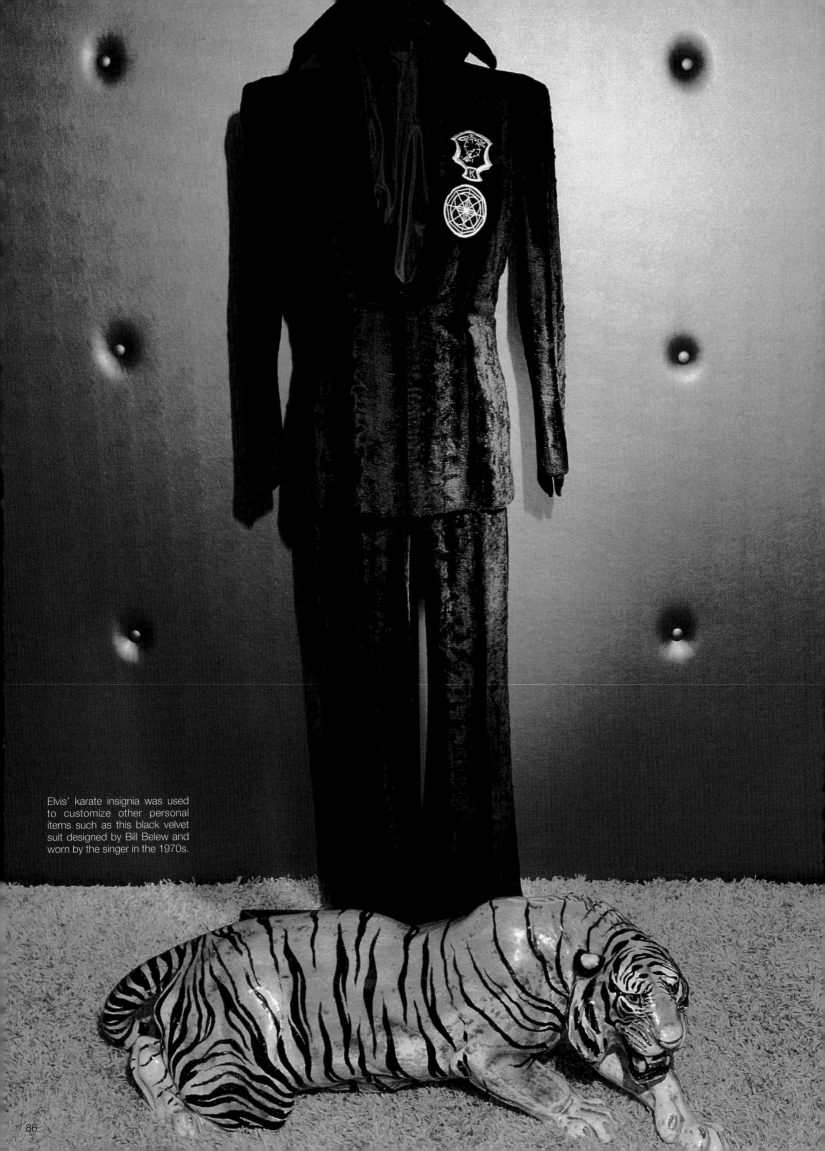

Elvis' karate insignia was used to customize other personal items such as this black velvet suit designed by Bill Belew and worn by the singer in the 1970s.

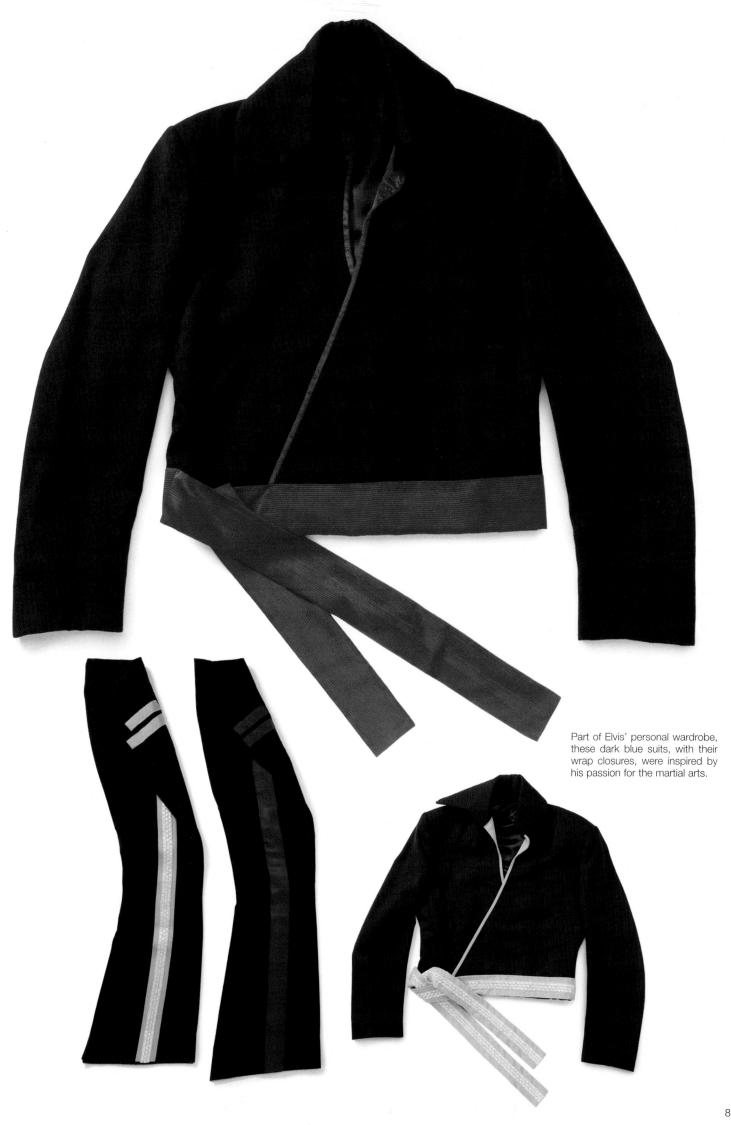

Part of Elvis' personal wardrobe, these dark blue suits, with their wrap closures, were inspired by his passion for the martial arts.

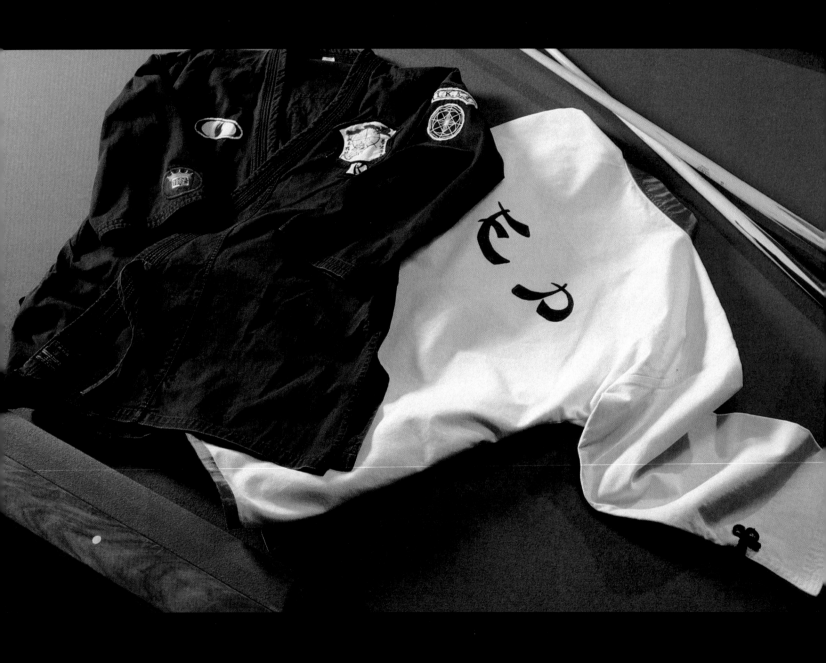

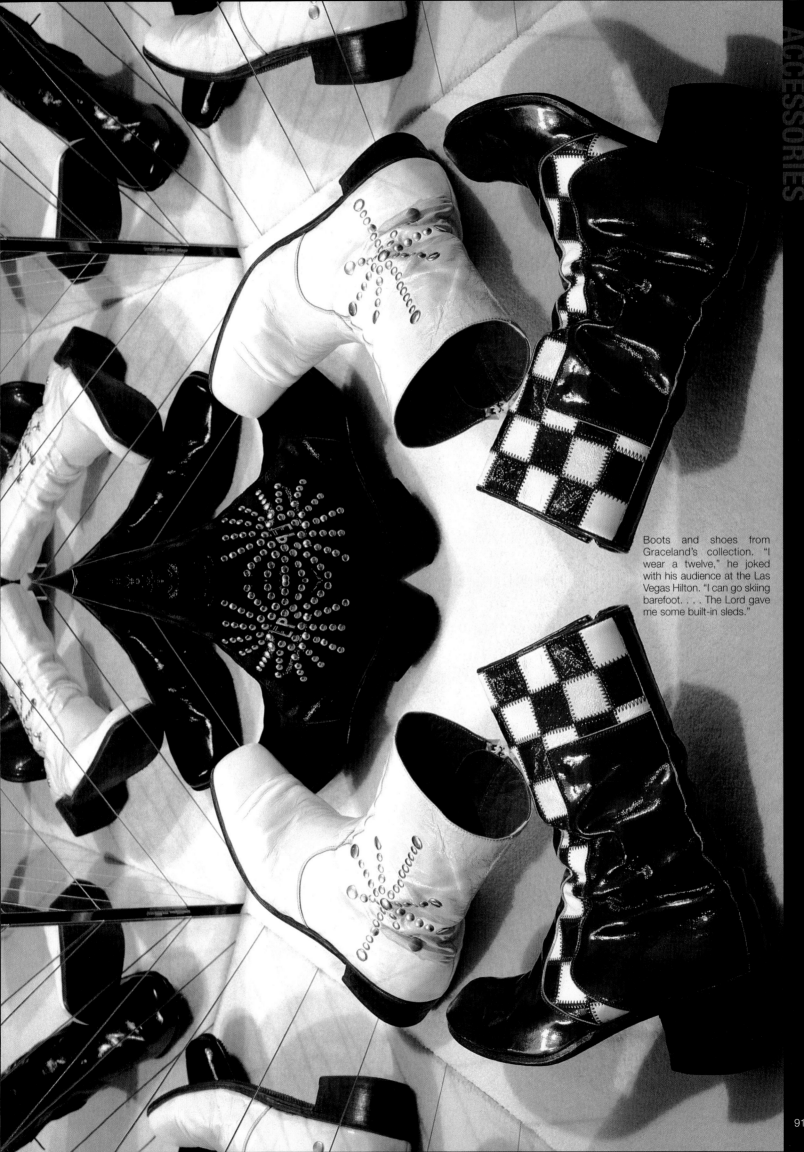

Boots and shoes from Graceland's collection. "I wear a twelve," he joked with his audience at the Las Vegas Hilton. "I can go skiing barefoot. . . . The Lord gave me some built-in sleds."

With shades, capes, canes, belts, guns, glowing rubies, and glistening diamonds, Elvis loved to accessorize. Often adorned with gold and sparkling with gems he aspired to these riches in his youth and, generous to a fault, gave many pieces away. In June 1956, on the local television program Wink Martindale's Dance Party, Elvis offered his fans the chance to own his fourteen diamond initial ring that became the door prize to his forthcoming concert at Russwood Park. This started a trend for giveaways that would continue for the rest of his career. Elvis dropped so many rings from his own fingers—passing them to friends, family, or curious admirers—that very few examples remain in Graceland's collection.

In the 1950s, the consummate addition to his store of accessories was his Cadillac—the pink Fleetwood 250—that became an enduring rock and roll symbol. As he cruised through Ferraris and Blackhawks, his personal accessories followed suit, becoming just as extravagant. "I guess he was what you would call a clotheshorse," Scotty Moore says. "He could wear stuff and look great when somebody else would look plain silly. Indeed, only Elvis could sport a flashlight as an accessory, rap his cane on the floor to mark his entrance, and breeze into the room in a plush velvet cape."

Beginning in 1970, he personalized many items with his initials or logo: a bolt of lightning crowned with the letters "TCB" (Taking Care of Business, in a flash). Although this was a popular motto at the time, Elvis adopted it as his own, incorporating it on jewelry, clothes, and accessories before commissioning the striking lightning bolt on the wall of his television room at Graceland.

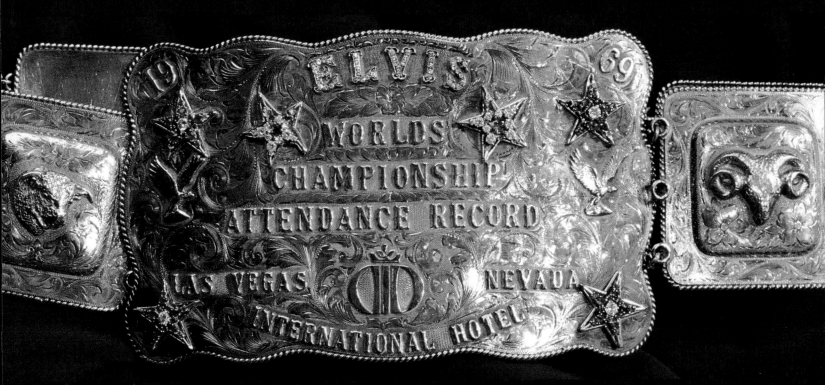

A gift from the International Hotel in Las Vegas, this gold belt was given to Elvis in recognition of his box office success in the city, when he broke all attendance records during his opening engagement in 1969. Elvis wore it constantly, parading it in concert and flaunting it for the media. "It's like a trophy but I wear it around," he told a reporter in 1972. "It's just to show off."

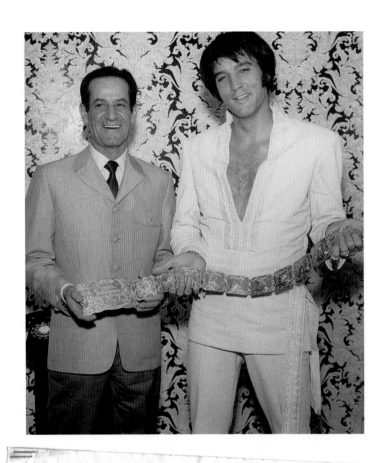

In Las Vegas, Alex Shoofey, then president of the International Hotel, presented Elvis with this gold belt in September 1970. Created in sterling silver and overlaid in gold, this spectacular belt was made by Nudie's of Hollywood, then customized further by Elvis. Intricately engraved, it was presented in an embossed leather case, but rarely put to rest and Elvis was frequently photographed wearing the belt over the next few years.

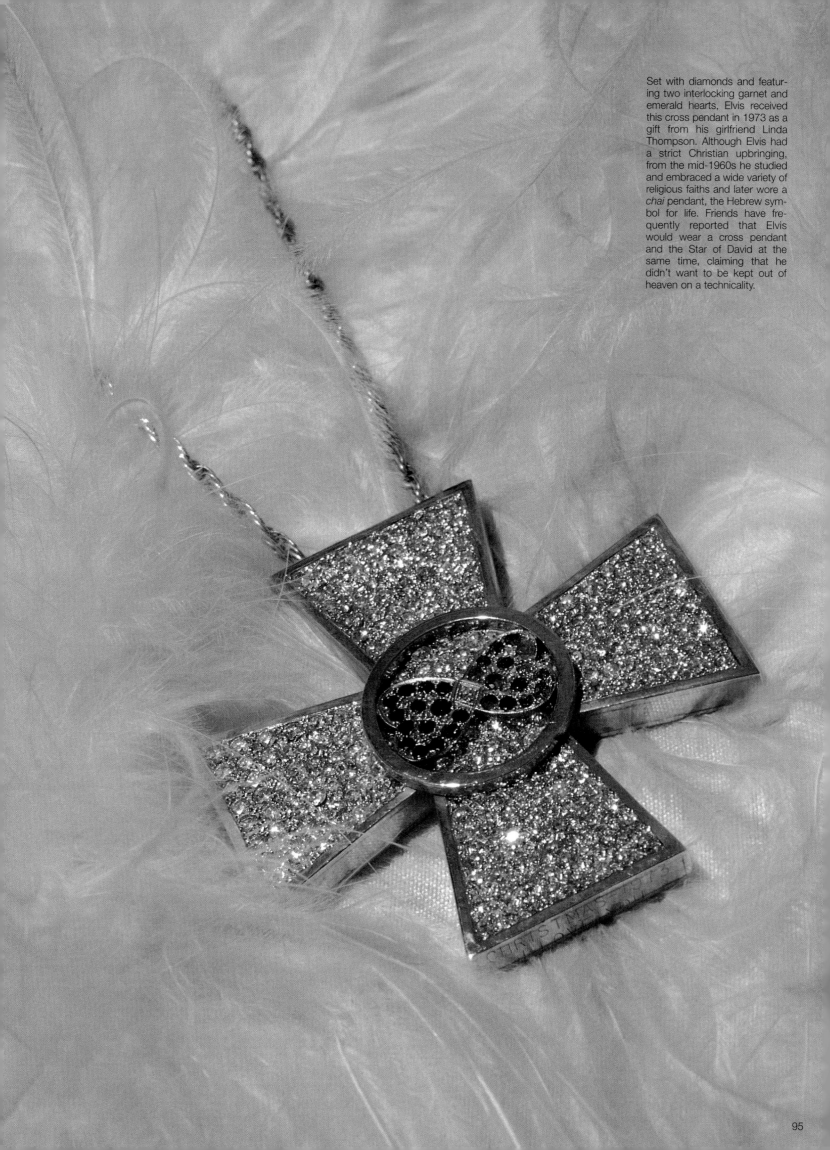

Set with diamonds and featuring two interlocking garnet and emerald hearts, Elvis received this cross pendant in 1973 as a gift from his girlfriend Linda Thompson. Although Elvis had a strict Christian upbringing, from the mid-1960s he studied and embraced a wide variety of religious faiths and later wore a *chai* pendant, the Hebrew symbol for life. Friends have frequently reported that Elvis would wear a cross pendant and the Star of David at the same time, claiming that he didn't want to be kept out of heaven on a technicality.

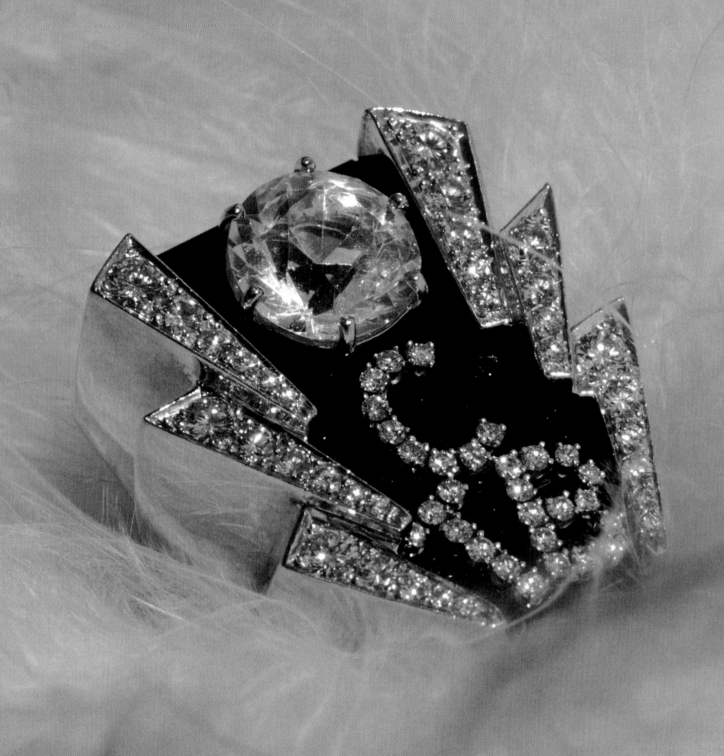

STATEMENT

Lowell Hays **JEWELERS**
& SONS, INC.

6685 POPLAR (Kirby Woods Mall)
MEMPHIS (Germantown), TENN. 38138
PHONE 901 - 754-2190

·Mr. Elvis Presley

·3764 Elvis Presley

·City 38116

DATE	DESCRIPTION	CHARGES	CREDITS	BALANCE
	BALANCE FORWARD			87003 00
8/16/75	Transfer from C/O Inv 5843 8/15/75	1478 25	-0-	88,481 25
8/16/75	Inv 5434	3009 00	-0-	91,490 25
8/16/75	Inv 5432	39337 50	-0-	130,827 75
8/16/75	Inv 5431	9570 90	-0-	140,398 65

TERMS ON CHARGE SALES: Net upon completion and invoicing of order. If payment is not received within 30 days from date of invoice, a charge of 1½% will be made, and will be made every 30 days thereafter. This charge is equivalent to 18% per annum on the unpaid balance.

PAY LAST AMOUNT IN THIS COLUMN

This stunning onyx TCB ring features a diamond solitaire—10.68 carats surrounded by a further 3.5 to form the letters and lightning. Made by the jeweler Lowell Hayes, it was purchased by Elvis on August 16, 1975. Elvis' statement of account with Hayes reached more than $150,000 when presented in September of that year. On this statement, item 5432 is Elvis' TCB ring, costing $39,337.50.

Elvis personalized his jewelry with his name, initials, or TCB logo. His jewelry was mainly purchased from Lowell Hayes and Harry Levitch in Memphis, Sol Schwartz and Lee Ableser in Beverly Hills, and, while in Las Vegas during the 1970s, Elvis became a frequent customer of the T-Bird Jewelers in the Thunderbird Hotel.

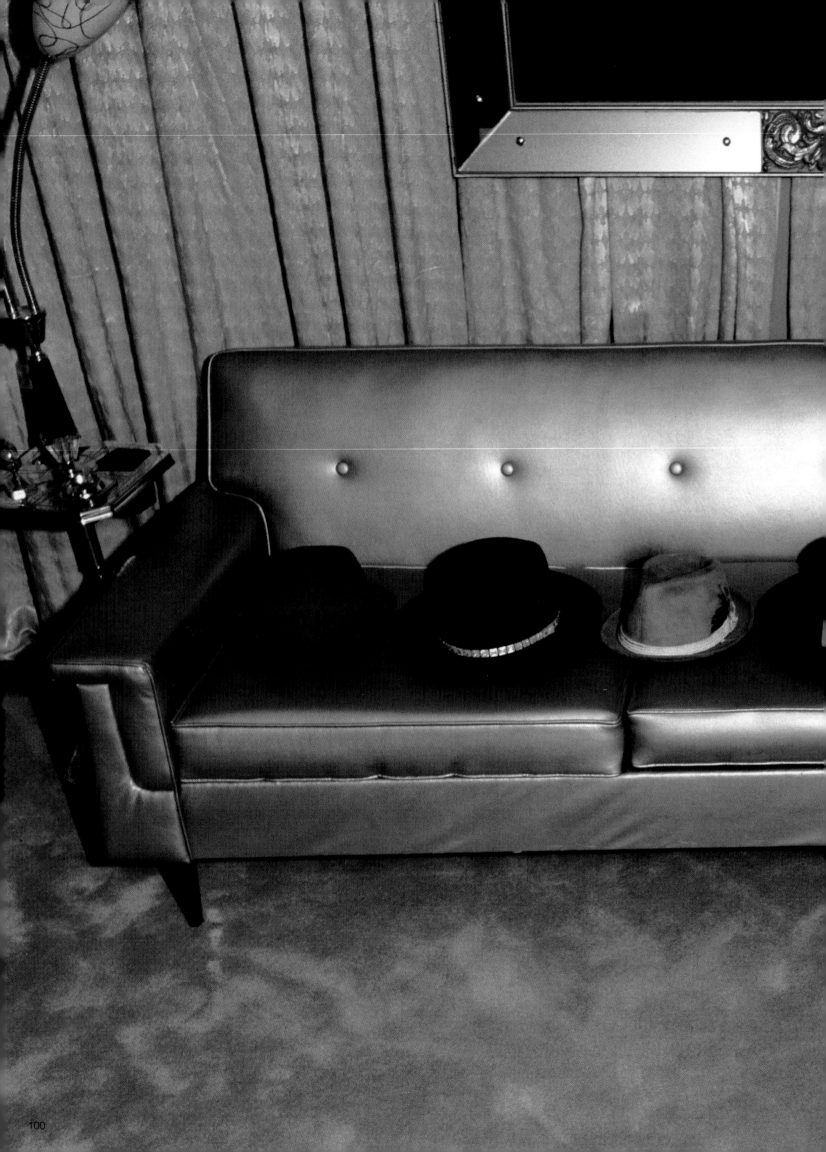

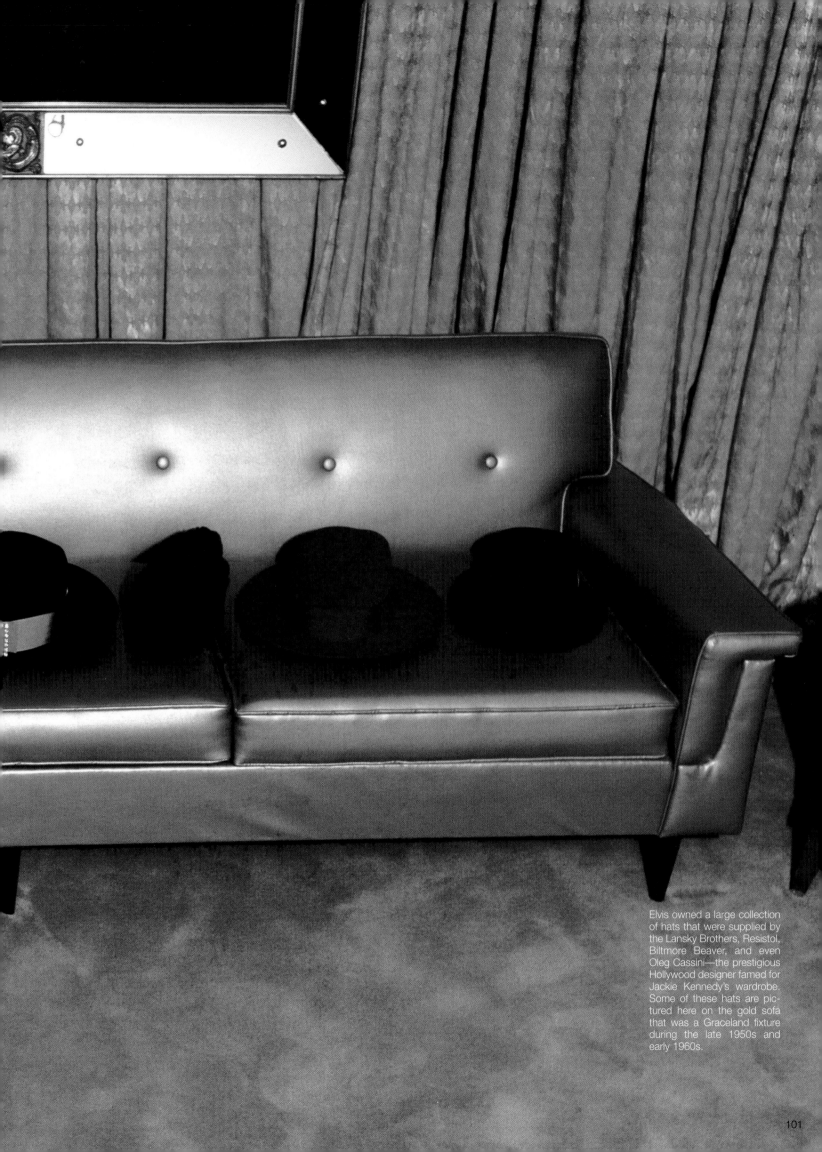

Elvis owned a large collection of hats that were supplied by the Lansky Brothers, Resistol, Biltmore Beaver, and even Oleg Cassini—the prestigious Hollywood designer famed for Jackie Kennedy's wardrobe. Some of these hats are pictured here on the gold sofa that was a Graceland fixture during the late 1950s and early 1960s.

Beginning in the mid-1960s, Elvis was frequently photographed wearing neckties and scarves. His signature silk scarves would become sought-after collectibles, thrown into the crowds at performances throughout the 1970s. During the same era, Elvis also wore larger scarves draped over his shoulders.

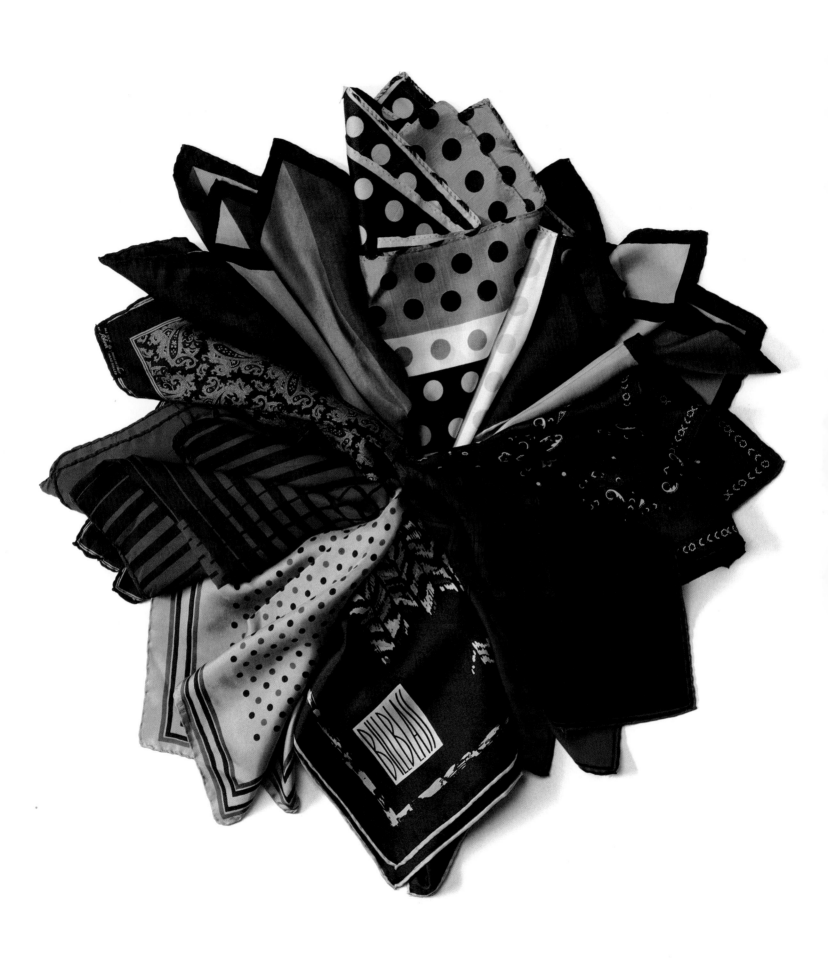

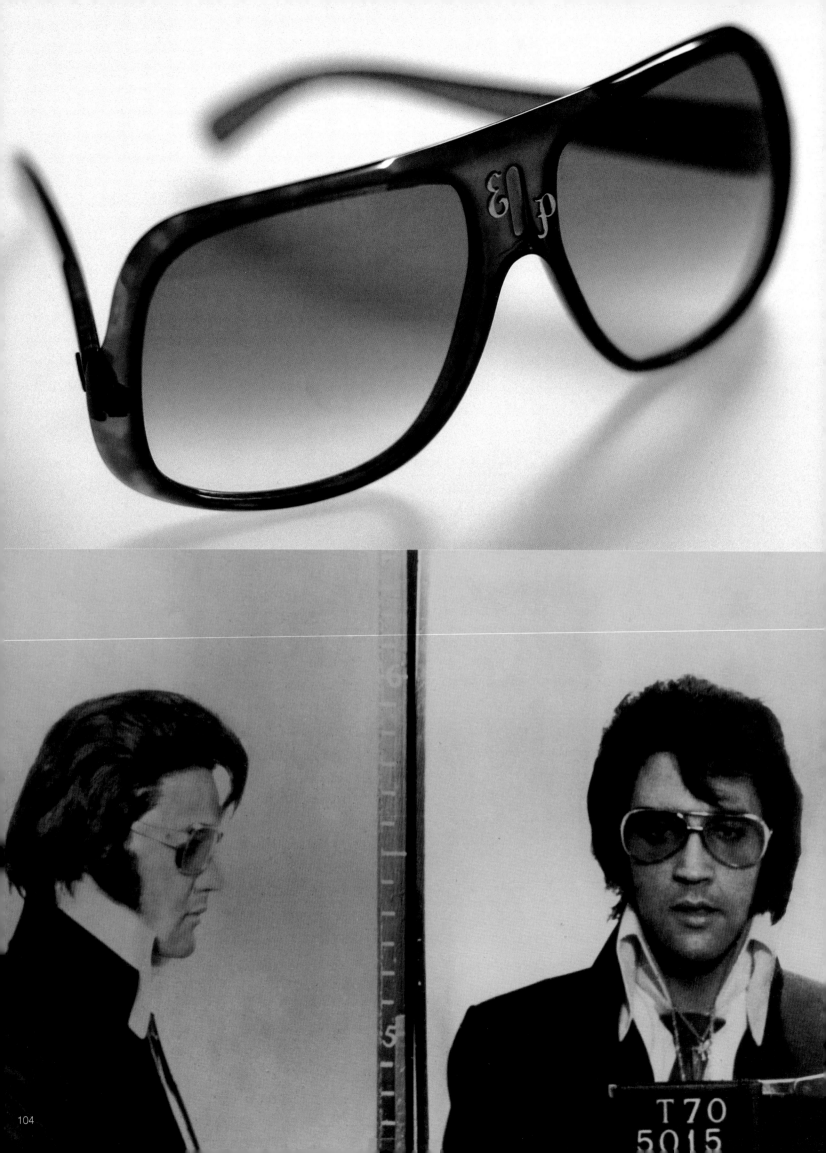

Dennis B. Roberts
OPTIQUE BOUTIQUE

8653 SUNSET BLVD.
LOS ANGELES, CALIF. 90069

TO: Mr Elvis Presley

2pr TCB gold glasses and custom case 796.00

Pd. 9-7-73
Ck # 12969

KINDLY USE THIS ENVELOPE FOR YOUR REMITTANCE
YOUR CANCELLED CHECK IS YOUR RECEIPT

These and other prescription glasses—frequently customized with his initials or the TCB (Taking Care of Business) logo—came to be recognized as "Elvis sunglasses." Contrary to popular belief, Elvis never wore sunglasses while performing, although he was frequently photographed wearing them off-stage, most notably in the MGM documentaries *That's the Way It Is* and *Elvis on Tour.*

Impeccably dressed, as always, but with a clip-on tie. In what looks like a mug shot, Elvis is actually posing for his police credentials.

"I CALL IT AMERIC

Enroute to Washington D.C. in 1970, Elvis scribbled a note on American Airlines stationery. The recipient was Richard Nixon, then the thirty-seventh president of the United States and completely unaware that Elvis Presley was planning an impromptu visit. The letter offered his services to the country and, in return, Elvis requested the credentials of a federal agent at large. An avid collector of police badges, Elvis was named sergeant, captain, or deputy sheriff in several counties throughout the United States. Although these were honorary titles, Elvis took his role seriously. He brandished his ID, amassed firearms, and enrolled his entourage as personal lawmen. It followed that his next decoration should come from the White House. On December 21, 1970, Elvis shook hands with the President. In a historic meeting they exchanged gifts, but Nixon was unable to give Elvis the credentials he hoped for. Instead, he promoted him to special assistant to the Bureau of Narcotics and Dangerous Drugs.

AN AND I LOVE IT."

—Elvis Presley

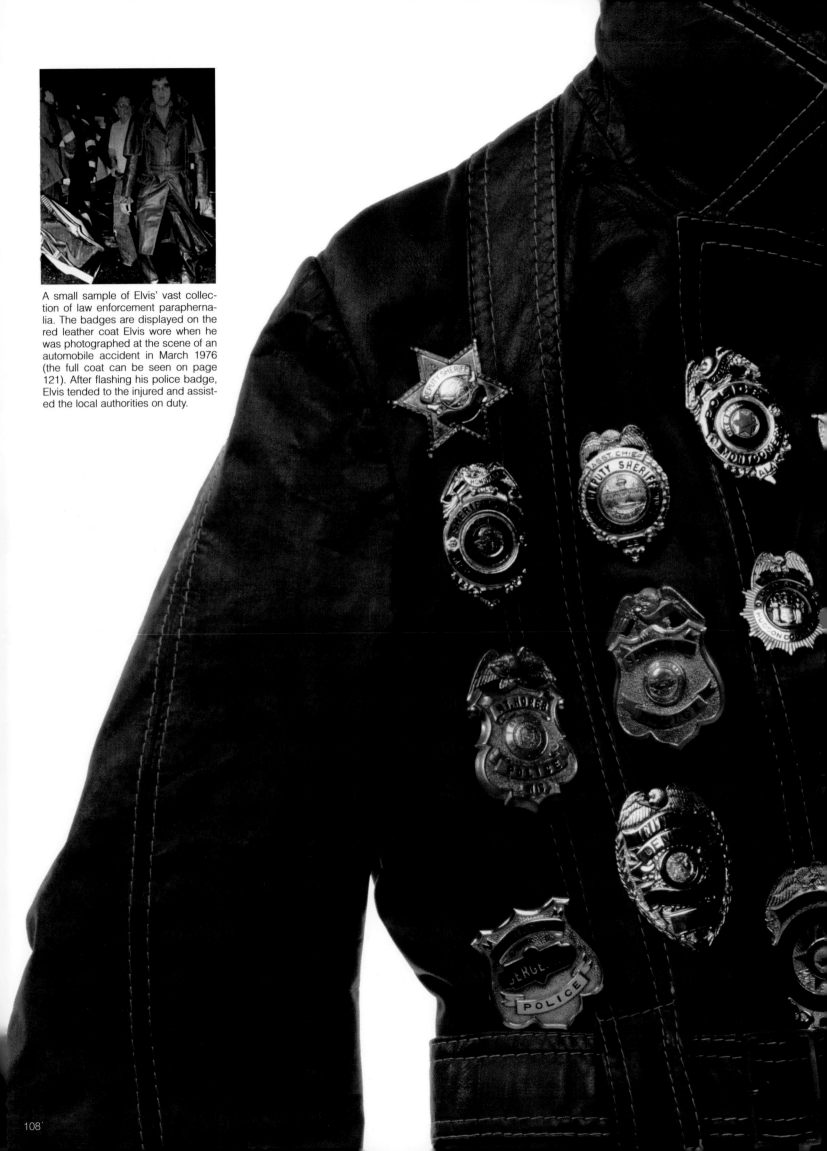

A small sample of Elvis' vast collection of law enforcement paraphernalia. The badges are displayed on the red leather coat Elvis wore when he was photographed at the scene of an automobile accident in March 1976 (the full coat can be seen on page 121). After flashing his police badge, Elvis tended to the injured and assisted the local authorities on duty.

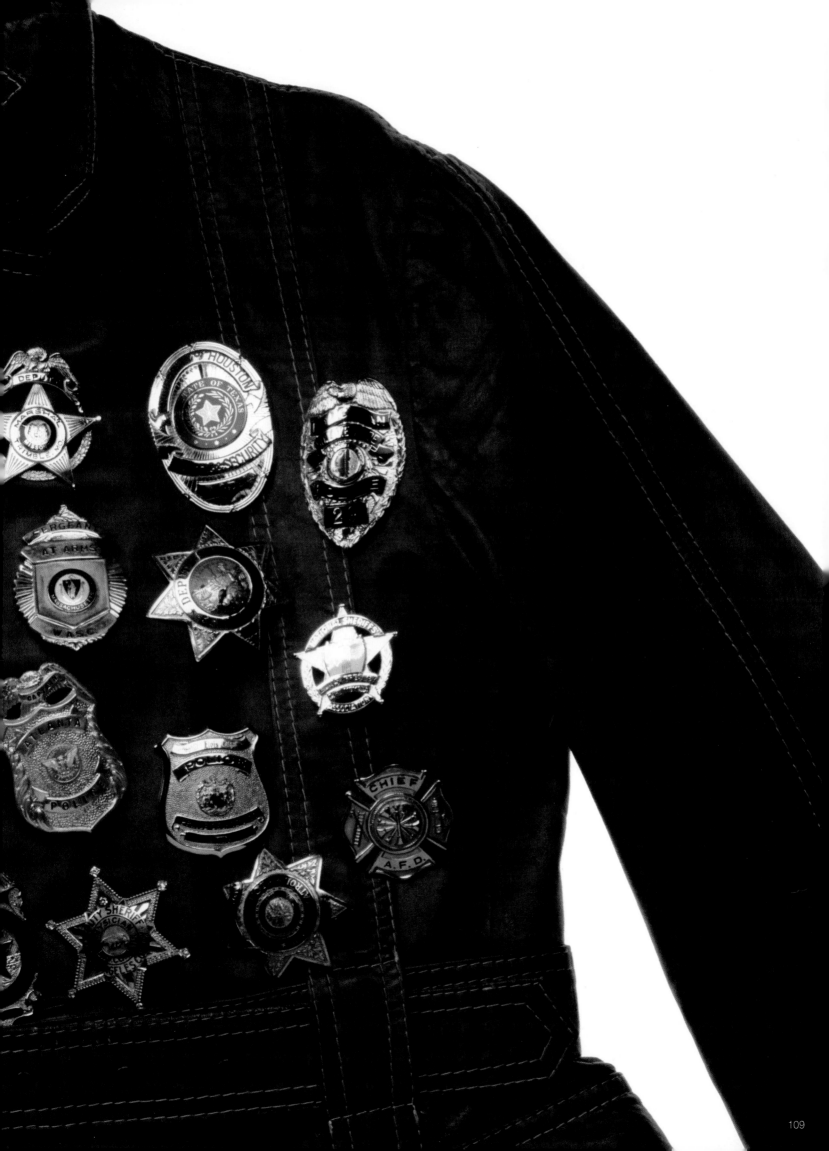

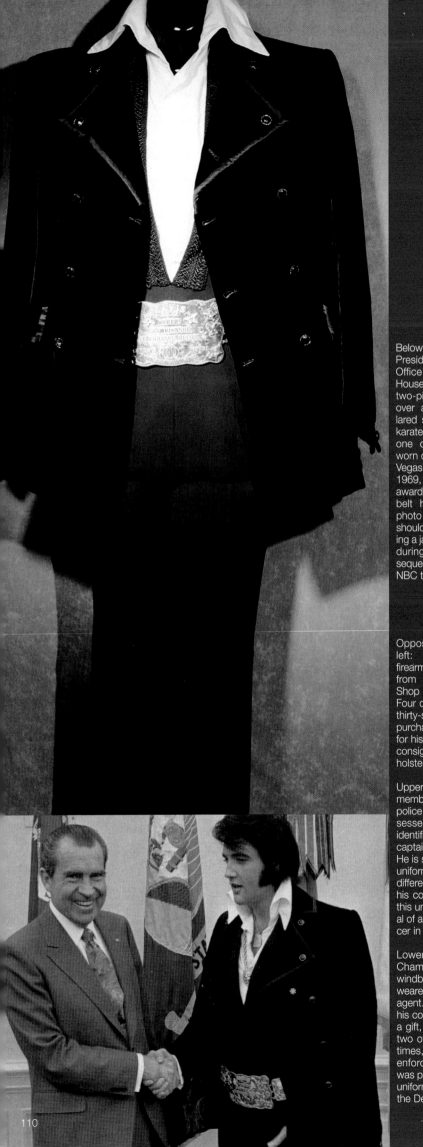

Below: Elvis meets the President in the Oval Office of the White House wearing a black two-piece stage outfit over a white high-collared shirt. Based on a karate *gi*, this suit was one of the costumes worn during his first Las Vegas engagements in 1969, for which he was awarded the solid gold belt he wears in the photo below. Over his shoulders, Elvis is wearing a jacket first featured during the nightclub sequence of his 1968 NBC television special.

Opposite page, upper left: An invoice for firearms and accessories from the Frontier Gun Shop in Palm Springs. Four days before, on his thirty-sixth birthday, Elvis purchased flashing lights for his cars, along with a consignment of shoulder holsters and handcuffs.

Upper right: An honorary member of the Denver police force, Elvis possessed a badge that identified him as a police captain and investigator. He is shown below in full uniform, tailored slightly differently from those of his colleagues. He wore this uniform to the funeral of a Denver police officer in January 1976.

Lower left: Made by Champion, this blue windbreaker identifies its wearer as a U.S. special agent. The T-shirt from his collection is probably a gift, but encompasses two of his greatest pastimes, karate and law enforcement. The hat was part of the complete uniform, given to Elvis by the Denver police force.

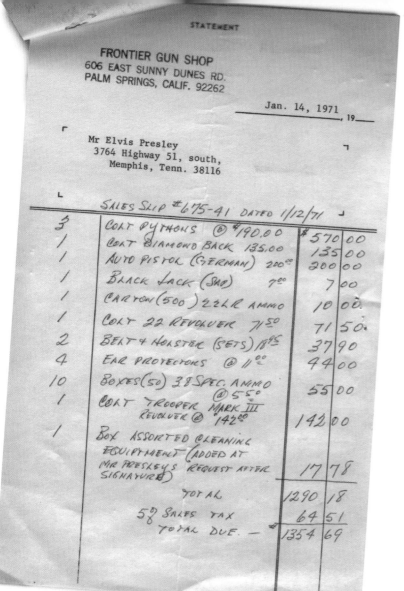

STATEMENT

FRONTIER GUN SHOP
606 EAST SUNNY DUNES RD.
PALM SPRINGS, CALIF. 92262

Jan. 14, 1971, 19___

Mr Elvis Presley
3764 Highway 51, south,
Memphis, Tenn. 38116

SALES SLIP #675-41 DATED 1/12/71

3	COLT PYTHONS @ $190.00	$570	00
1	COLT DIAMOND BACK 135.00	135	00
1	AUTO PISTOL (GERMAN) 200.00	200	00
1	BLACK JACK (SAP) 7.00	7	00
1	CARTON (500) 22LR AMMO	10	00
1	COLT 22 REVOLVER 71.50	71	50
2	BELT & HOLSTER (SETS) 18.95	37	90
4	EAR PROTECTORS @ 11.00	44	00
10	BOXES (50) 38 SPEC. AMMO @ 5.50	55	00
1	COLT TROOPER MARK III REVOLVER @ $142.00	142	00
1	BOX ASSORTED CLEANING EQUIPMENT (ADDED AT MR PRESLEYS REQUEST AFTER SIGNATURE)	17	78
	TOTAL	1290	18
	5% SALES TAX	64	51
	TOTAL DUE.— $	1354	69

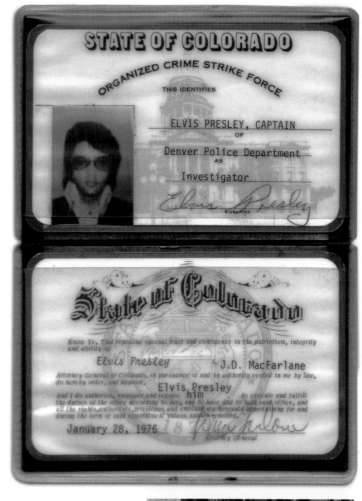

STATE OF COLORADO

ORGANIZED CRIME STRIKE FORCE

THIS IDENTIFIES

ELVIS PRESLEY, CAPTAIN
OF
Denver Police Department
AS
Investigator

State of Colorado

Know Ye, That reposing special trust and confidence in the patriotism, integrity and ability of

Elvis Presley J.D. MacFarlane

Attorney General of Colorado, in pursuance of and by authority vested in me by law, do hereby order, and appoint,

Elvis Presley
him

And I do authorize, empower and require to execute and fulfill the duties of the office according to law, and to have and to hold said office, and all the rights, authorities, privileges, and emoluments hereunto appertaining for and during the term of said appointment unless sooner removed.

January 28, 1976

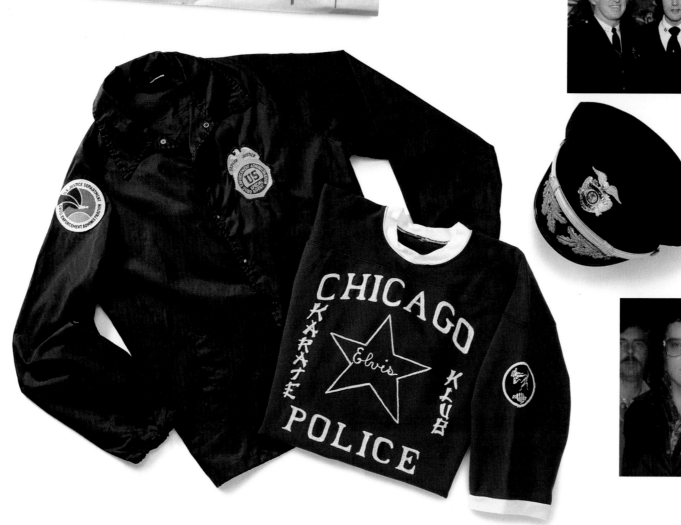

"Elvis could be really bizarre and wild looking..."

—Joe Esposito

From gold lamé to black leather, Elvis was known for his flash—for voluptuous fabrics, startling colors, and unprecedented style. Since the start of his career, fashion and clothes manufacturing had changed dramatically. Elvis became an American icon in the era of easy-care fabrics and man-made fibers, at a time when designers headed across the Atlantic for inspiration. Along with his contemporaries, Elvis shattered the trickle-down theory that fashion originated in the upper classes and traveled down to the lower socioeconomic strata. That trend had been suddenly reversed by the teenage revolution, when street clothes came into vogue.

At the onset of his fame, with limited finances, Elvis recycled his wardrobe. The same jacket he wore on television would reappear as day wear, again at a media event, or onstage a few days later. But, as his wealth grew, his collection increased, and by the mid-1970s, Elvis boasted an expensive and varied wardrobe.

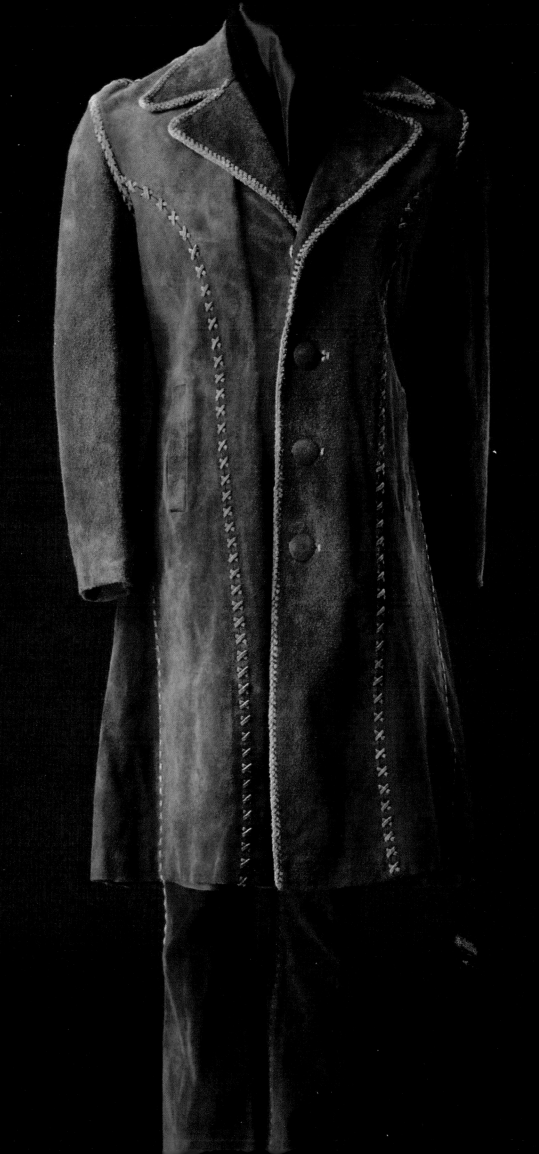

Priscilla bought this purple suede suit with gray suede trim from North Beach Leather in 1971, just in time for Christmas. Elvis is shown on the opposite page with hotel executive Alex Shoofey in Las Vegas wearing the suit the following spring.

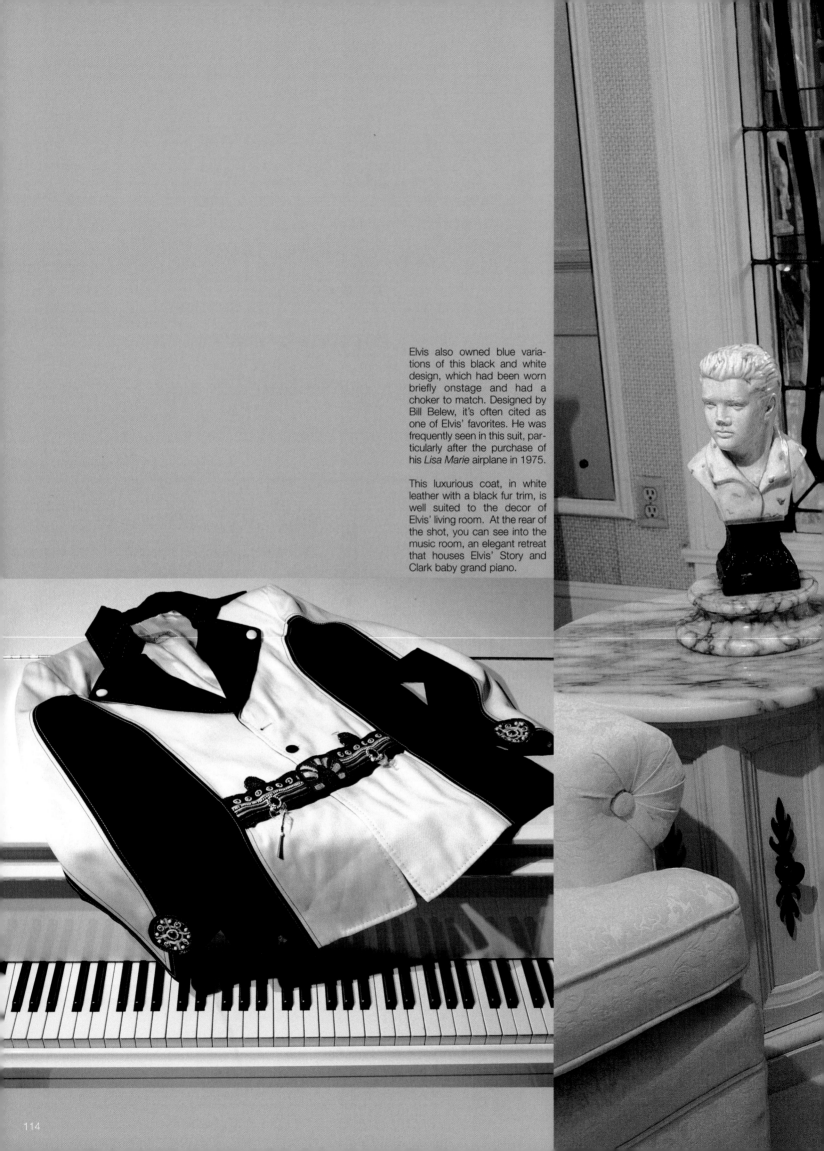

Elvis also owned blue variations of this black and white design, which had been worn briefly onstage and had a choker to match. Designed by Bill Belew, it's often cited as one of Elvis' favorites. He was frequently seen in this suit, particularly after the purchase of his *Lisa Marie* airplane in 1975.

This luxurious coat, in white leather with a black fur trim, is well suited to the decor of Elvis' living room. At the rear of the shot, you can see into the music room, an elegant retreat that houses Elvis' Story and Clark baby grand piano.

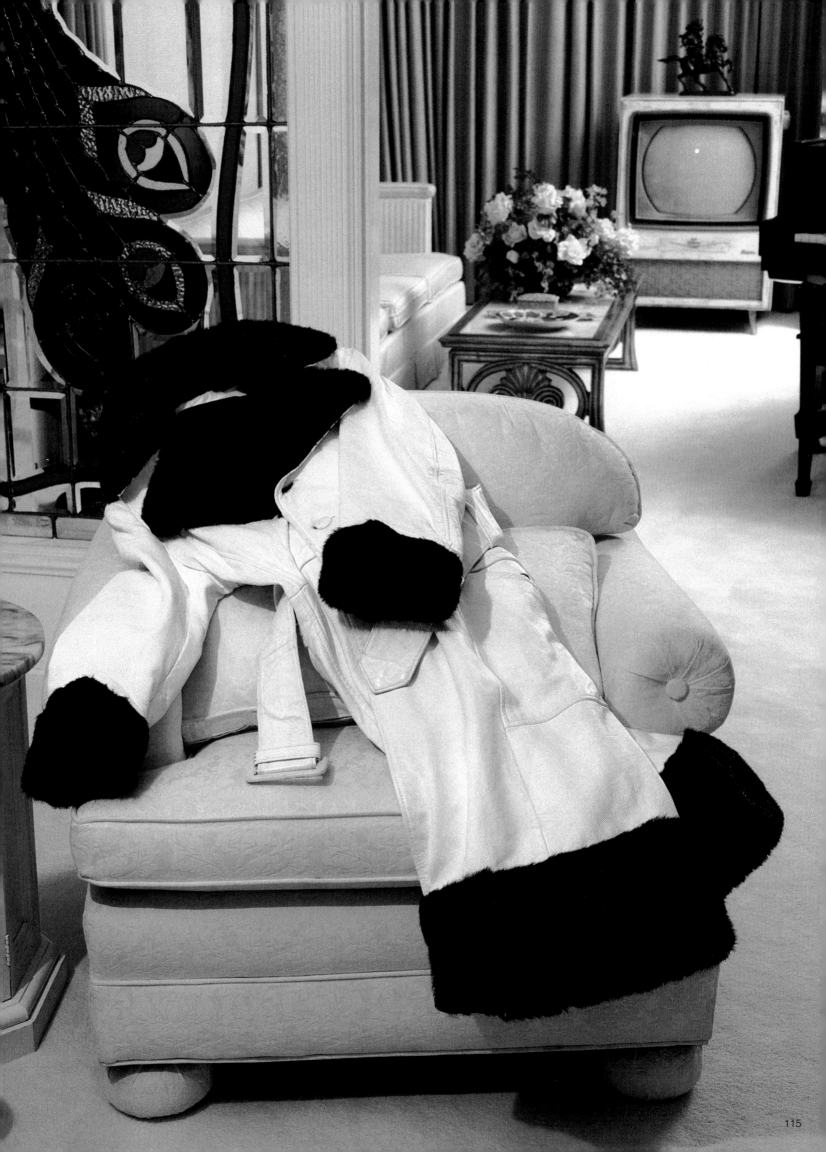

At an official breakfast where he was to receive his award from the United States Junior Chamber of Commerce, Elvis dressed in chocolate brown faux fur, far outshining his fellow nominees in their traditional business suits. This suit was created by Elvis' personal designer, Bill Belew, with wood and brass buttons, brass grommets, and a matching faux fur hat.

Opposite page: Made by International Fashion, these are three sparkling, casual suits from Elvis' personal collection. Although he disliked denim, these clothes present a compromise—the fabric is in keeping with denim fashions of the time, while the patchwork design and rhinestones bear no resemblance to the workwear he despised.

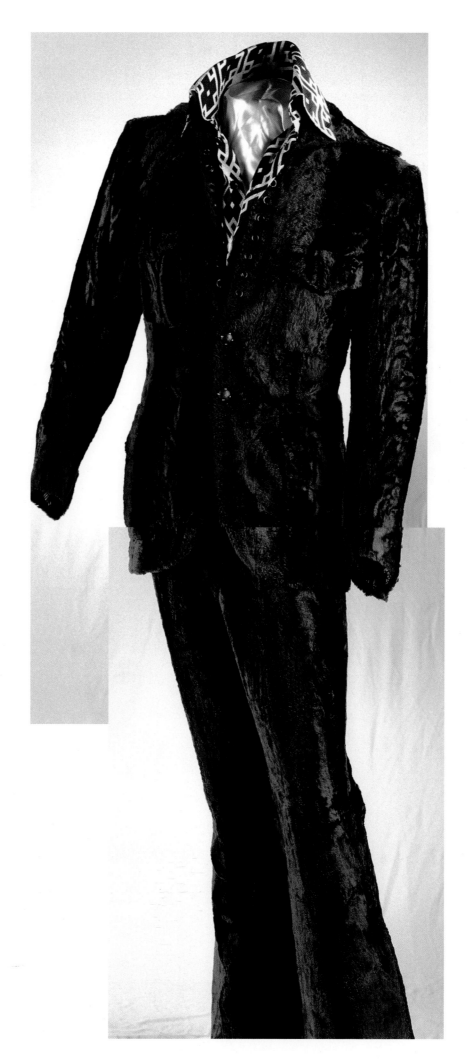

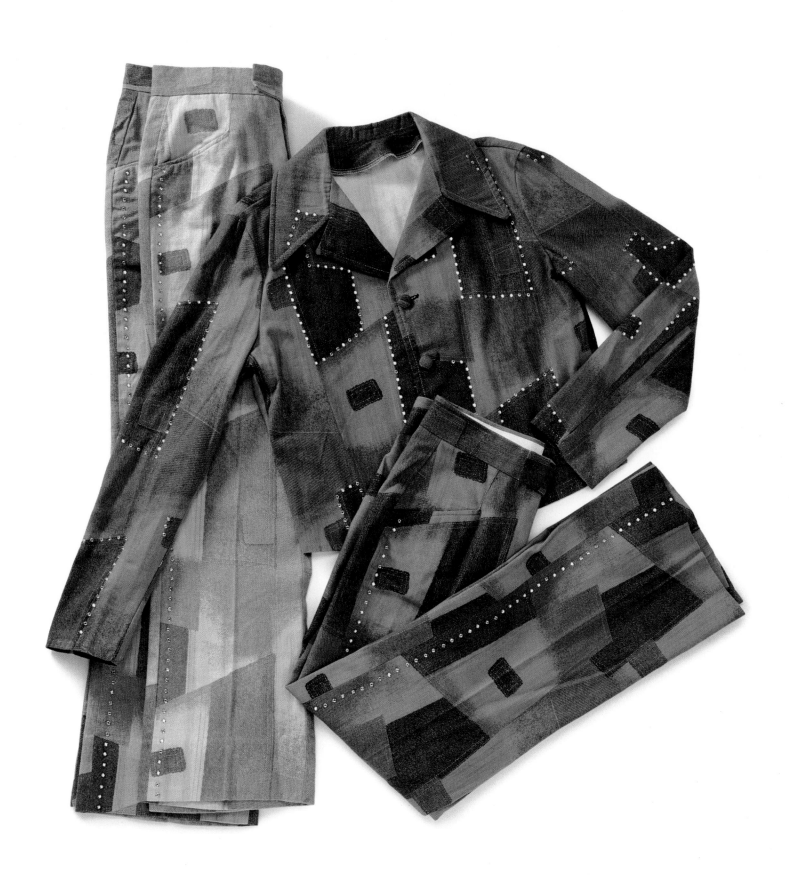

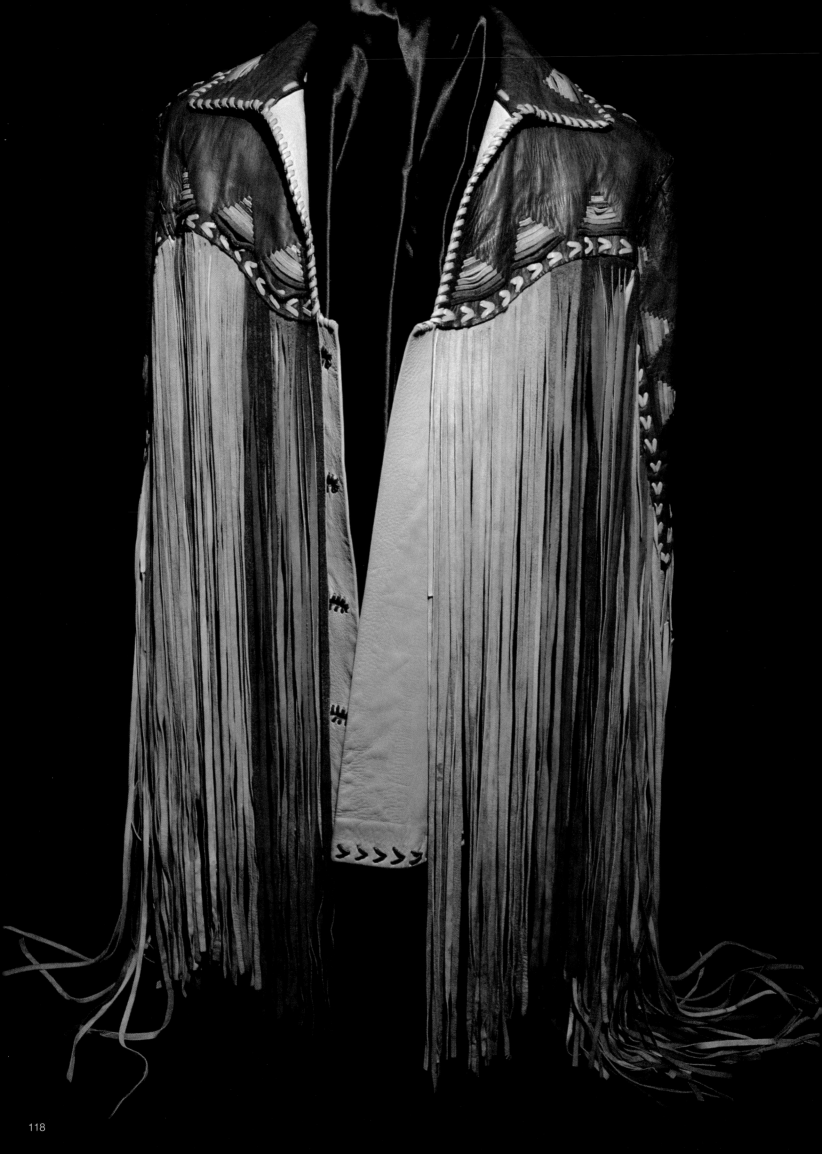

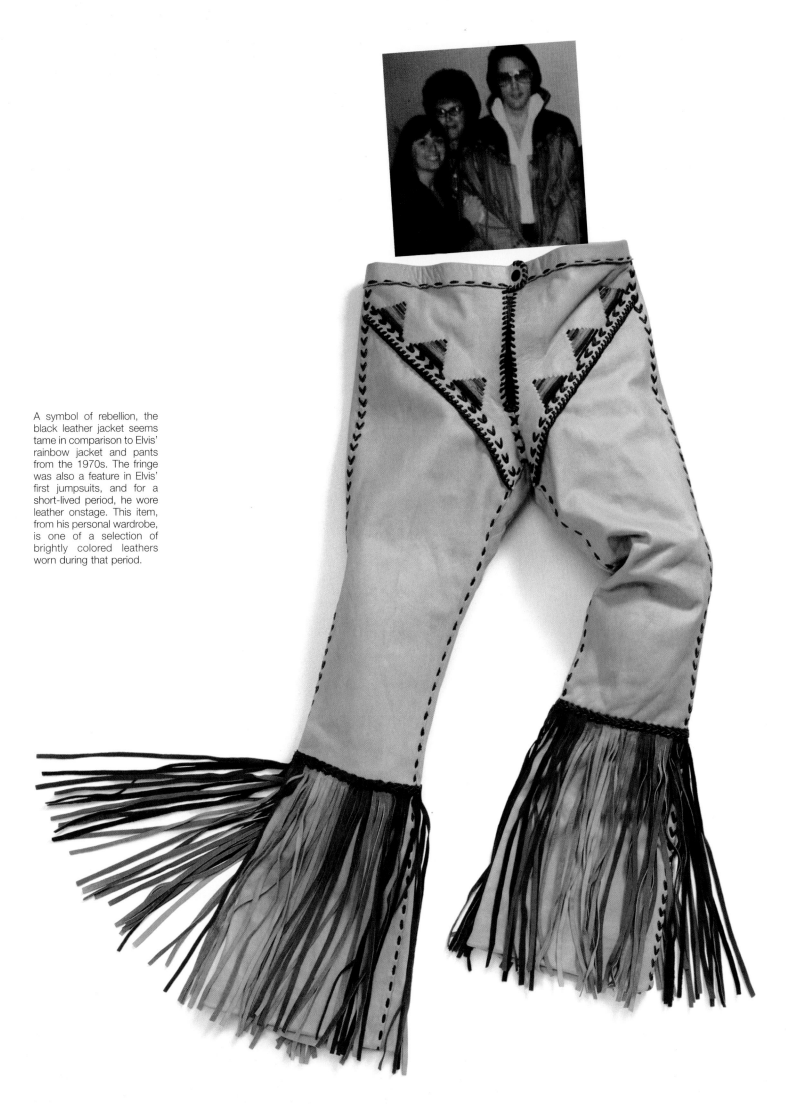

A symbol of rebellion, the black leather jacket seems tame in comparison to Elvis' rainbow jacket and pants from the 1970s. The fringe was also a feature in Elvis' first jumpsuits, and for a short-lived period, he wore leather onstage. This item, from his personal wardrobe, is one of a selection of brightly colored leathers worn during that period.

HE'D BUY WHAT HE SAW...

"Elvis had no set idea. He would go shopping for the sake of shopping and

From Elvis' personal collection: this red leather coat, in size 42, was made by Martin Bernard and Elvis is pictured wearing this jacket at the scene of an automobile accident on page 108.

This luxurious black and white Lansky Brothers fur coat is teamed here with white velvet pants. In the mid-1970s, Elvis was known to wear this outfit with a black and white velvet hat.

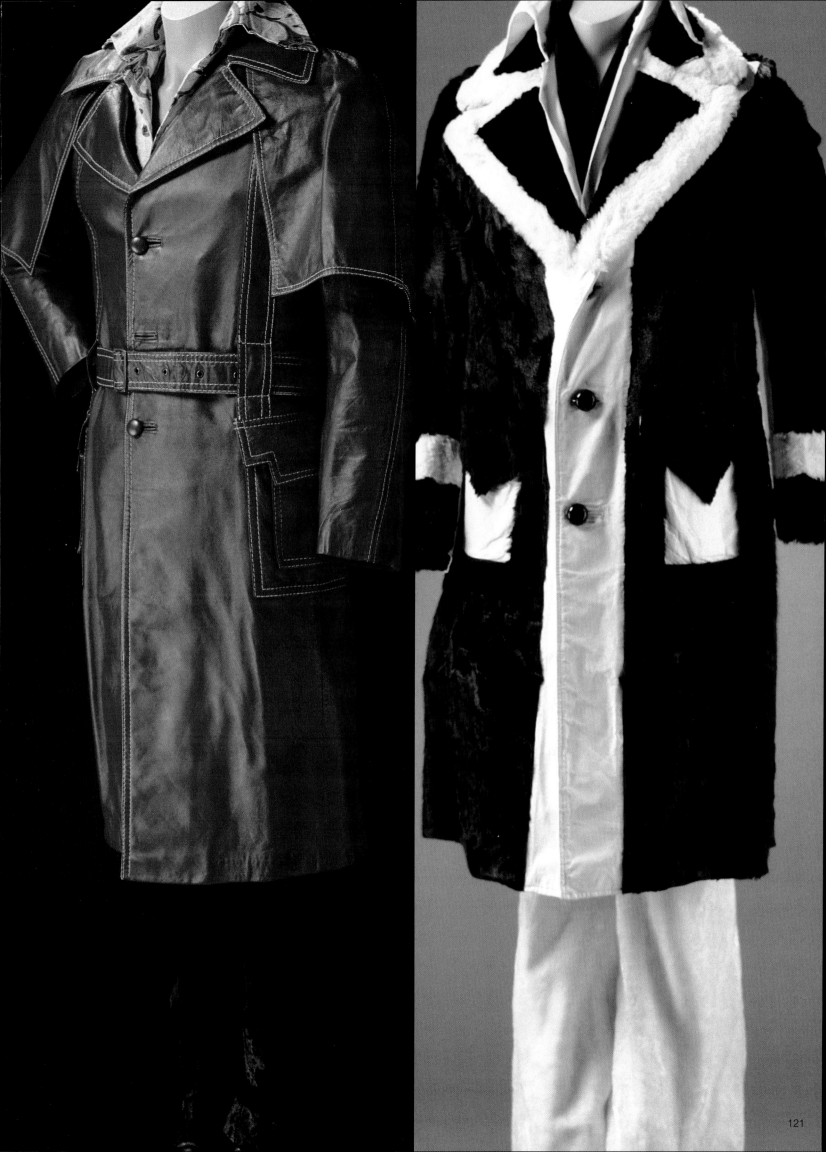

These long fur-trimmed coats were inspired by the 1965 movie *Dr. Zhivago* and Elvis wore endless variations of this design. The deep blue one worn in this picture with Muhammad Ali, is labeled "International Fashion."

ANYTHING THAT CAUGHT HIS EYE."

—Joe Esposito

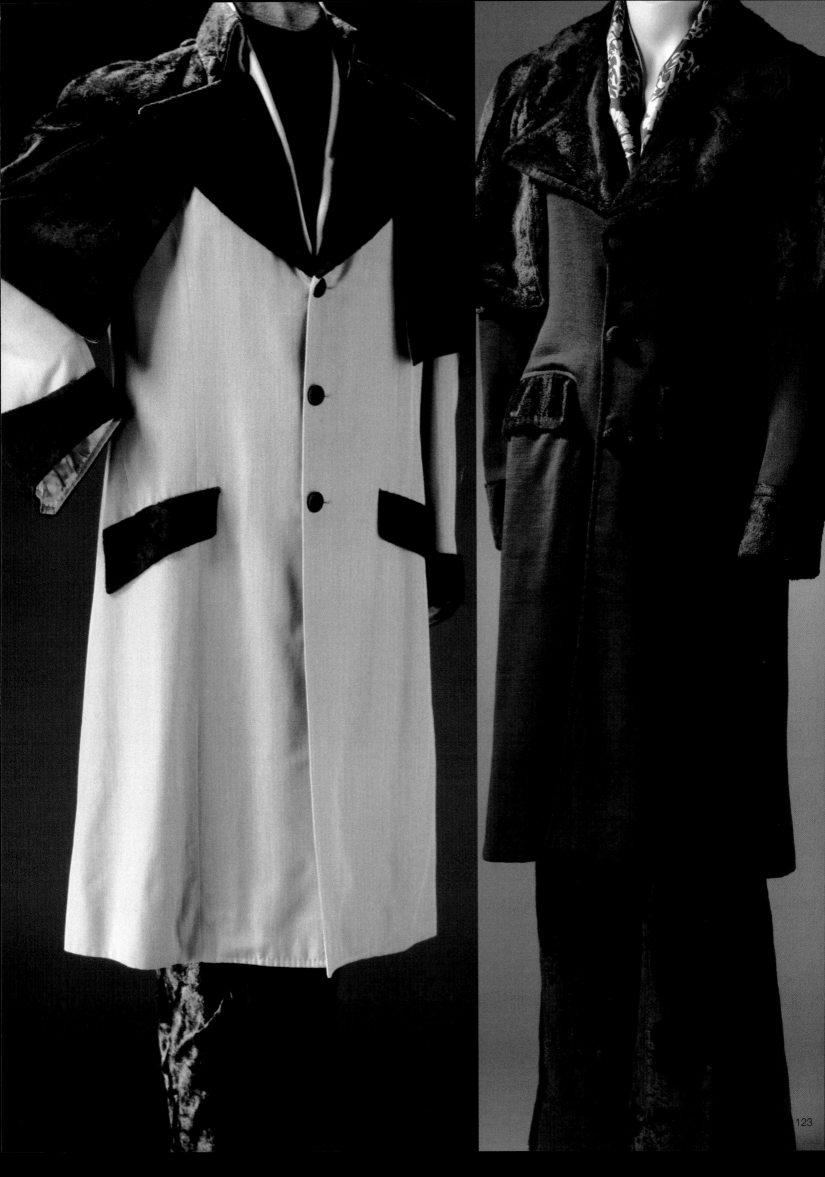

"For a long time Elvis was having shirts made with those puffed-up sleeves. He went through a whole series of those for a long time until he got tired and didn't buy them anymore.

ELVIS DID EVERYTHING IN
EXCESS."

—Joe Esposito

Elvis' puff-sleeved shirts, elasticated on the upper arms and cuffs, were designed by Bill Belew. In the early 1970s, they became a regular feature of Elvis' attire, onstage and off, and can be seen in both of his documentary movies: *Elvis: That's the Way It Is* and *Elvis on Tour*.

A good example is the white shirt shown here draped across Elvis' luxurious faux fur bed that includes a built-in stereo and television. Elvis purchased the bed, along with a matching ottoman, in the mid-1970s and kept it in his wardrobe room.

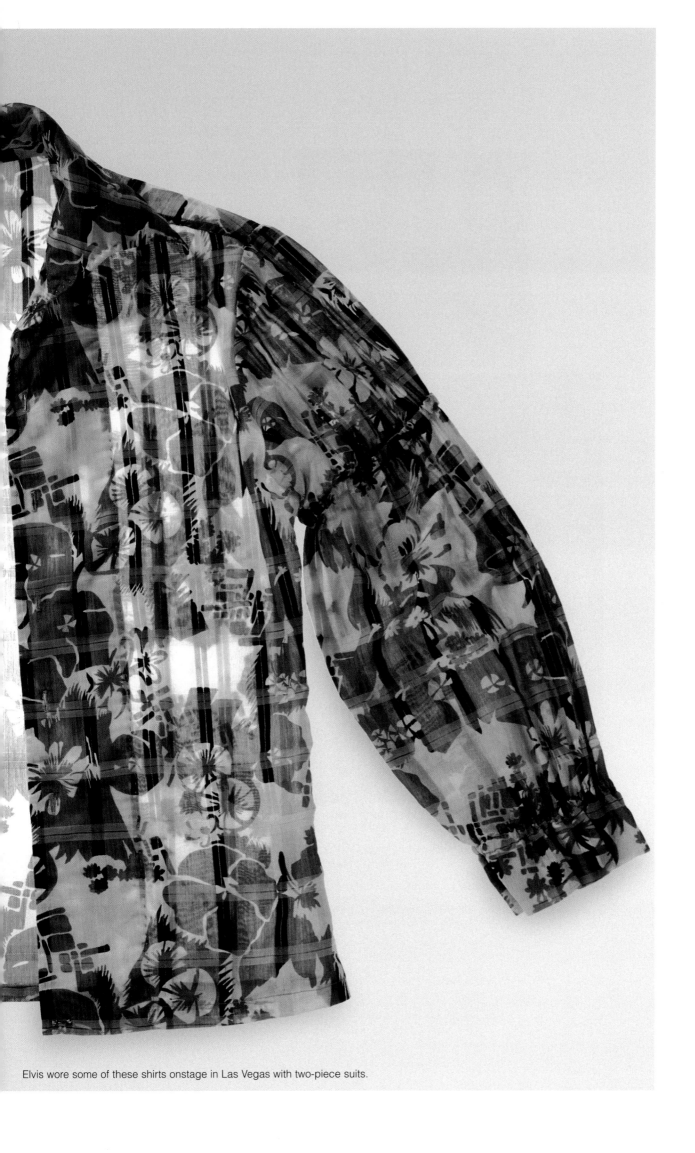

Elvis wore some of these shirts onstage in Las Vegas with two-piece suits.

With girlfriend Linda Thompson and her mother, Elvis is wearing the shirt featured on the facing page, albeit with a different jacket.

Taken at Graceland in 1972, this snapshot shows Elvis opening gifts with Lisa Marie on Christmas morning in the dining room wearing the shirt shown on the previous page.

Rarely seen by the public, Elvis' vibrant silk jacket linings were designed to match the patterns of his shirts—a unique fashion feature conceived by Bill Belew. "I have a thing about linings in suits," he laughs. "I like a bit of color—thank God he never complained about them!"

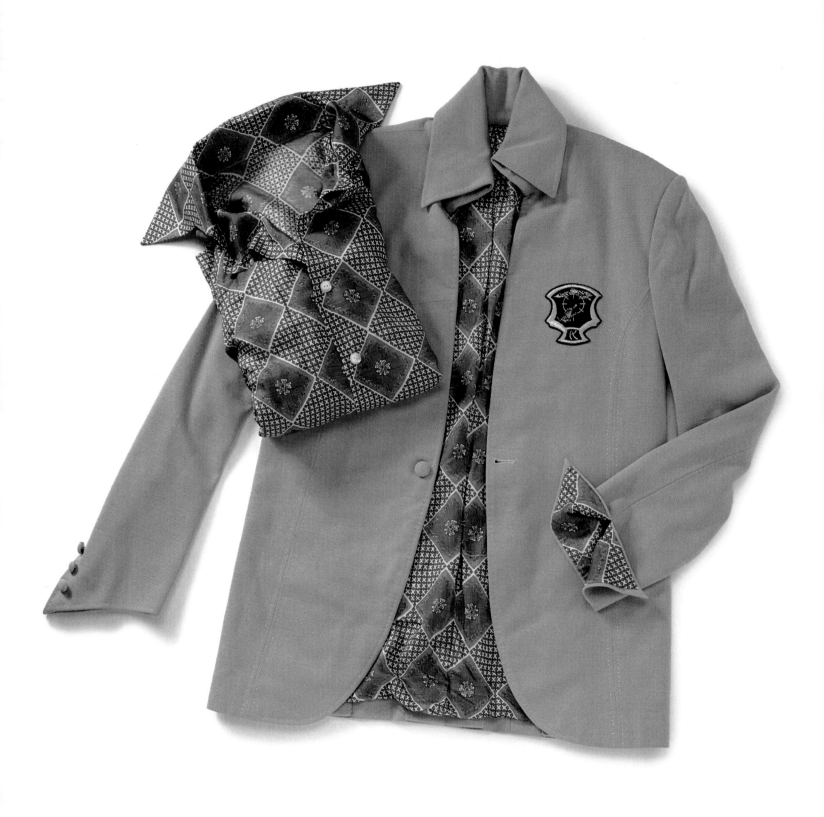

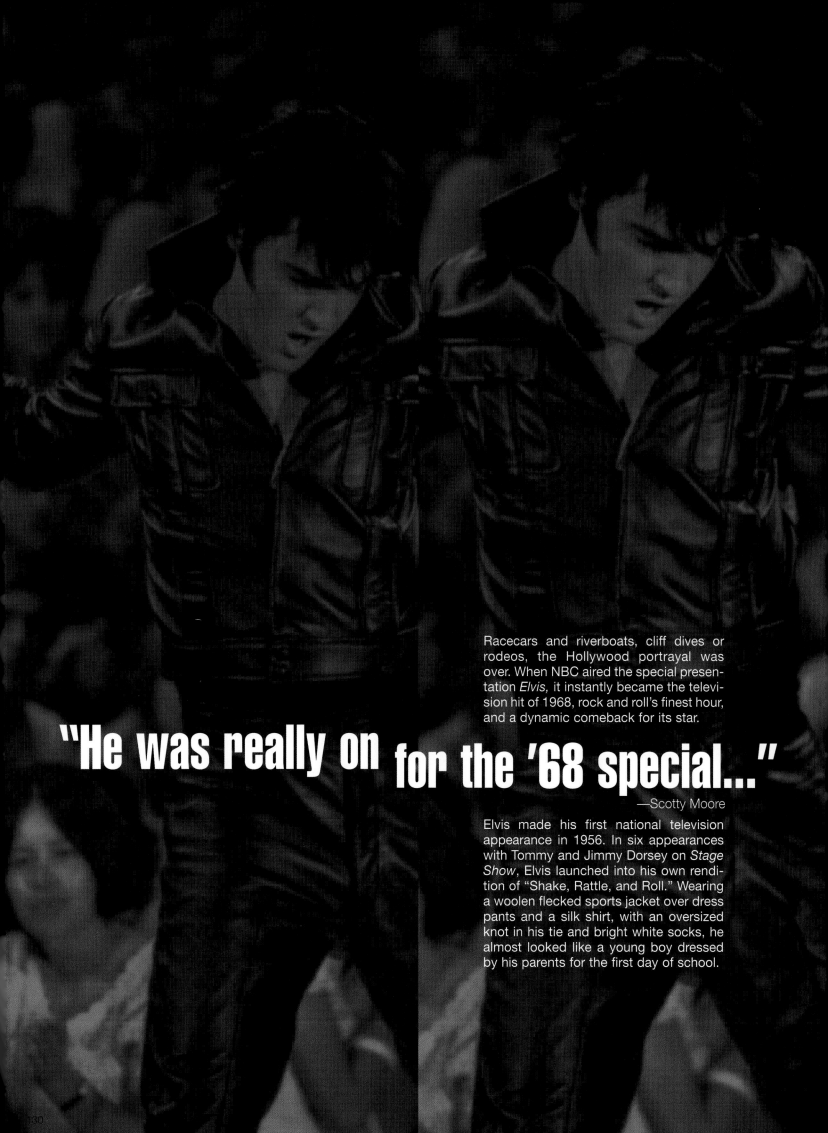

Racecars and riverboats, cliff dives or rodeos, the Hollywood portrayal was over. When NBC aired the special presentation *Elvis,* it instantly became the television hit of 1968, rock and roll's finest hour, and a dynamic comeback for its star.

"He was really on for the '68 special..."

—Scotty Moore

Elvis made his first national television appearance in 1956. In six appearances with Tommy and Jimmy Dorsey on *Stage Show,* Elvis launched into his own rendition of "Shake, Rattle, and Roll." Wearing a woolen flecked sports jacket over dress pants and a silk shirt, with an oversized knot in his tie and bright white socks, he almost looked like a young boy dressed by his parents for the first day of school.

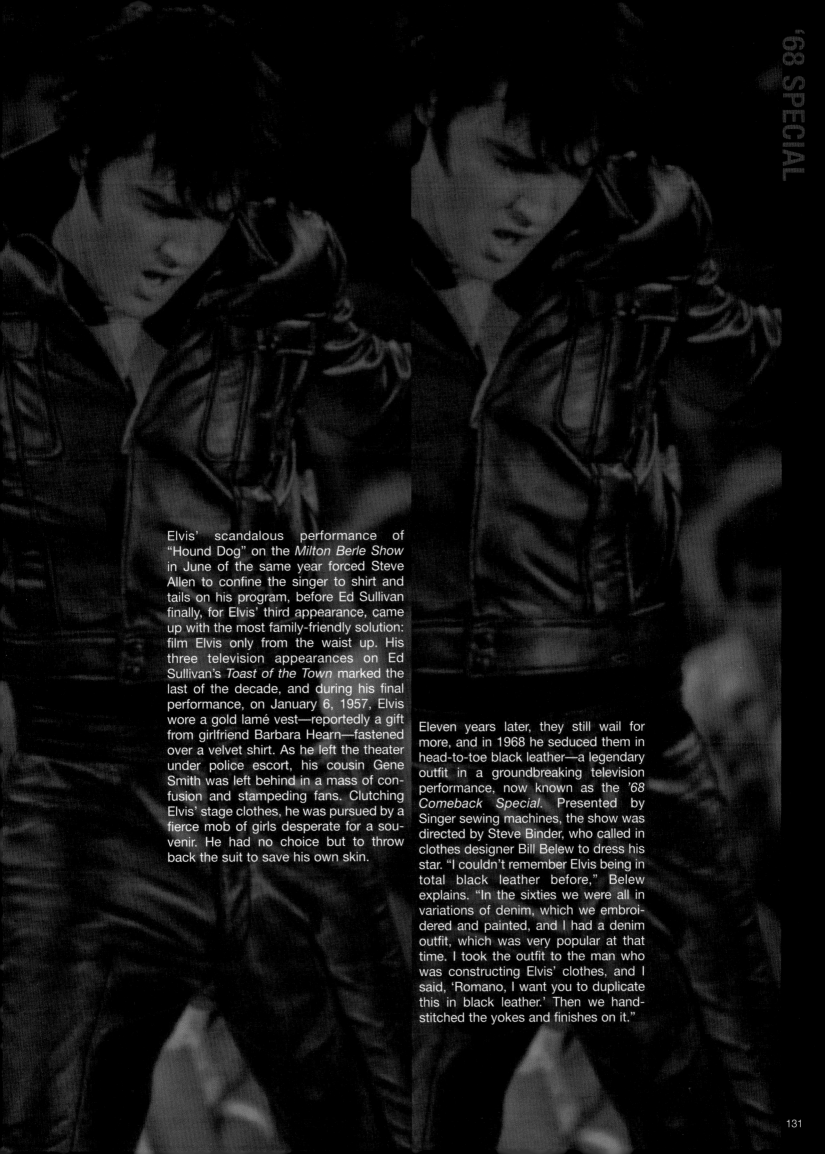

Elvis' scandalous performance of "Hound Dog" on the *Milton Berle Show* in June of the same year forced Steve Allen to confine the singer to shirt and tails on his program, before Ed Sullivan finally, for Elvis' third appearance, came up with the most family-friendly solution: film Elvis only from the waist up. His three television appearances on Ed Sullivan's *Toast of the Town* marked the last of the decade, and during his final performance, on January 6, 1957, Elvis wore a gold lamé vest—reportedly a gift from girlfriend Barbara Hearn—fastened over a velvet shirt. As he left the theater under police escort, his cousin Gene Smith was left behind in a mass of confusion and stampeding fans. Clutching Elvis' stage clothes, he was pursued by a fierce mob of girls desperate for a souvenir. He had no choice but to throw back the suit to save his own skin.

Eleven years later, they still wail for more, and in 1968 he seduced them in head-to-toe black leather—a legendary outfit in a groundbreaking television performance, now known as the *'68 Comeback Special*. Presented by Singer sewing machines, the show was directed by Steve Binder, who called in clothes designer Bill Belew to dress his star. "I couldn't remember Elvis being in total black leather before," Belew explains. "In the sixties we were all in variations of denim, which we embroidered and painted, and I had a denim outfit, which was very popular at that time. I took the outfit to the man who was constructing Elvis' clothes, and I said, 'Romano, I want you to duplicate this in black leather.' Then we hand-stitched the yokes and finishes on it."

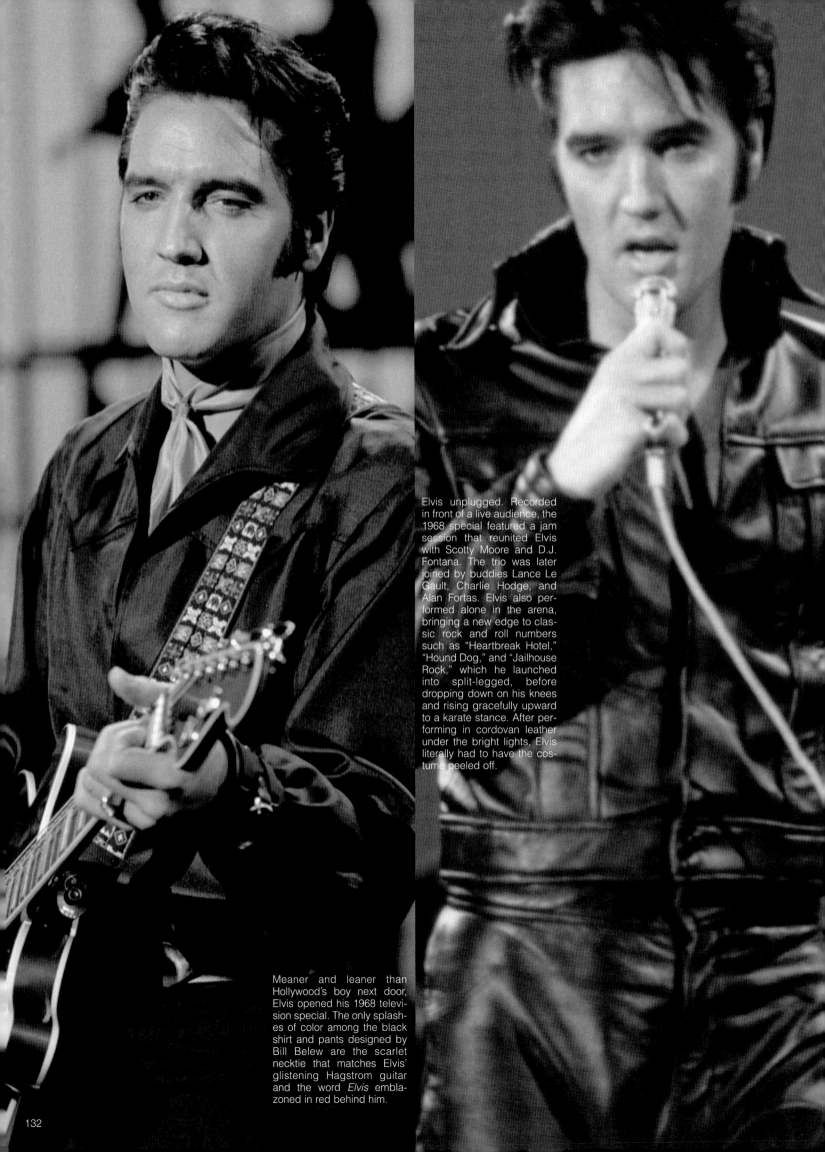

Elvis unplugged. Recorded in front of a live audience, the 1968 special featured a jam session that reunited Elvis with Scotty Moore and D.J. Fontana. The trio was later joined by buddies Lance Le Gault, Charlie Hodge, and Alan Fortas. Elvis also performed alone in the arena, bringing a new edge to classic rock and roll numbers such as "Heartbreak Hotel," "Hound Dog," and "Jailhouse Rock," which he launched into split-legged, before dropping down on his knees and rising gracefully upward to a karate stance. After performing in cordovan leather under the bright lights, Elvis literally had to have the costume peeled off.

Meaner and leaner than Hollywood's boy next door, Elvis opened his 1968 television special. The only splashes of color among the black shirt and pants designed by Bill Belew are the scarlet necktie that matches Elvis' glistening Hagstrom guitar and the word *Elvis* emblazoned in red behind him.

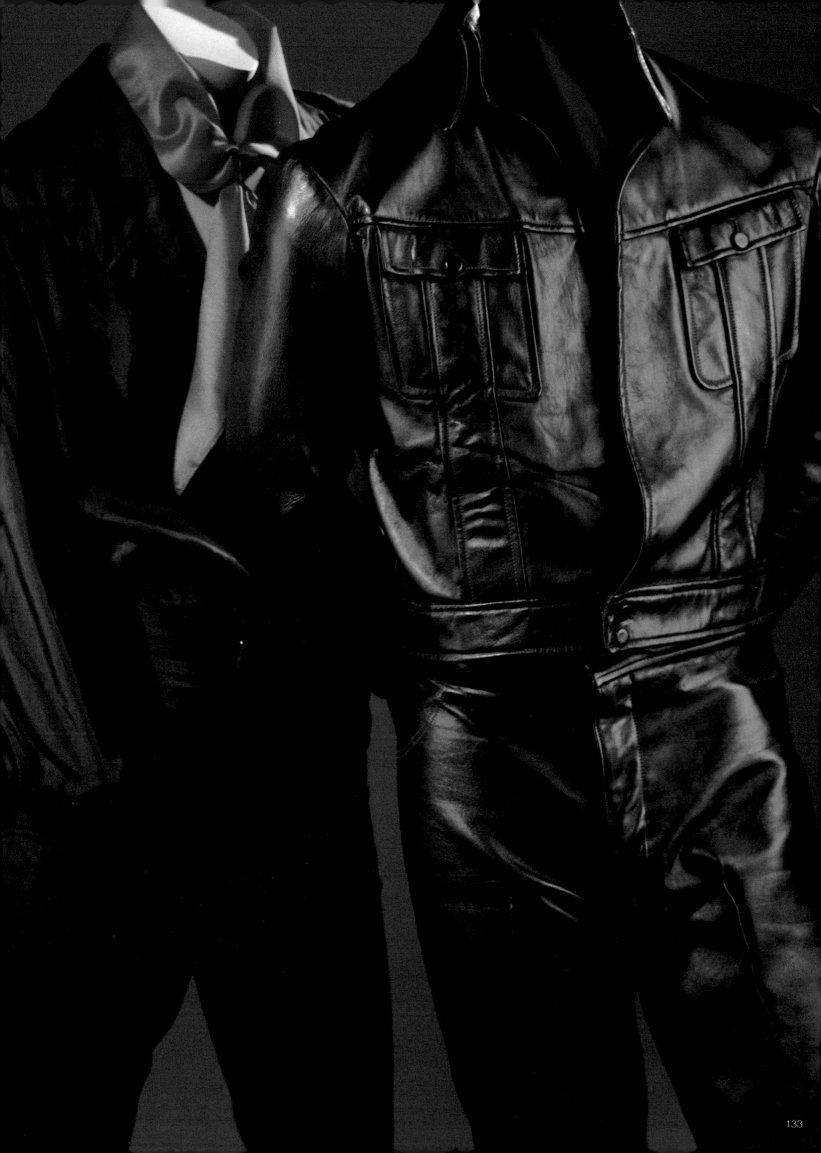

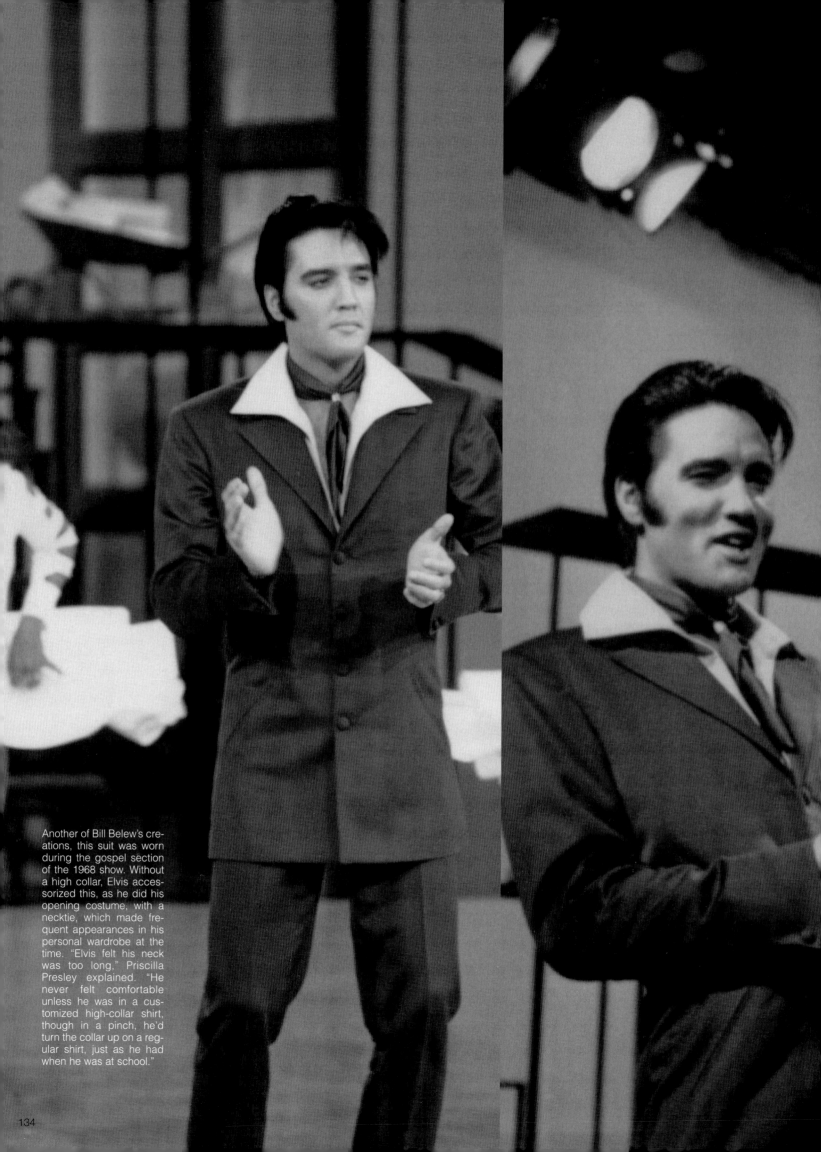

Another of Bill Belew's creations, this suit was worn during the gospel section of the 1968 show. Without a high collar, Elvis accessorized this, as he did his opening costume, with a necktie, which made frequent appearances in his personal wardrobe at the time. "Elvis felt his neck was too long," Priscilla Presley explained. "He never felt comfortable unless he was in a customized high-collar shirt, though in a pinch, he'd turn the collar up on a regular shirt, just as he had when he was at school."

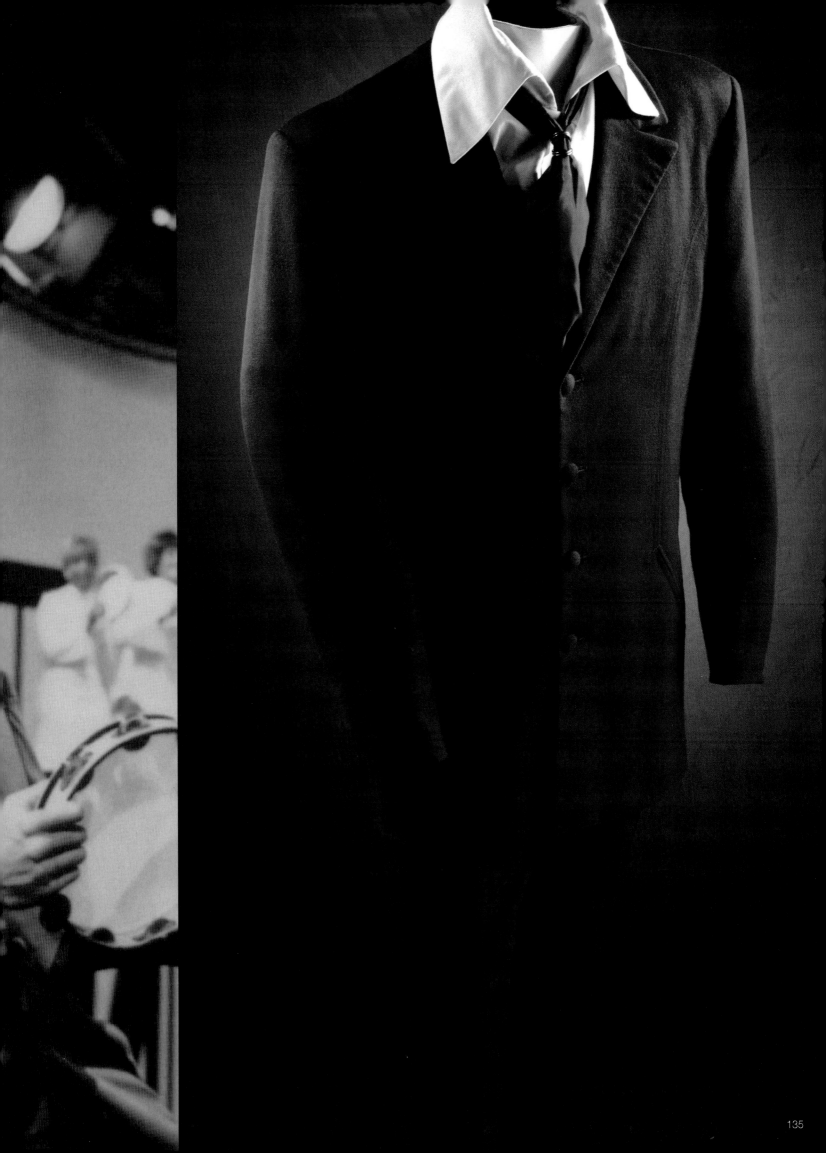

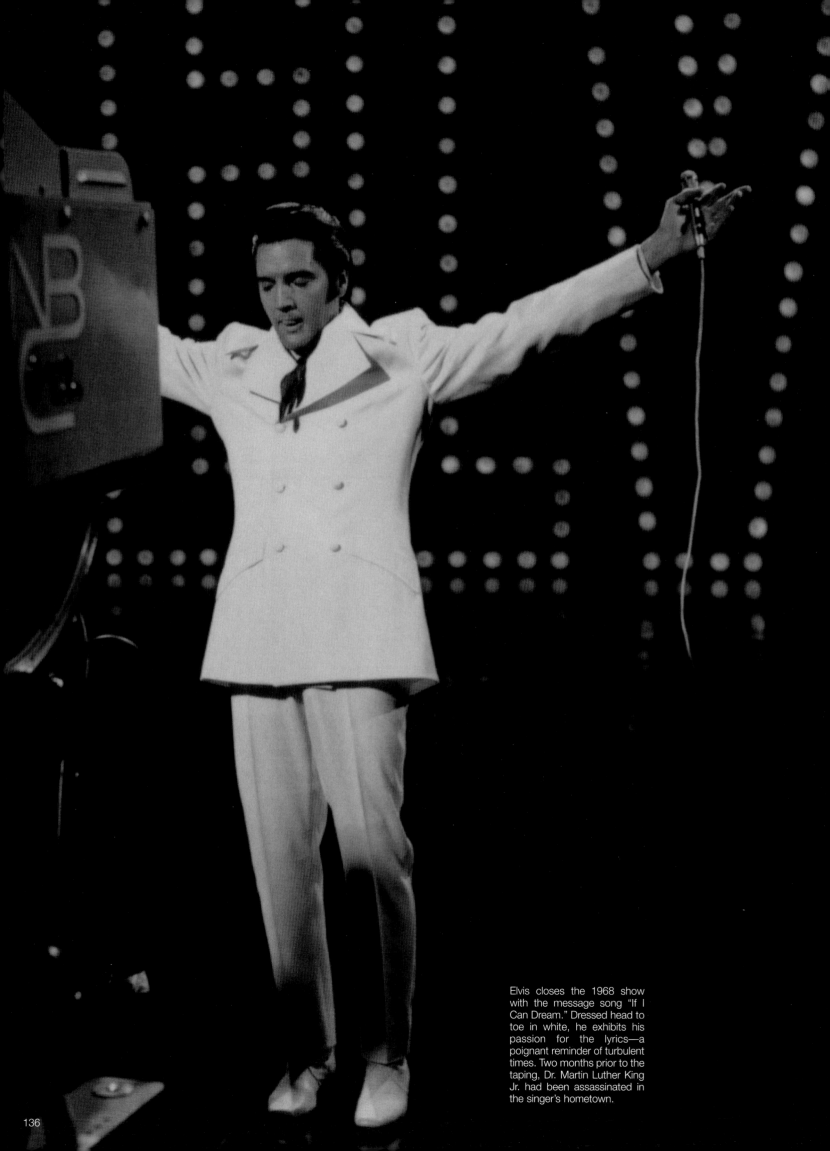

Elvis closes the 1968 show with the message song "If I Can Dream." Dressed head to toe in white, he exhibits his passion for the lyrics—a poignant reminder of turbulent times. Two months prior to the taping, Dr. Martin Luther King Jr. had been assassinated in the singer's hometown.

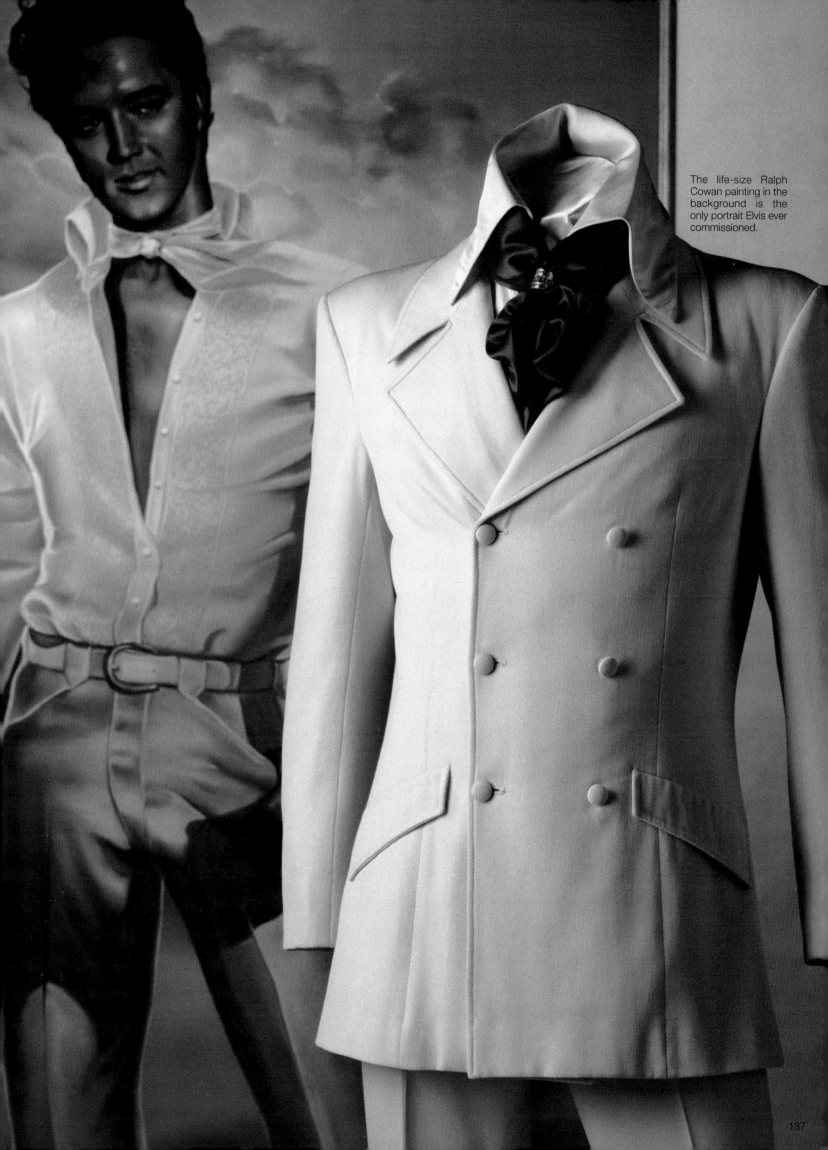

The life-size Ralph Cowan painting in the background is the only portrait Elvis ever commissioned.

137

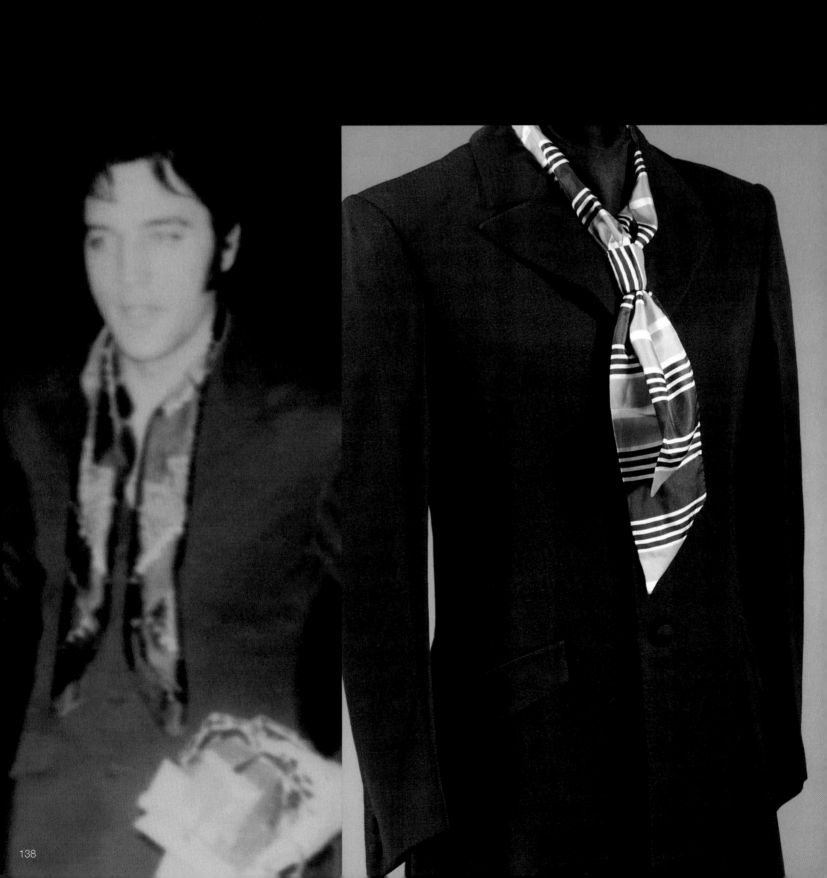

138

ed jacket is one of many created by Bill Belew similar in design to the jackets worn in the club sequence and performance of "If I Can Dream" on the '68 Special. The wide lapels would soon evolve to include the high Napoleonic collars that were a signature look of the 1970s.

Elvis' costumes from the '68 Special were later considered by RCA for inclusion in the Worldwide Gold Award Hits series, which included swatches of material from Elvis' own wardrobe. Seeing the clothes destined for destruction, Elvis' friend Mike McGregor, a master leather craftsman, advised Vernon Presley to save the black leather suit. The white suit worn at the close of the show was also spared and given to McGregor as a gift.

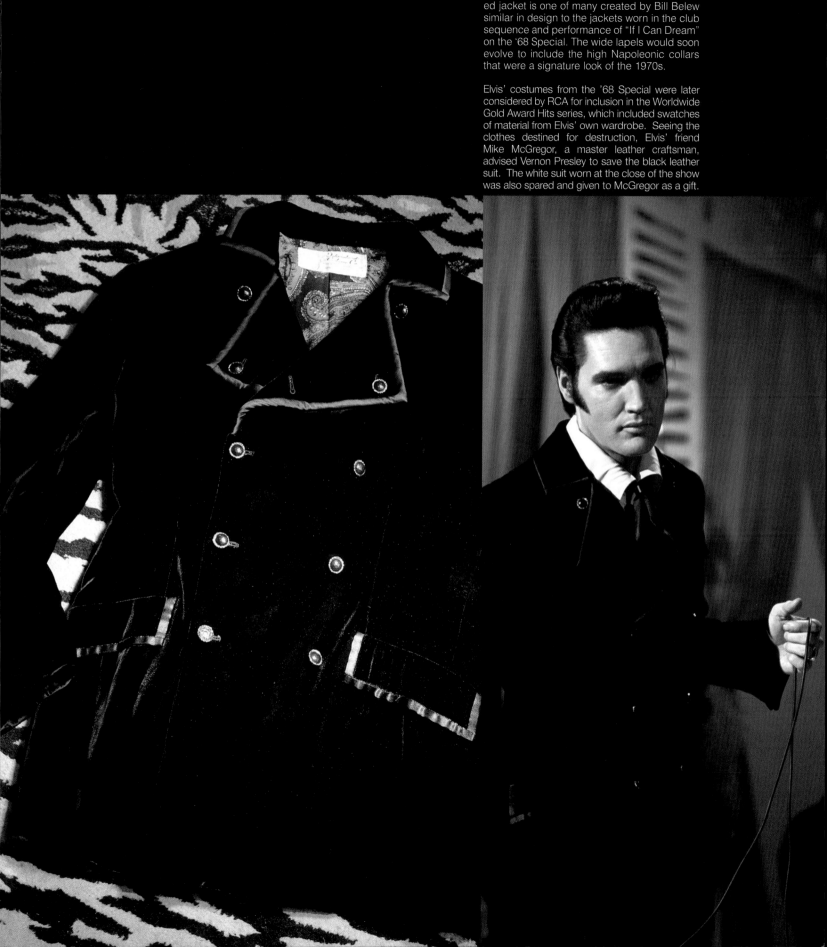

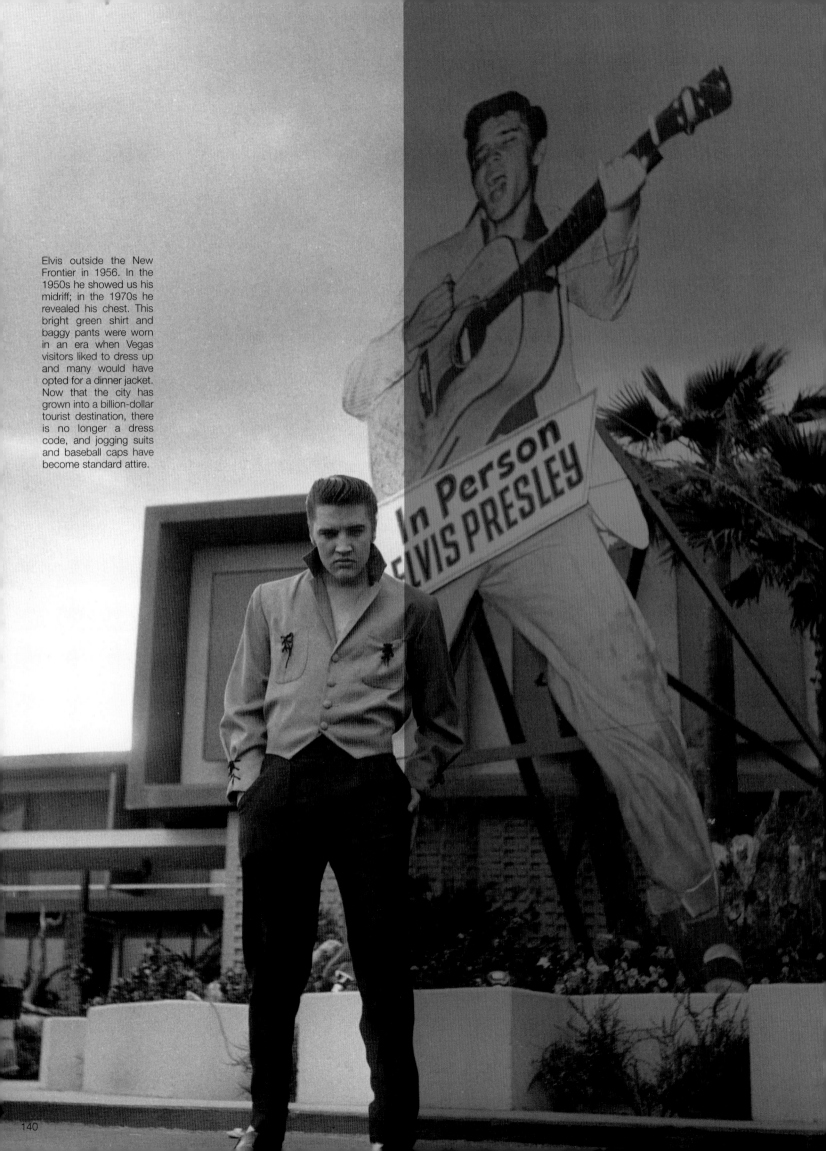

Elvis outside the New Frontier in 1956. In the 1950s he showed us his midriff; in the 1970s he revealed his chest. This bright green shirt and baggy pants were worn in an era when Vegas visitors liked to dress up and many would have opted for a dinner jacket. Now that the city has grown into a billion-dollar tourist destination, there is no longer a dress code, and jogging suits and baseball caps have become standard attire.

Las Vegas in the 1950s was a fashionable new resort, with breathtaking architecture, ostentatious design, glamorous showgirls, and distinguished headliners: a glittering desert playground far removed from the collection of dude ranches and gyp joints that had occupied the area in previous decades.

In 1956 one of the hottest properties on the burgeoning Las Vegas strip was the remodeled New Frontier Hotel. Its design encompassed everything from the atomic era—with planets and flying saucers decorating the Cloud Nine dining room and celestial chandeliers hovering over the casino—to kitsch pink-and-white leather sofas on black and white marble floors. Elvis would have fit in perfectly, but even Vegas was unprepared for the Atomic Powered Singer.

Elvis Presley made his debut at the New Frontier's futuristic new showroom, the Venus Room, on April 23, 1956. Dressing up his sports jacket with a bow tie, Elvis' performance did little to shake, rattle, or roll the stuffy Las Vegas clientele, who soon turned back to their dice games. After his two week engagement, Elvis returned to his appreciative teenage flock, and it would be another thirteen years before he played Las Vegas again. On his return, he would break every attendance record in the city's history.

In 1969 Elvis stepped back into the Nevada spotlight. This time it was at the International Hotel, Kirk Kerkorian's new thirty-story, $80 million super-resort, which dwarfed its low-rise strip competitors. Designed by Martin Stern Jr., the International was the largest hotel in the world at the time. Its magnificent three-sided form boasted 1,519 rooms; a 30,000-square-foot casino; and the 2,000-capacity Showroom Internationale—the largest in the city, filled, on that hot July evening, with a Hollywood guest list that only Elvis Presley could entertain.

Booked for a four-week, fifty-seven-show engagement, Elvis presented his new image in Las Vegas. No pink sports coat or tuxedo; he simply wore a two-piece suit based on a karate *gi*, the forerunner of the jumpsuit. "Elvis was very much into karate," road manager Joe Esposito says, "and that's where he came up with the idea of the karate suits, but he kept tearing the pants out. That's why we went for the jumpsuits so they wouldn't drop down when he was onstage moving."

In charge of his wardrobe at the time was friend and entourage member Richard Davis. "When we were out in Vegas," Davis recalls, "we would be there for a month doing two shows a night, so I would get some outfits, put them on a rack, and let him pick out what he wanted to wear that night. I'd also keep a back-up onstage behind the curtains in case something happened to the one he was wearing. He often tore out the seat of his pants doing a squat or a karate kick or something, so he would just walk over to the end of the stage and I would take the curtain, pull it around him so nobody could see, then he would change—right there, onstage while he was still singing and never miss a note."

Elvis' stage costumes were designed by Bill Belew—sleek white jumpsuits, some with embroidered or fringed lapels, while others were accessorized with beads, chains, or silver conchas framing the collar, lapels, and running down the pant seam and arms. Making their first appearance in 1970, many of these suits were featured in the MGM movie *Elvis: That's the Way It Is,* which documented the singer's phenomenal success in Las Vegas. According to Belew, "The only thing that came to my mind was that I didn't want him to be the typical Las Vegas showperson, like Liberace. So I sculpted the clothes to enhance his performance."

Over the years, Bob Mackie, the award-winning designer famous for creating costumes for Cher, was also credited with Elvis' wardrobe, particularly the white jumpsuit, but the claim is incorrect. The pair never so much as met, and Elvis remained loyal to Bill Belew. "Where I had my embroidery done, they were always working on a new Elvis outfit," Mackie remembers. "It was a strong look for the time, and all the men in nightclub acts were wearing these jumpsuits, but Bill took the look, put it on Elvis, and it became him—it doesn't belong to anyone now except for Elvis."

Breaking box-office records throughout the city, Elvis returned to Las Vegas twice a year for a series of engagements that would continue until 1976. Although decades have passed, in this ever-changing city, Elvis' luminous onstage image is still promoted today. Elvis' conquest of the city gave him all the encouragement he needed. He had exorcised the ghosts from 1956, and America was calling. It was time to take his show back on the road.

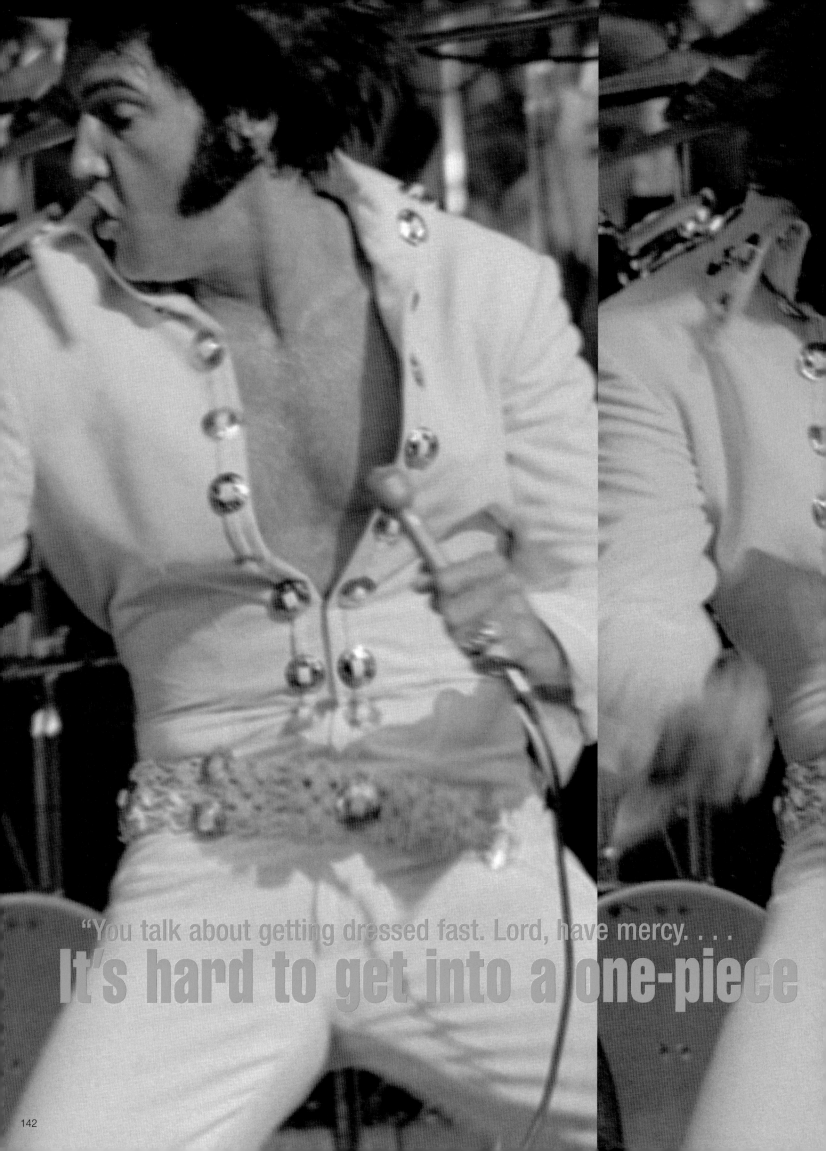

"You talk about getting dressed fast. Lord, have mercy. . . .
It's hard to get into a one-piece

suit without hurting yourself."

—Elvis Presley

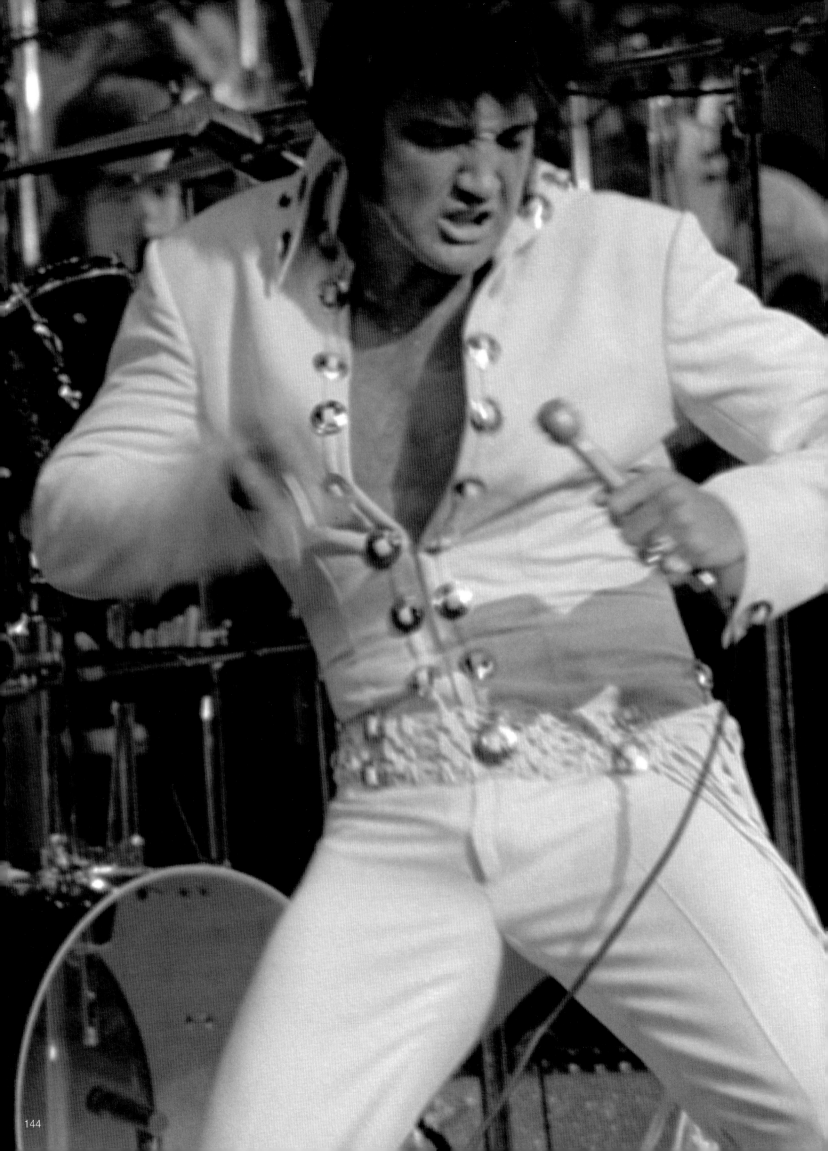

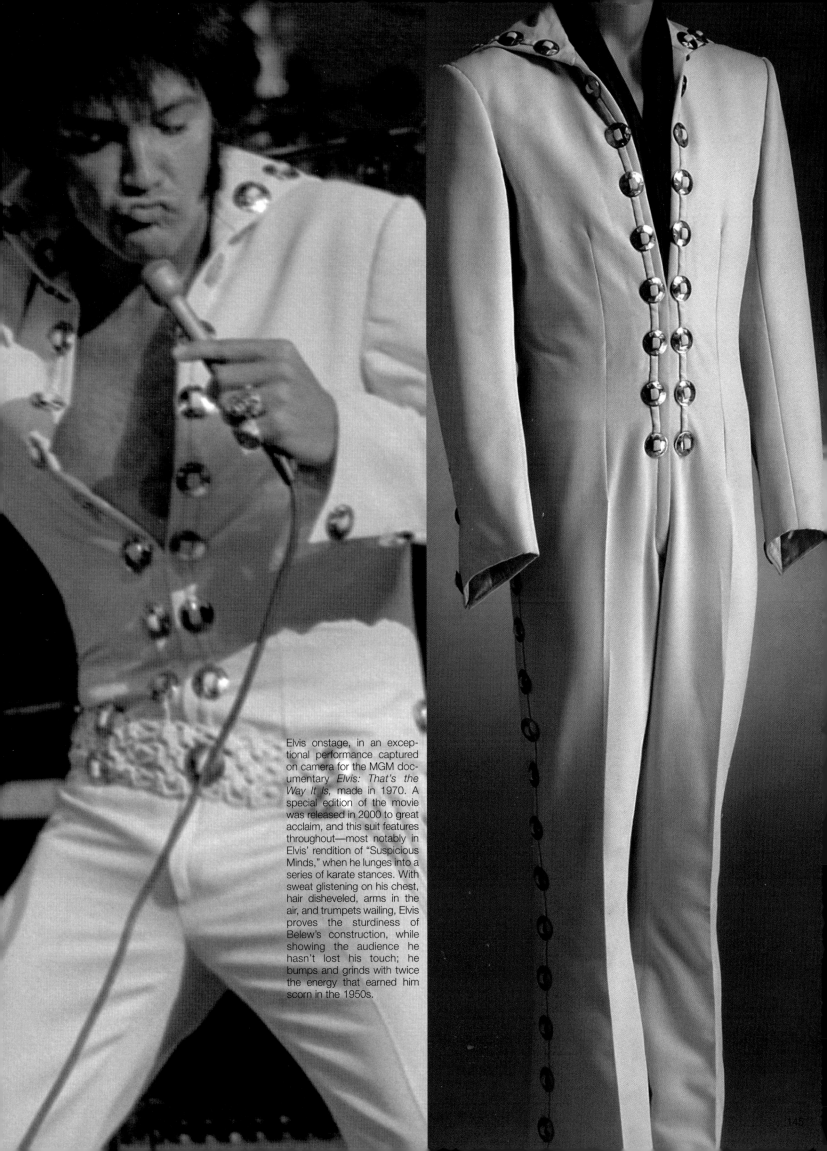

Elvis onstage, in an exceptional performance captured on camera for the MGM documentary *Elvis: That's the Way It Is*, made in 1970. A special edition of the movie was released in 2000 to great acclaim, and this suit features throughout—most notably in Elvis' rendition of "Suspicious Minds," when he lunges into a series of karate stances. With sweat glistening on his chest, hair disheveled, arms in the air, and trumpets wailing, Elvis proves the sturdiness of Belew's construction, while showing the audience he hasn't lost his touch; he bumps and grinds with twice the energy that earned him scorn in the 1950s.

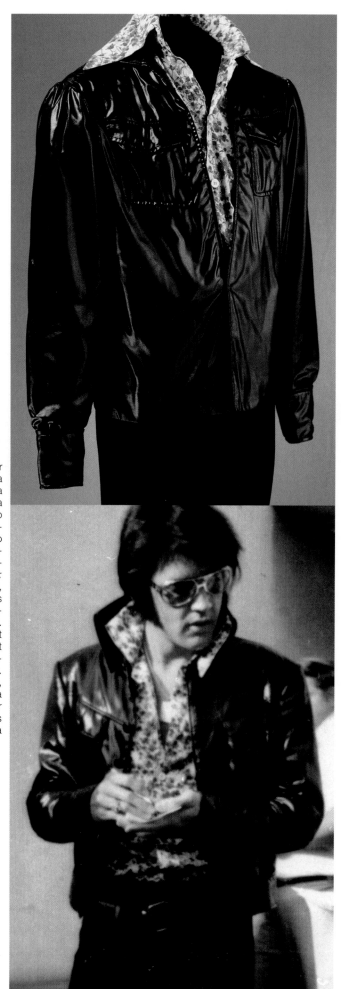

Signing autographs for fans, Elvis is wearing a puff-sleeved shirt in a flower design under a black jacket, which also forms part of a two-piece suit with pants to match. The original outfit can be seen in the re-edited version of *Elvis: That's the Way It Is*, when he receives his celebrity guests backstage in Las Vegas. Elvis greets Cary Grant exclaiming, "I made it back, man!" before talking to Sammy Davis Jr. Friends since the 1950s, Elvis and Sammy had a mutual admiration for each other's careers and certainly shared a taste in wild tailoring.

It's hard to imagine a grown man slim enough to fit into this outfit, designed by Bill Belew for Elvis' opening night. After his first performance on July 31, 1969, Elvis wore this suit to greet the press in Las Vegas. Its sleek finish includes a false pocket design on the front seams embroidered with arrowheads, similar in style to the pockets of Western shirts.

This costume was worn during the first of six shows at the Houston Astrodome in February 1970. Bill Belew created two other variations of this style: a blue suit worn in Houston the following day, and a black version with gold-embroidered lapels. The latter is reminiscent of a costume first used by dancers on the 1968 television special. Elvis also wore these in Las Vegas and Lake Tahoe, where he performed a regular series of engagements at the Sahara Hotel.

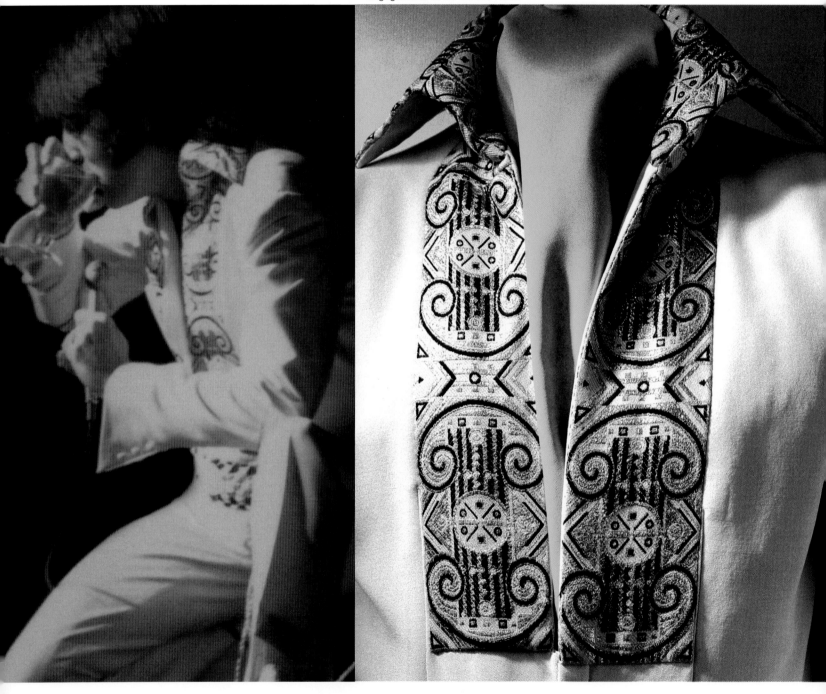

Featured in the 1970 movie *Elvis: That's the Way It Is*, this combination of red puff-sleeved shirt with pinstriped pants was worn with a red leather and suede belt decorated with brass grommets and lions' heads linked by chains.

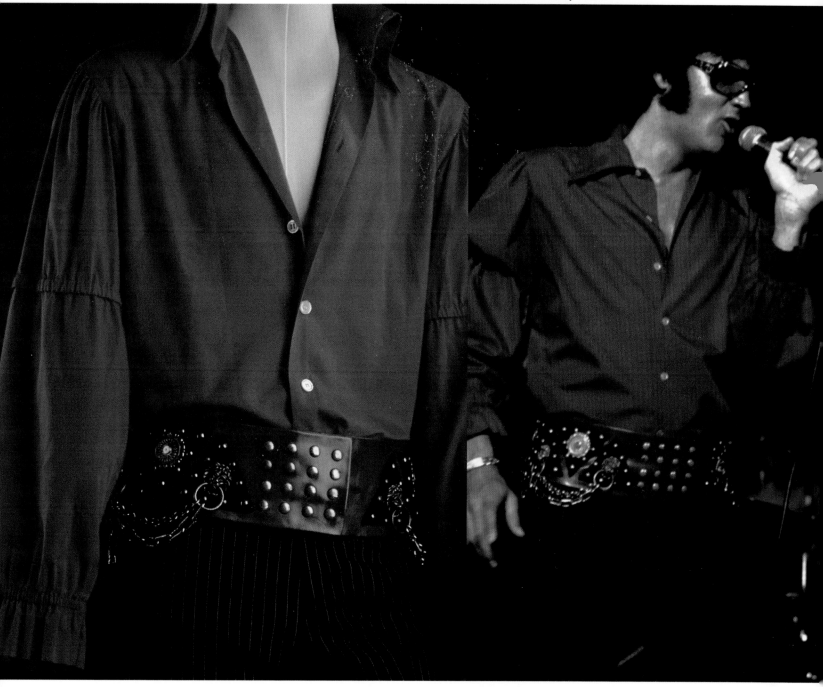

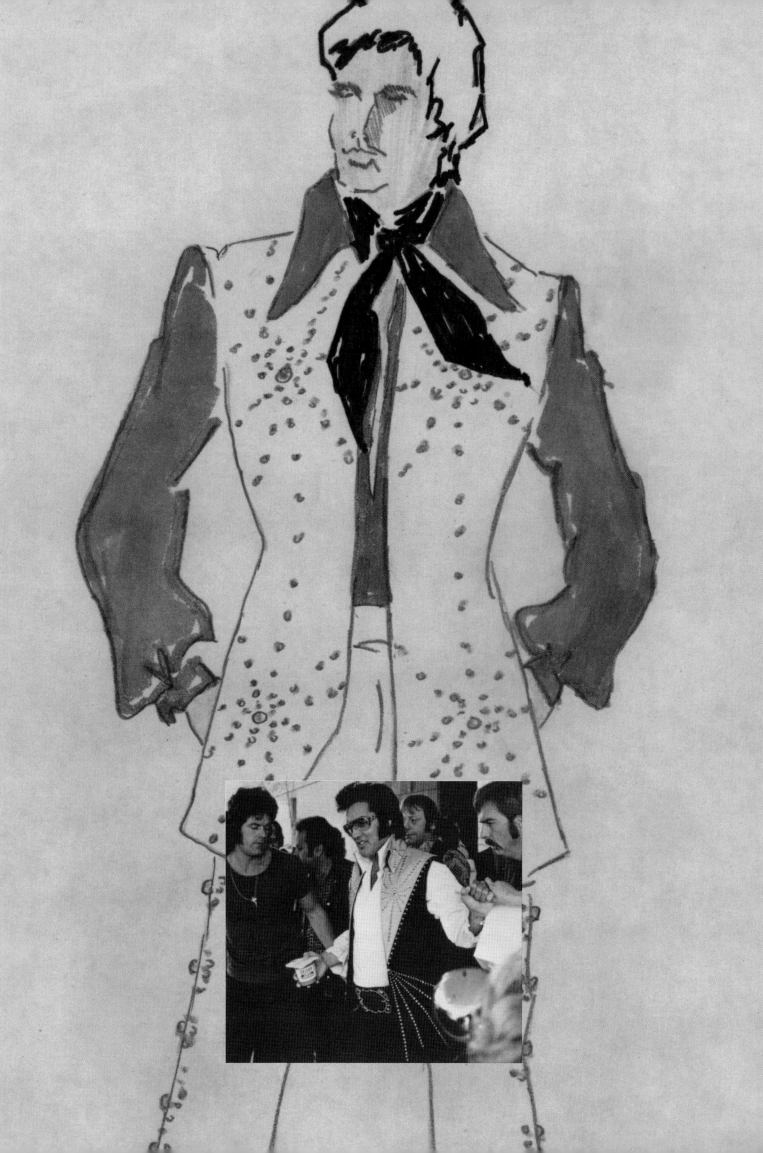

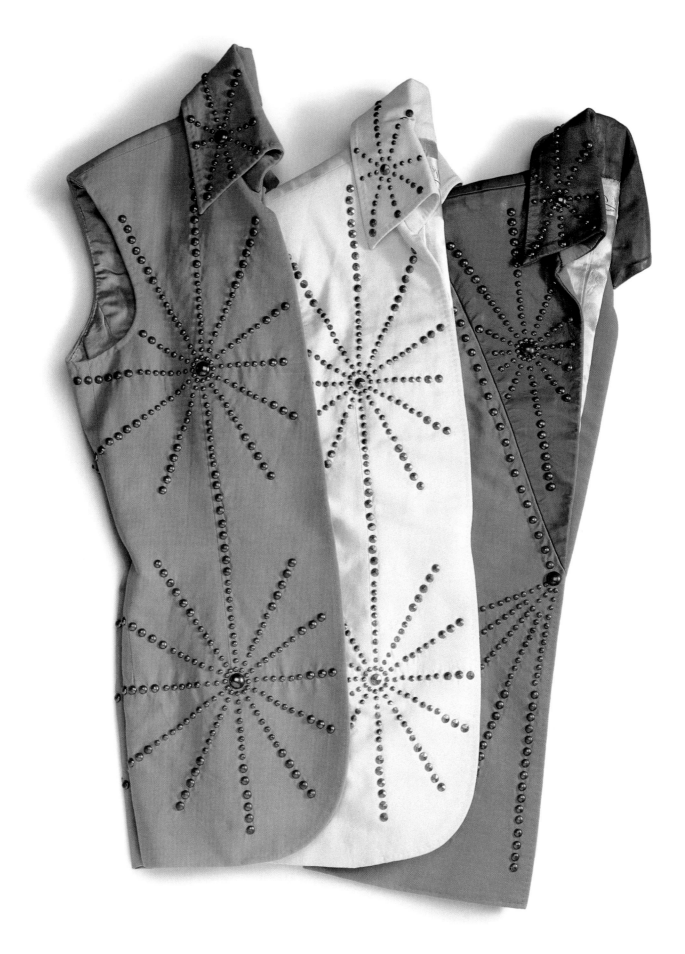

Fans would often nickname items in Elvis' wardrobe and this particular design—which made its first appearance in 1971—became affectionately known as the "Cisco Kid." Twenty years later, Elvis' variations of the Cisco Kid included black jumpsuits with a blue, green, or red leather yoke, and two-piece stage suits, including jackets and vests with the starburst motif. As Elvis' stagewear evolved, some of these items were moved to his personal wardrobe, which also included shirts with the same design.

"ELVIS HAD A GREAT BODY TO DESIGN FOR"

I'VE ALWAYS SAID THAT BOB MACKIE HAD CHER AND I HAD ELVIS.
—Bill Belew

From the sharp suited to the hippie movement, the 1960s were restless. At the end of the decade, fashion once boosted by the "spend, spend, spend" ethos of postwar prosperity now reflected the social unrest of the nation. The 1970s would bring more contrast: anti-fashion, the punk movement, and the flamboyant era of glam rock.

In this, the last decade of his life, Elvis is remembered for his showmanship. Luminous stage costumes, flashy jewelry, and swirling capes—not as shocking, or effeminate, as other glam rock incarnations, but magnificent in design. Elvis' place in the hierarchy was unchallenged.

Bill Belew, who started designing for Elvis for his NBC television special in 1968, created these beautiful costumes. "I had done a job for the producers on a special with Petula Clark, then Steve Binder called me. He was looking for fresh talent in Hollywood and, more or less, for people that had come from the East Coast with novel ideas."

These fresh ideas and a new look for Elvis were carried over to Las Vegas the following year when he was booked to play at the International Hotel in a triumphant return to the live stage. For Elvis' engagement Belew devised a stage costume based on a karate *gi* in three colors—black, navy, and white—with a silk scarf.

The following year, Elvis' legendary white jumpsuit made its first appearance. Early designs featured high Napoleonic collars, flared legs, and woven belts matching the design on the suit. They were made by the I.C. Costume Company in wool gabardine. Belew designed new costumes for each Las Vegas or touring season, and to ease identification fans gave them nicknames—the Adonis suit, the Mad Tiger, the King of Spades, or simply the Memphis suit (named for the 1974 concert tour that included several performances in Elvis' hometown).

Confident in Belew's designs, the singer also asked him to create his personal wardrobe. "Elvis had an individual style. He had his own style and way he wanted to look. He was always given clothes, but he ended up giving them to his guys. He had a great body, broad shoulders, a forty-two inch chest, and a waist that fluctuated between thirty and thirty-two inches. Everything he bought had to be altered, so I began to design for him."

One feature carried from the stage to Elvis' personal wear was the high collar, which Belew made a staple. Another characteristic feature was the use of brightly patterned silk linings on his suits, many of which matched the equally colorful shirts he wore them with.

Now dividing his time between Los Angeles and a retreat in Palm Springs, Bill Belew reflects fondly on his time designing for Elvis. "Five years ago," he smiles, "there was an article in *Esquire* magazine by Gianni Versace, who said 'The one person I envied was Bill Belew. I would have given anything to design for Elvis.' I wonder what he would have done."

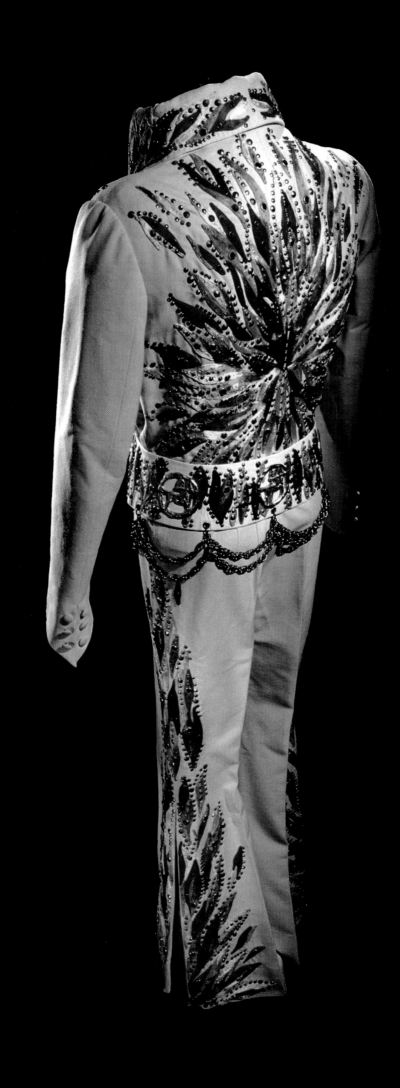

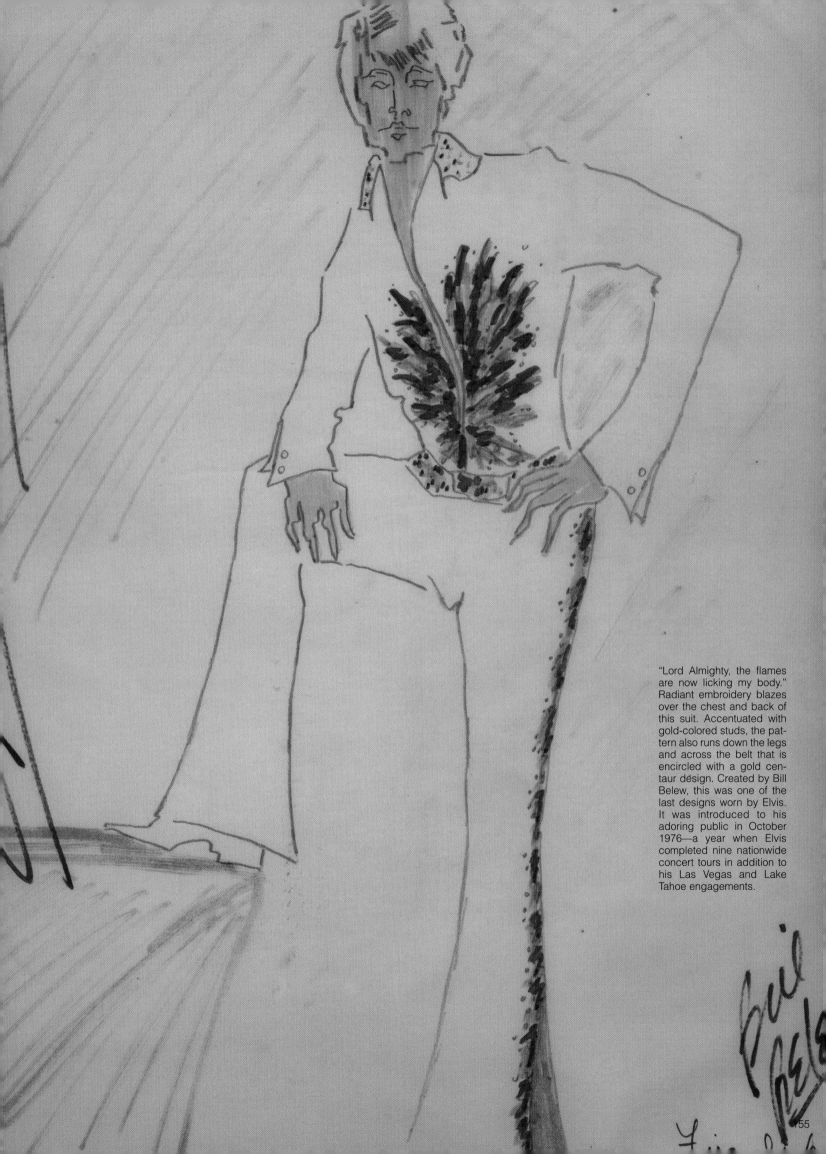

"Lord Almighty, the flames are now licking my body." Radiant embroidery blazes over the chest and back of this suit. Accentuated with gold-colored studs, the pattern also runs down the legs and across the belt that is encircled with a gold centaur design. Created by Bill Belew, this was one of the last designs worn by Elvis. It was introduced to his adoring public in October 1976—a year when Elvis completed nine nationwide concert tours in addition to his Las Vegas and Lake Tahoe engagements.

155

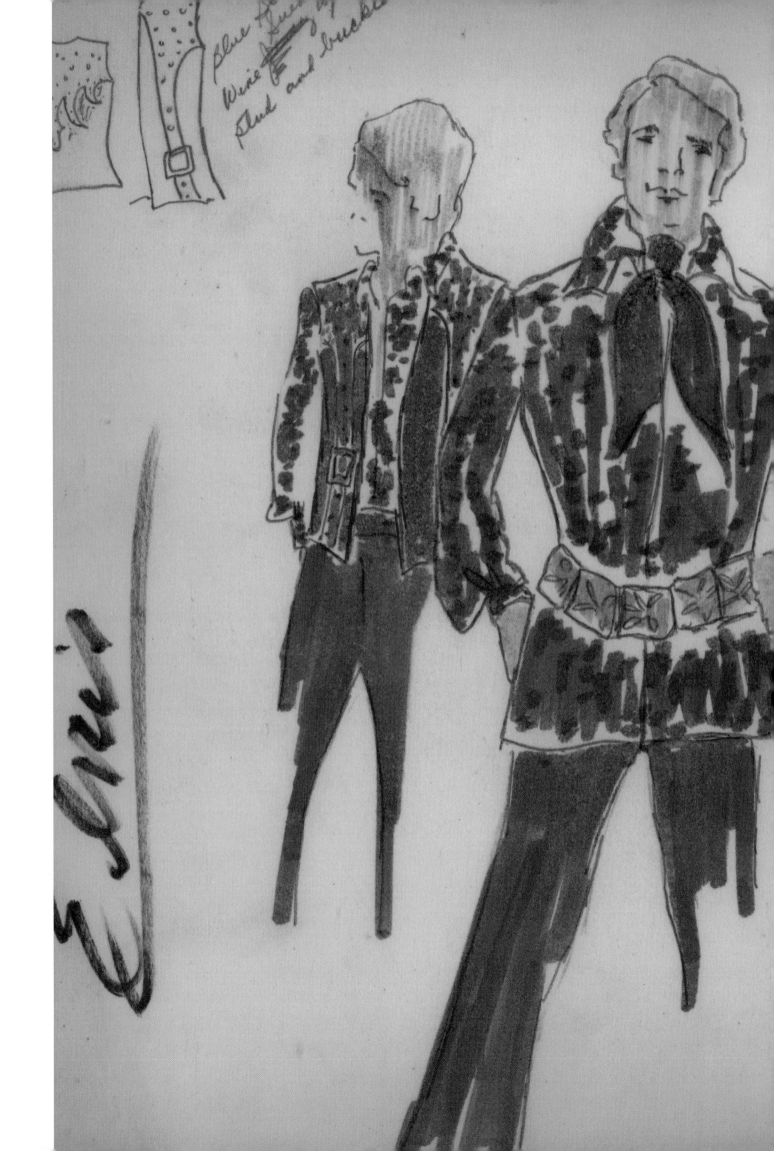

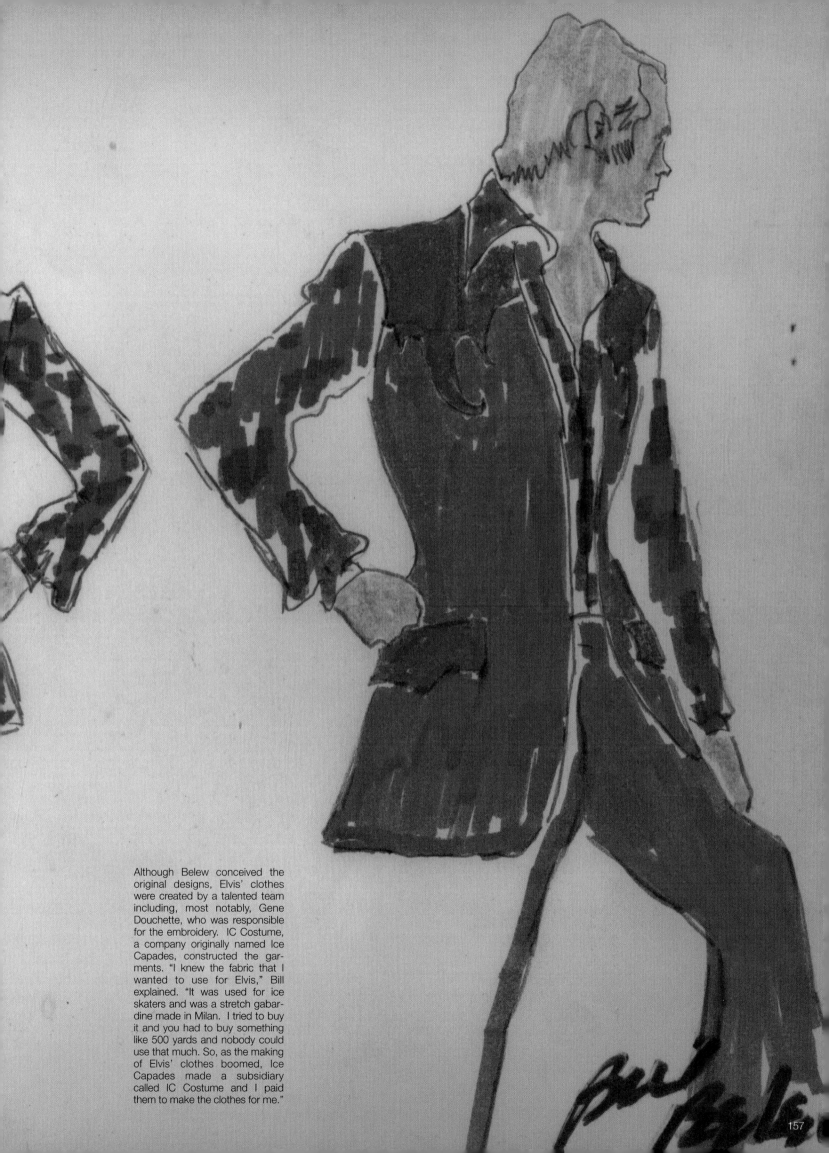

Although Belew conceived the original designs, Elvis' clothes were created by a talented team including, most notably, Gene Douchette, who was responsible for the embroidery. IC Costume, a company originally named Ice Capades, constructed the garments. "I knew the fabric that I wanted to use for Elvis," Bill explained. "It was used for ice skaters and was a stretch gabardine made in Milan. I tried to buy it and you had to buy something like 500 yards and nobody could use that much. So, as the making of Elvis' clothes boomed, Ice Capades made a subsidiary called IC Costume and I paid them to make the clothes for me."

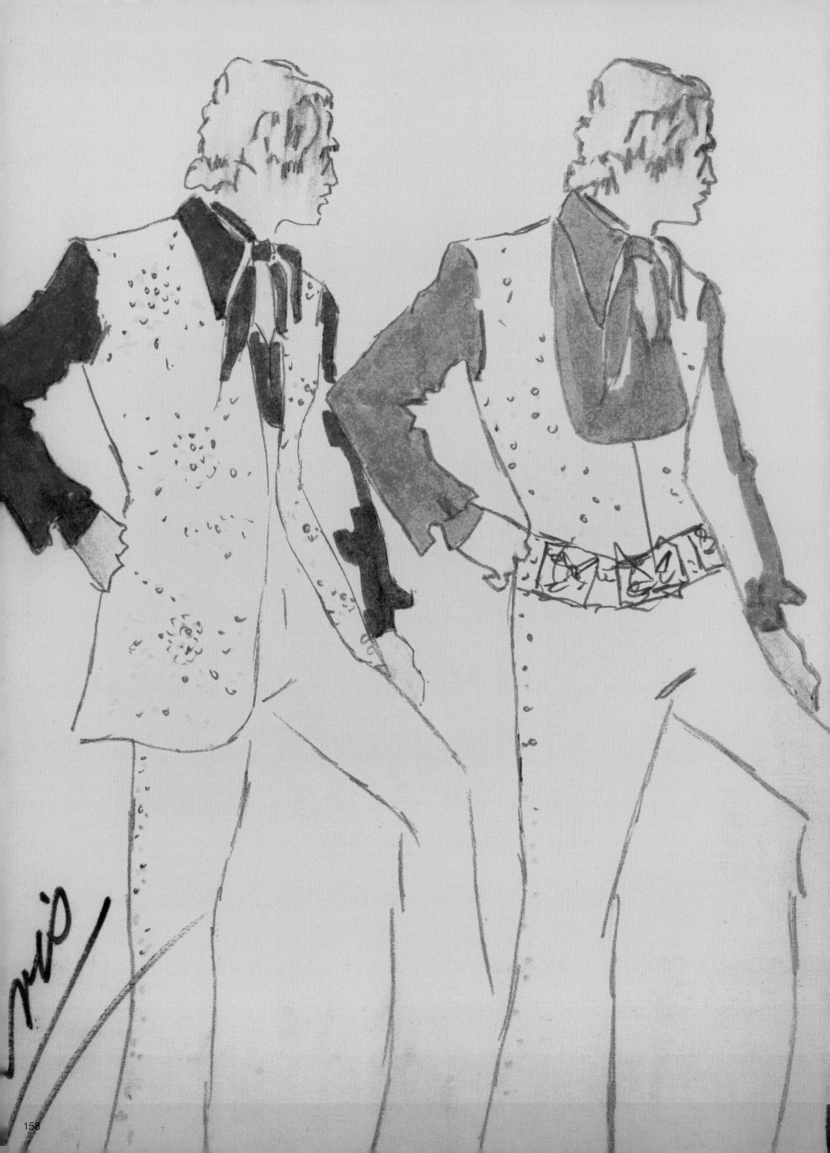

158

158

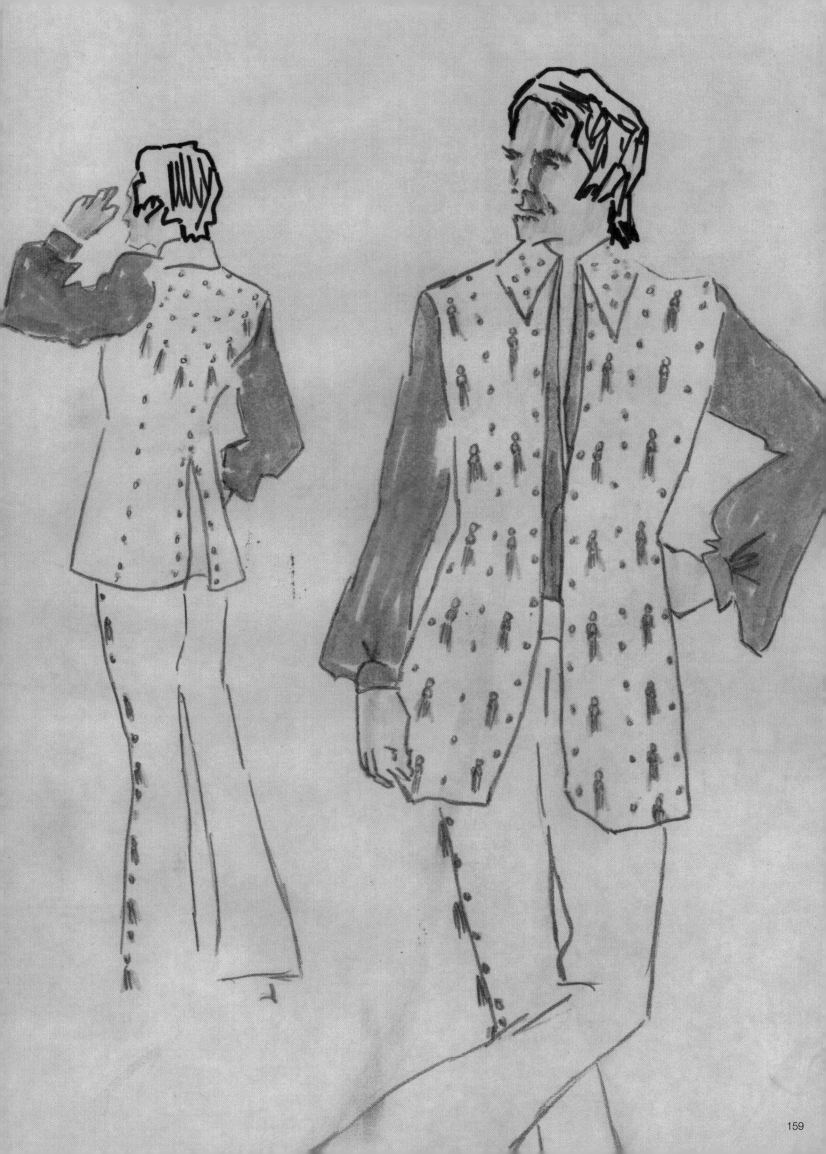

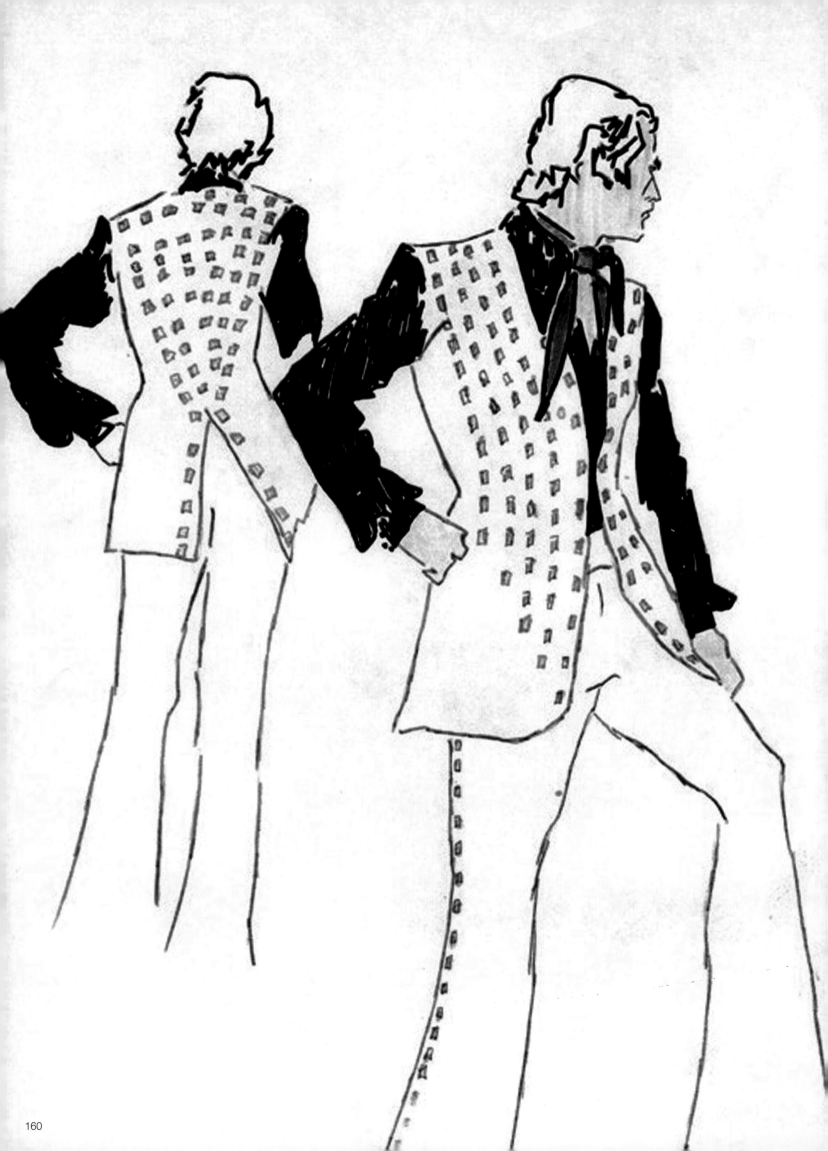

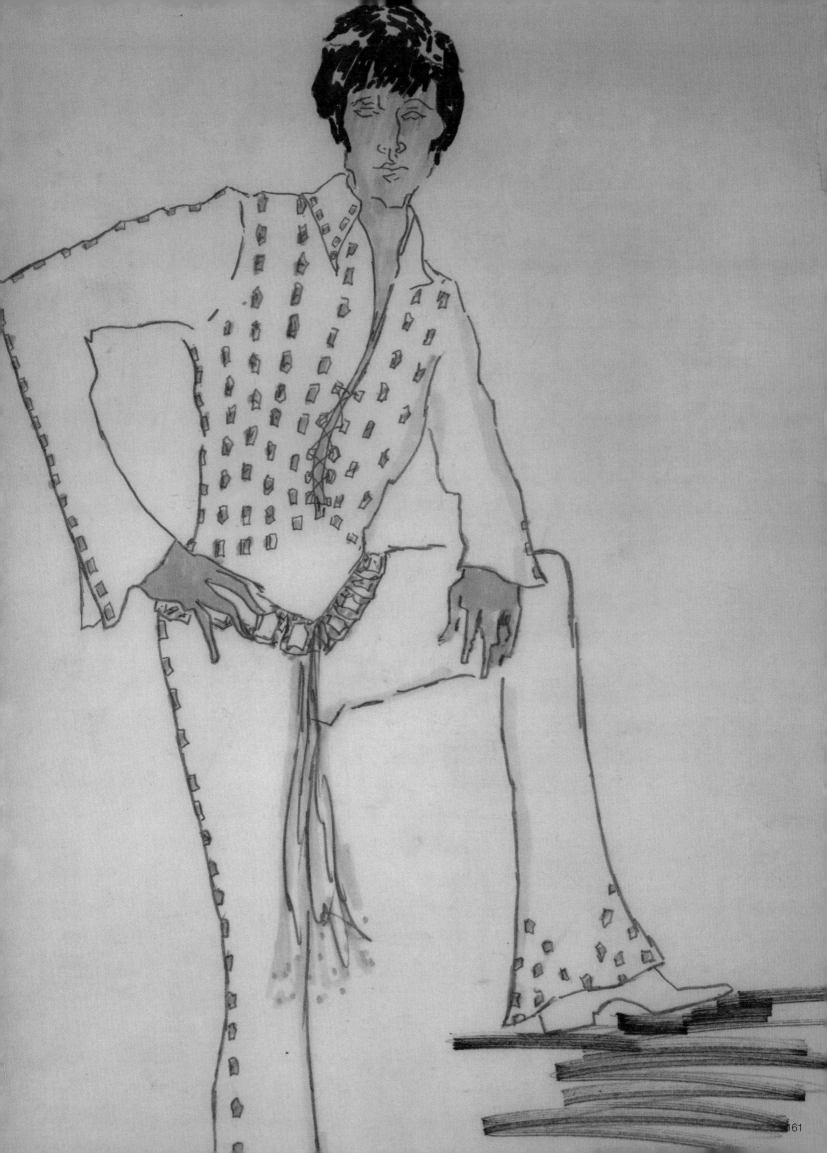

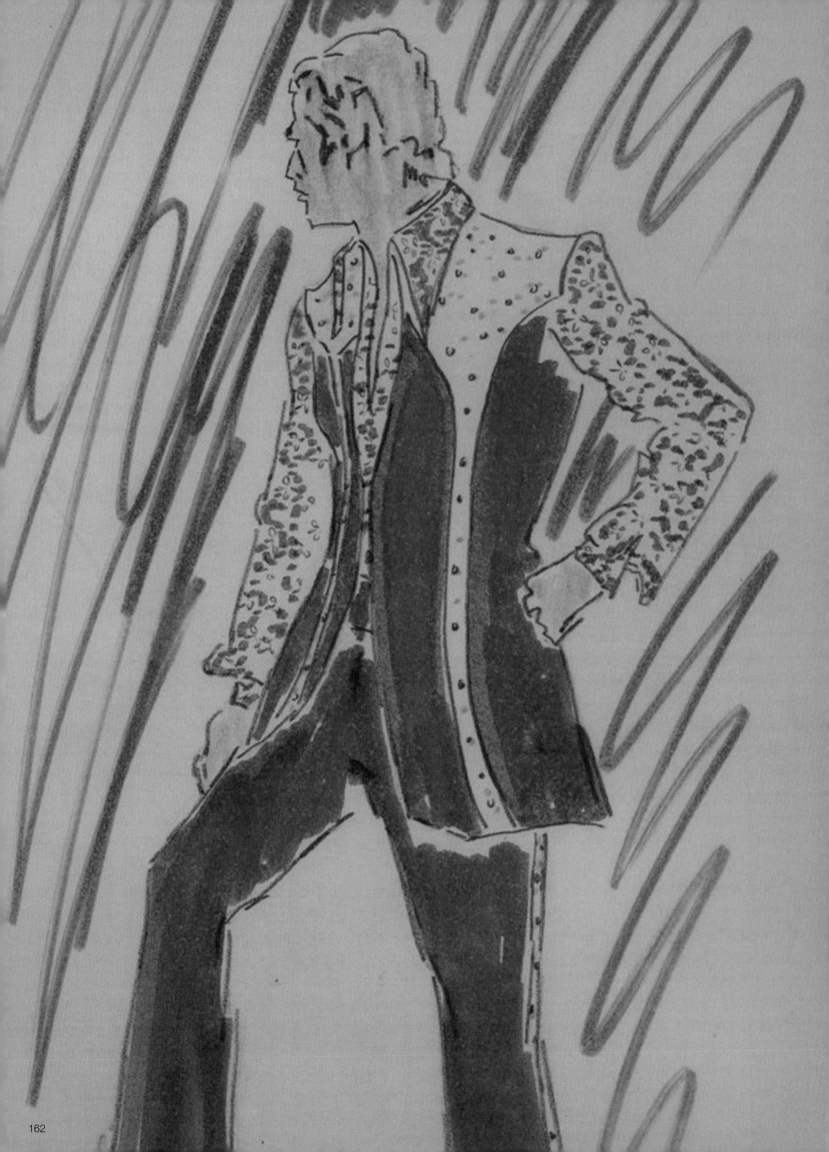

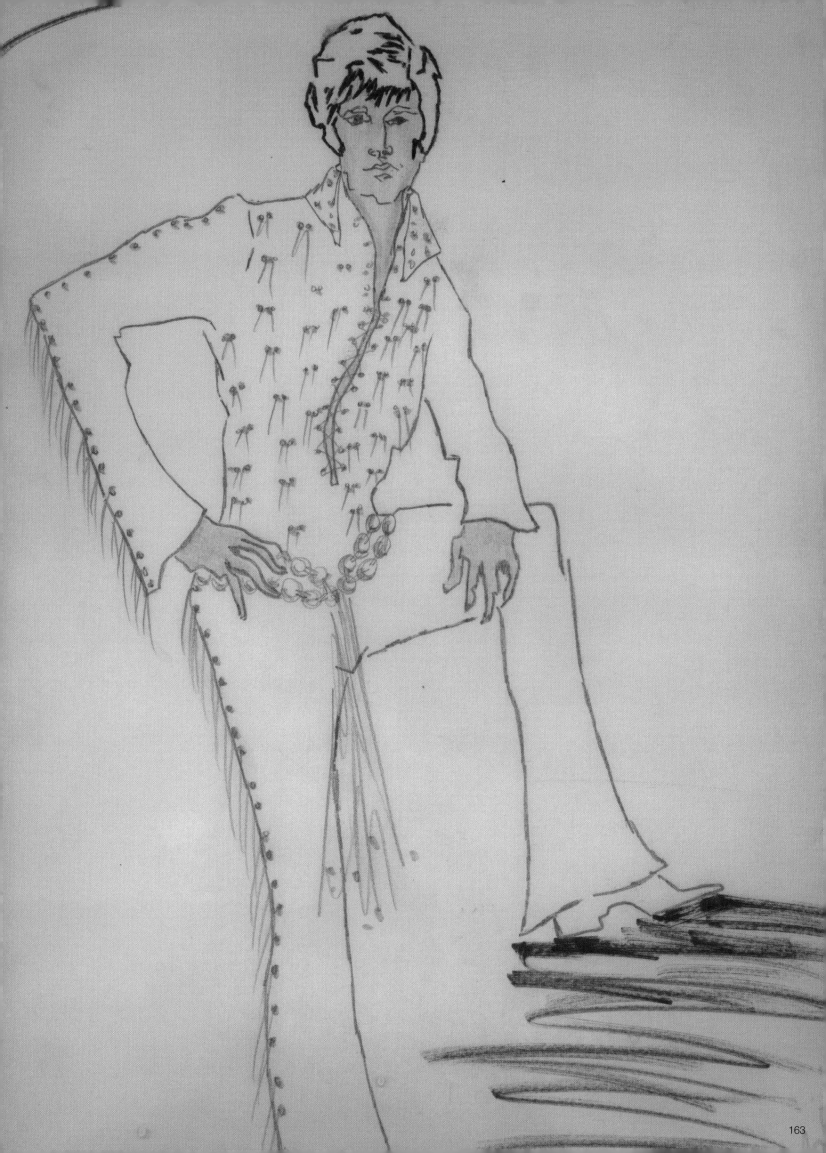

The tour crowds were wilder than in Las Vegas. No showroom etiquette or dinner reservations, just Elvis live onstage for the taking. "He may shake his head more now than the hip bones," the *Detroit News* commented, "but he can still throw a mean bump." Detroit's Olympia Arena was the third date in Elvis' first concert tour since 1957. In just six days he played to more than 90,000 people in a whirlwind blitz across five states. The audience exhausted Elvis and he jokingly laid down on the stage to catch his breath with the fringes of his suit spreading on the floor around him. This may have been his last chance to pause, as more public appearances were demanded of him. Elvis would go on to complete twenty-eight more concert tours—some of which were three or four times the length of this initial run—along with his usual casino engagements and additional calls to perform.

Elvis continued to wear the white jumpsuits worn in Las Vegas until 1971 when the suits began to evolve: fringes grew, studs surfaced, colors intensified, and capes were added for a dramatic effect. "I started out simple," Bill Belew explained, "but the fans really dictated where we went because they demanded more opulent things from Elvis and he was willing to go along with it." Simple macramé belts (which Elvis laughingly referred to as tassels from the curtain of a room at Howard Johnson's) were replaced by heavier ones accessorized with brass studs, chains, and beautiful waistbands that matched the design of the jumpsuit.

His success on the road prompted MGM to commission a second documentary, *Elvis on Tour*, in 1972, which followed Elvis across the United States during his April and June tours of that year. Released in November 1972, *Elvis on Tour*, which captured Elvis at the pinnacle of his performing career, went on to receive the Golden Globe for Best Documentary.

Elvis modeling new jumpsuits in his suite at the Hilton Hotel, formerly the International, in Las Vegas. First making their appearance at the end of 1971, these vibrant suits—with sparking capes lined in gold or silver—were worn in concert over the following year. Decorated with brass details, the pattern is created by diamond shaped ornaments on the red suit and small brass butterflies on the black. The silver decoration on the light blue suit forms a more complicated design fluttered across the body and legs of the costume.

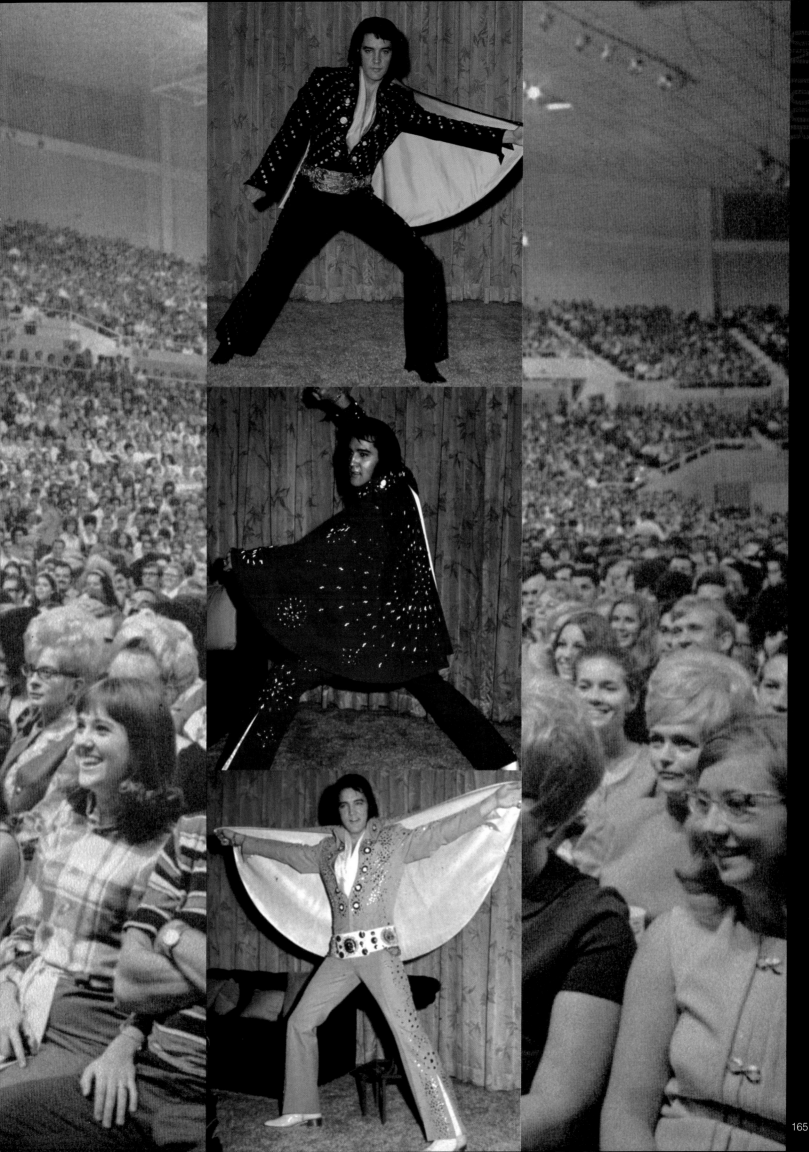

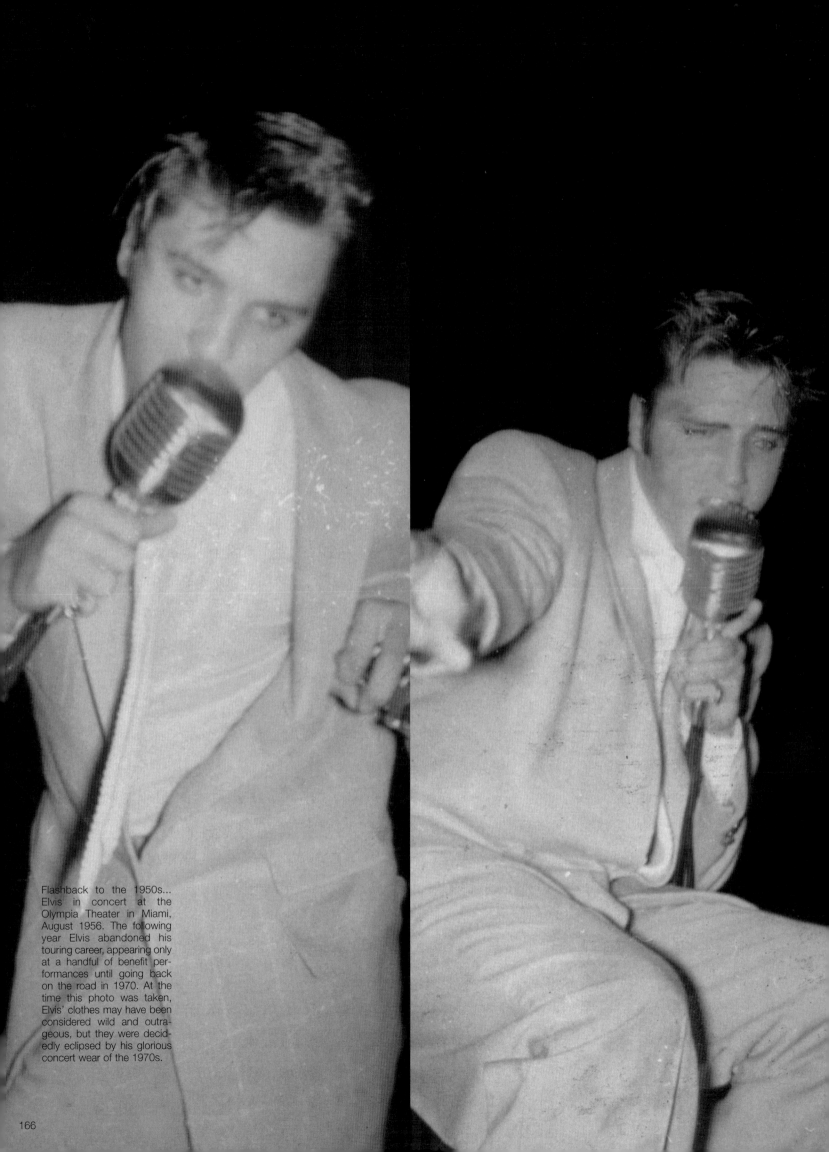

Flashback to the 1950s...
Elvis in concert at the
Olympia Theater in Miami,
August 1956. The following
year Elvis abandoned his
touring career, appearing only
at a handful of benefit per-
formances until going back
on the road in 1970. At the
time this photo was taken,
Elvis' clothes may have been
considered wild and outra-
geous, but they were decid-
edly eclipsed by his glorious
concert wear of the 1970s.

ELVIS
NOV 17 & 18 ARENA
ALL 3 SHOWS
SOLD OUT

Colonel Parker proudly displays another sell-out concert tour in 1972. Elvis' ensemble was the first of his suits to feature a single design radiating across the chest. The complicated arrangements on the arms and legs resemble a circuit board, giving it a futuristic look.

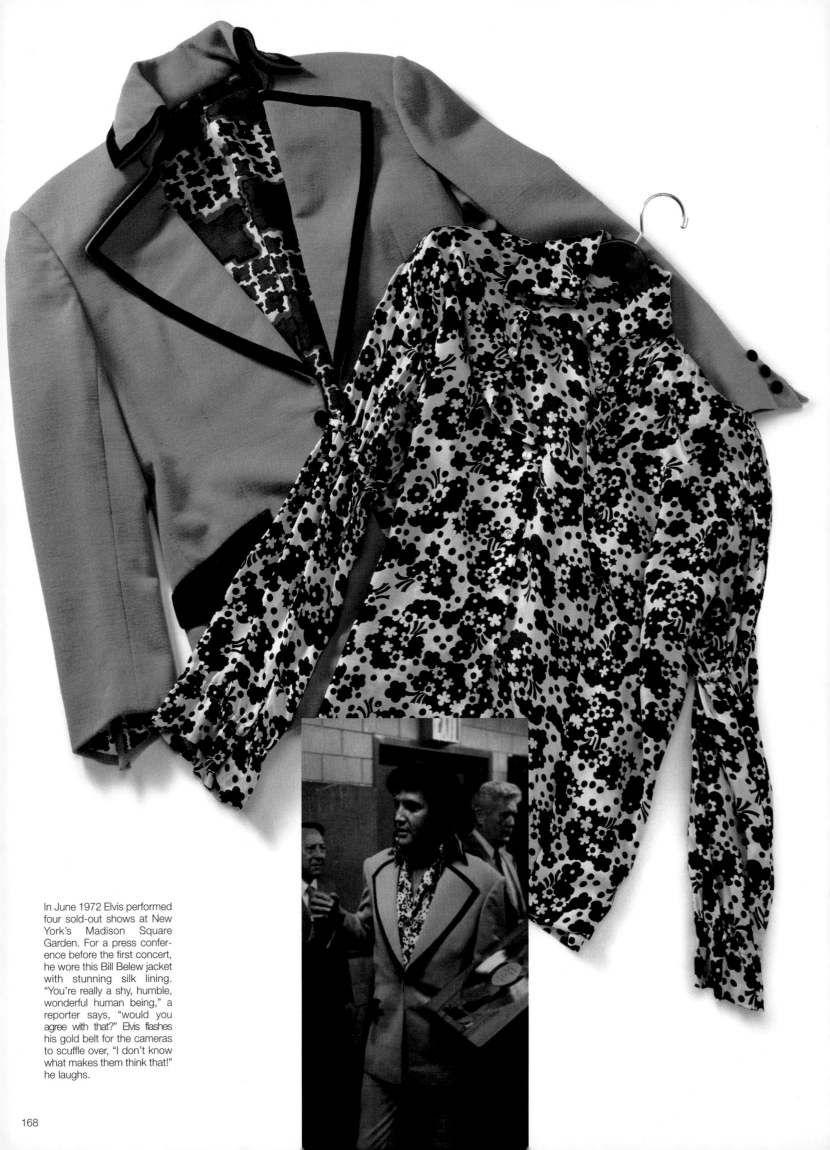

In June 1972 Elvis performed four sold-out shows at New York's Madison Square Garden. For a press conference before the first concert, he wore this Bill Belew jacket with stunning silk lining. "You're really a shy, humble, wonderful human being," a reporter says, "would you agree with that?" Elvis flashes his gold belt for the cameras to scuffle over, "I don't know what makes them think that!" he laughs.

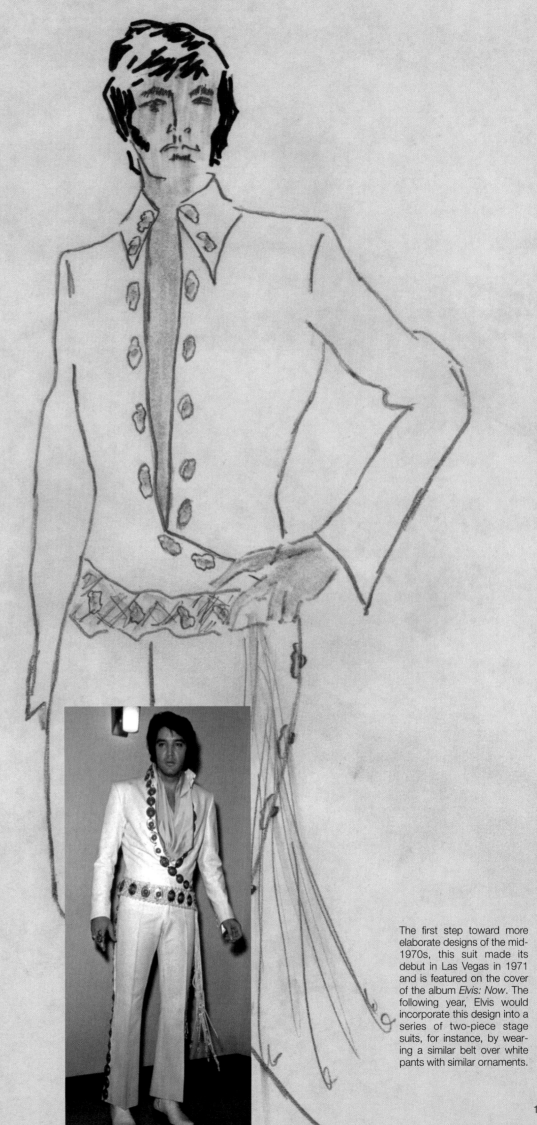

The first step toward more elaborate designs of the mid-1970s, this suit made its debut in Las Vegas in 1971 and is featured on the cover of the album *Elvis: Now*. The following year, Elvis would incorporate this design into a series of two-piece stage suits, for instance, by wearing a similar belt over white pants with similar ornaments.

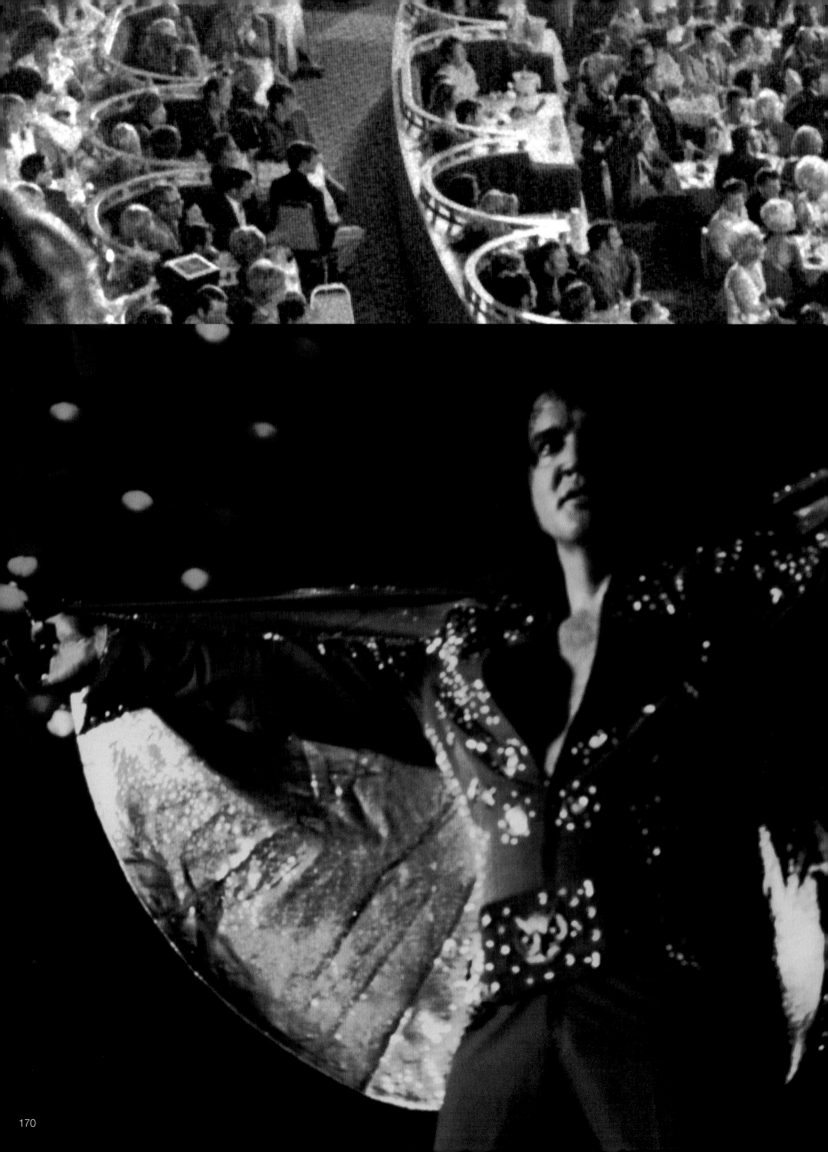

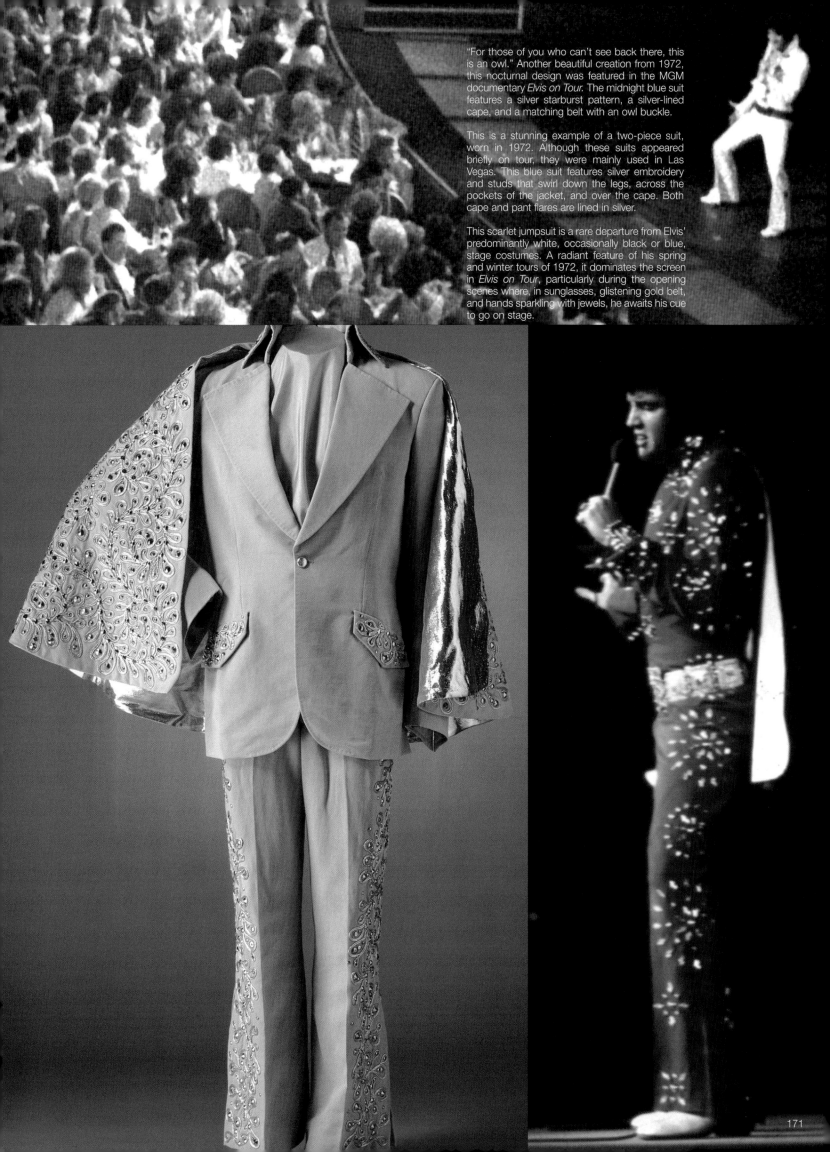

"For those of you who can't see back there, this is an owl." Another beautiful creation from 1972, this nocturnal design was featured in the MGM documentary *Elvis on Tour*. The midnight blue suit features a silver starburst pattern, a silver-lined cape, and a matching belt with an owl buckle.

This is a stunning example of a two-piece suit, worn in 1972. Although these suits appeared briefly on tour, they were mainly used in Las Vegas. This blue suit features silver embroidery and studs that swirl down the legs, across the pockets of the jacket, and over the cape. Both cape and pant flares are lined in silver.

This scarlet jumpsuit is a rare departure from Elvis' predominantly white, occasionally black or blue, stage costumes. A radiant feature of his spring and winter tours of 1972, it dominates the screen in *Elvis on Tour*, particularly during the opening scenes where, in sunglasses, glistening gold belt, and hands sparkling with jewels, he awaits his cue to go on stage.

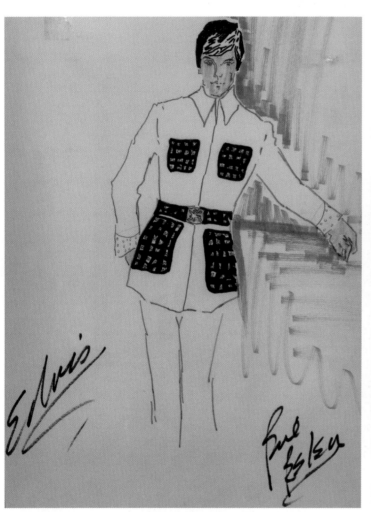

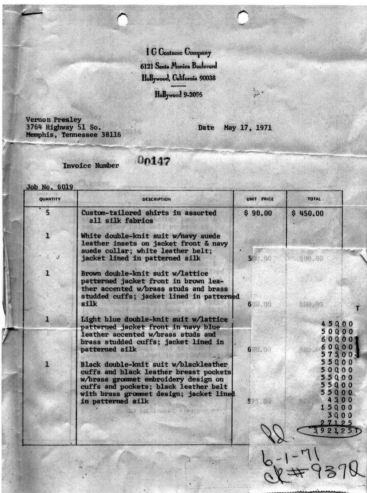

I C Costume Company
6121 Santa Monica Boulevard
Hollywood, California 90038

Hollywood 9-2056

Vernon Presley
3764 Highway 51 So.
Memphis, Tennessee 38116

Date May 17, 1971

Invoice Number 00147

Job No. 6019

QUANTITY	DESCRIPTION	UNIT PRICE	TOTAL
5	Custom-tailored shirts in assorted all silk fabrics	$ 90.00	$ 450.00
1	White double-knit suit w/navy suede leather insets on jacket front & navy suede collar; white leather belt; jacket lined in patterned silk	500.00	500.00
1	Brown double-knit suit w/lattice patterned jacket front in brown leather accented w/brass studs and brass studded cuffs; jacket lined in patterned silk	600.00	600.00
1	Light blue double-knit suit w/lattice patterned jacket front in navy blue leather accented w/brass studs and brass studded cuffs; jacket lined in patterned silk	600.00	600.00
1	Black double-knit suit w/blackleather cuffs and black leather breast pockets w/brass grommet embroidery design on cuffs and pockets; black leather belt with brass grommet design; jacket lined in patterned silk	575.00	575.00

```
       450 00
       500 00
       600 00
       600 00
       575 00
       550 00
       500 00
       550 00
       550 00
       550 00
        45 00
       150 00
        30 00
       271 25
     3921 25
```

6-1-71
ck#9372

Invoice and sketches for personal clothes by Bill Belew.
The light blue jacket, with a lattice pattern overlay, was
featured offstage in the movie *Elvis on Tour* and another
version also exists in brown. The black suit with the leather
cuffs, pictured here, was also worn during the same era.

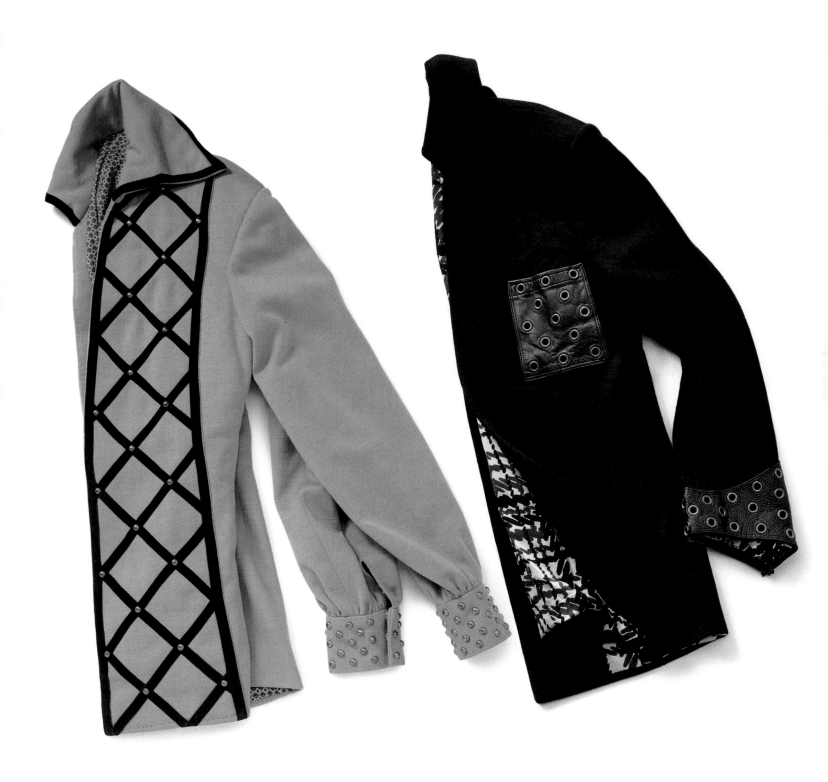

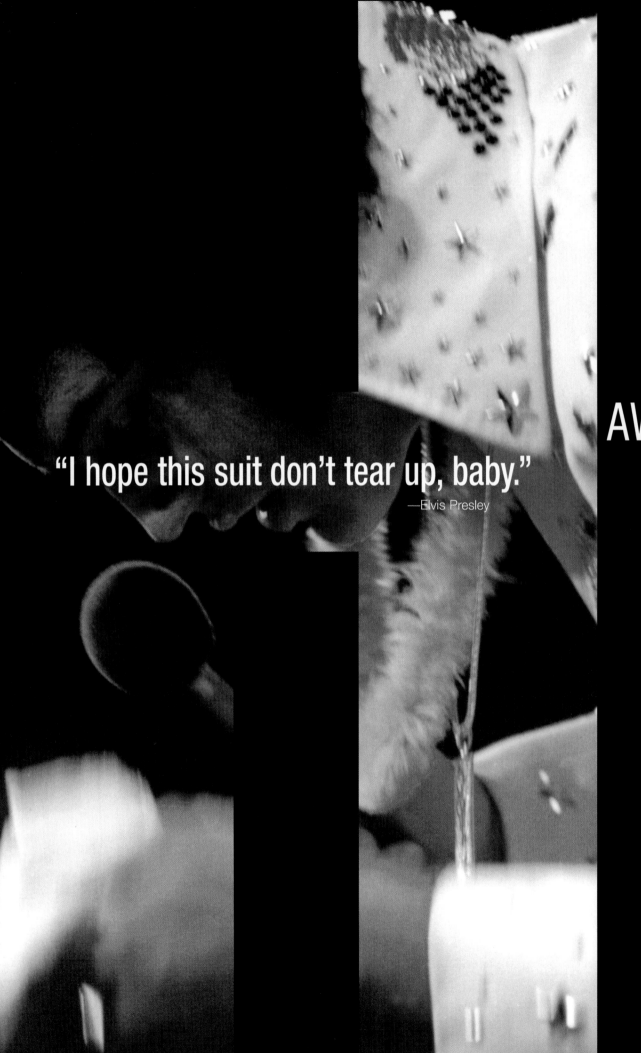

"I hope this suit don't tear up, baby."

—Elvis Presley

AWAI

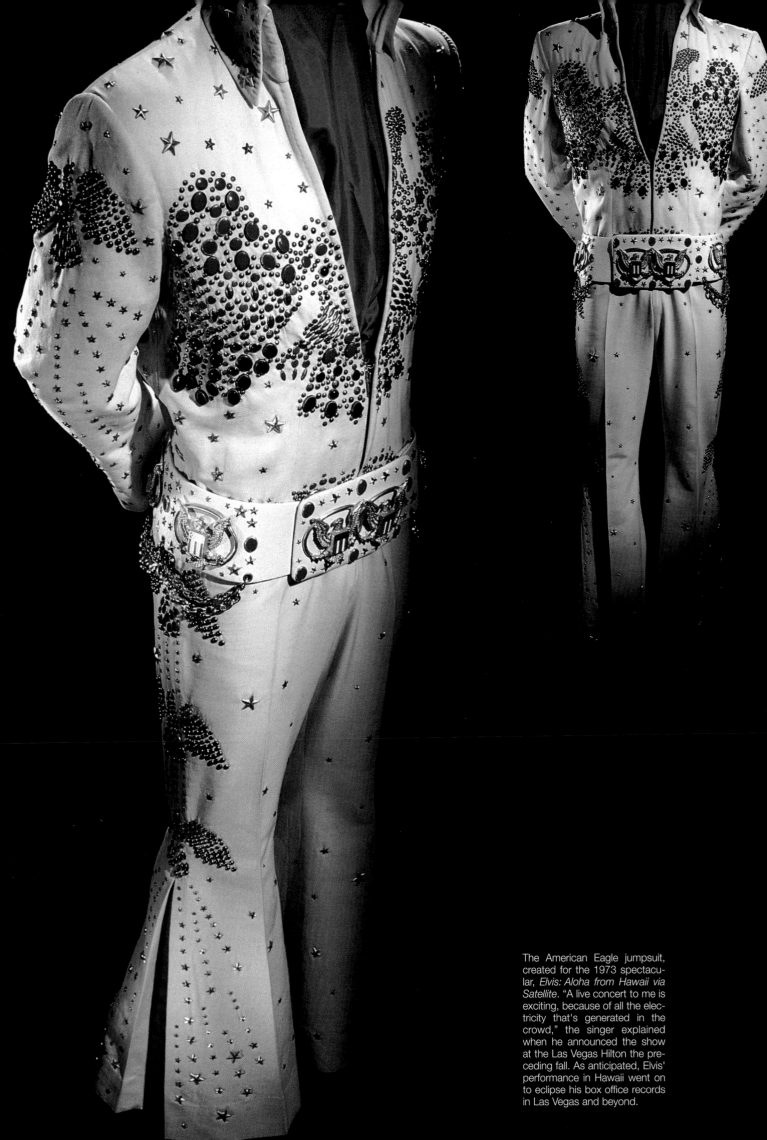

The American Eagle jumpsuit, created for the 1973 spectacular, *Elvis: Aloha from Hawaii via Satellite*. "A live concert to me is exciting, because of all the electricity that's generated in the crowd," the singer explained when he announced the show at the Las Vegas Hilton the preceding fall. As anticipated, Elvis' performance in Hawaii went on to eclipse his box office records in Las Vegas and beyond.

175

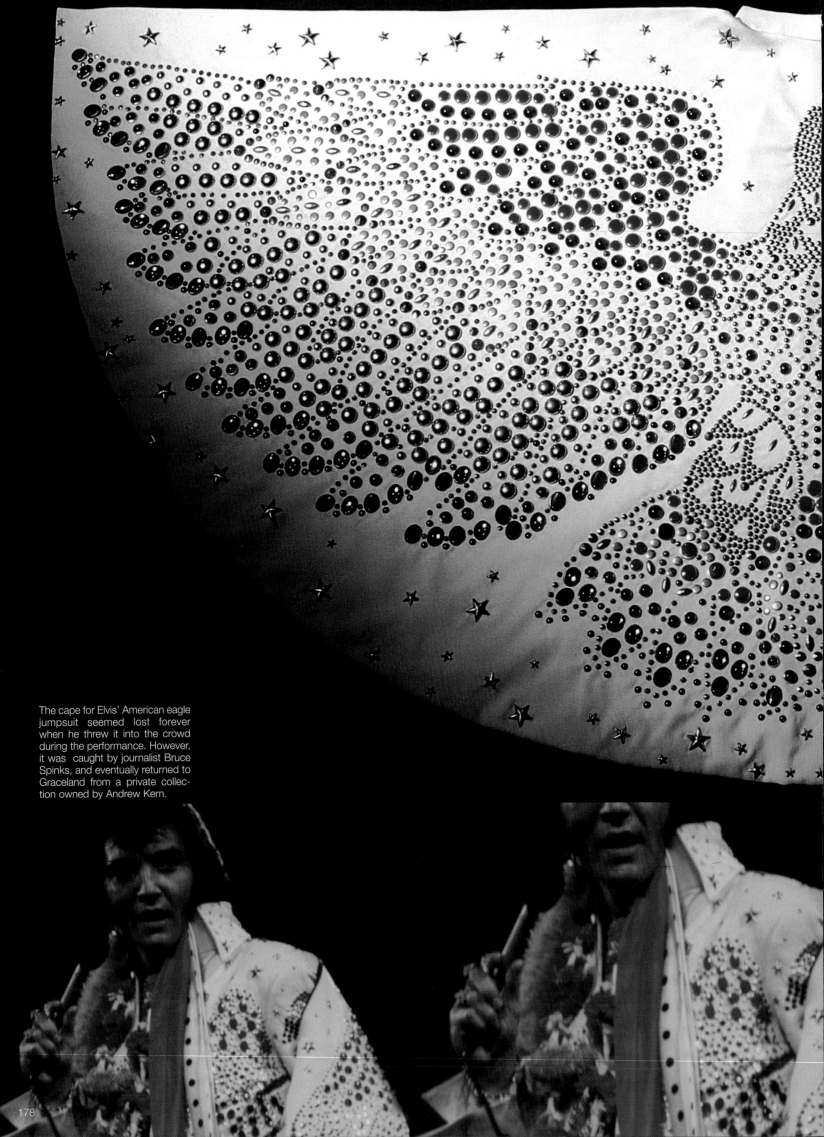

The cape for Elvis' American eagle jumpsuit seemed lost forever when he threw it into the crowd during the performance. However, it was caught by journalist Bruce Spinks, and eventually returned to Graceland from a private collection owned by Andrew Kern.

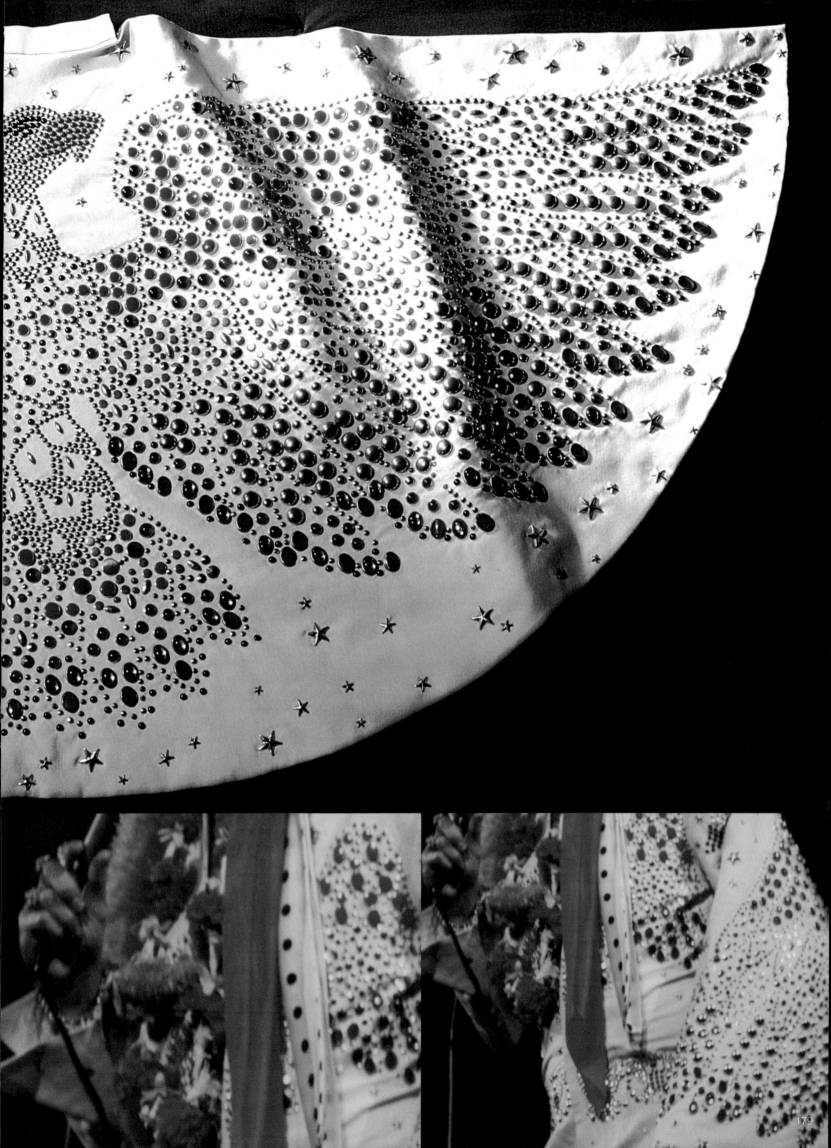

On September 4, 1972, in Las Vegas, Elvis and the Colonel announced the forthcoming *Aloha from Hawaii* concert. Elvis wore a white suit with black leather pockets and black inserts in the pants, paired with a flamboyant puff-sleeved shirt (below)—an ensemble typical of Elvis' attire at the time. The two jackets seen here, from the Graceland archives, also have leather insets and pockets, this time in aqua and green. Both are two-piece stage costumes from the same era.

Elvis' love affair with Hawaii started in 1957 when he performed at the Honolulu Stadium and Scholfield Barracks, in his last concert before joining the army. Although Elvis wore a variety of Hawaiian shirts during his movie career, he was rarely photographed wearing them casually. These shirts were popularized in the 1940s, and were more in keeping with Colonel Parker's dress-sense than with Elvis'. On this singular occasion he wore a colorful example at the Hawaiian Village Hotel.

Wearing a cream-colored suit in elephant corduroy, Elvis arrived at the Hawaiian Village Hotel in Honolulu on January 9, 1973. The day before his live broadcast, Elvis performed a dress rehearsal in front of a full-capacity crowd, who in lieu of an entrance fee were asked to contribute to the Kui Lee Cancer Fund, the designated beneficiary of proceeds from the satellite performance.

"Elvis, this is

First worn on tour in 1973 and featuring rows of nailhead studs that create a glittering mirrored effect, this cape is part of a white suit worn by Elvis during a record-breaking appearance in front of 43,000 people at the Houston Astrodome in 1974.

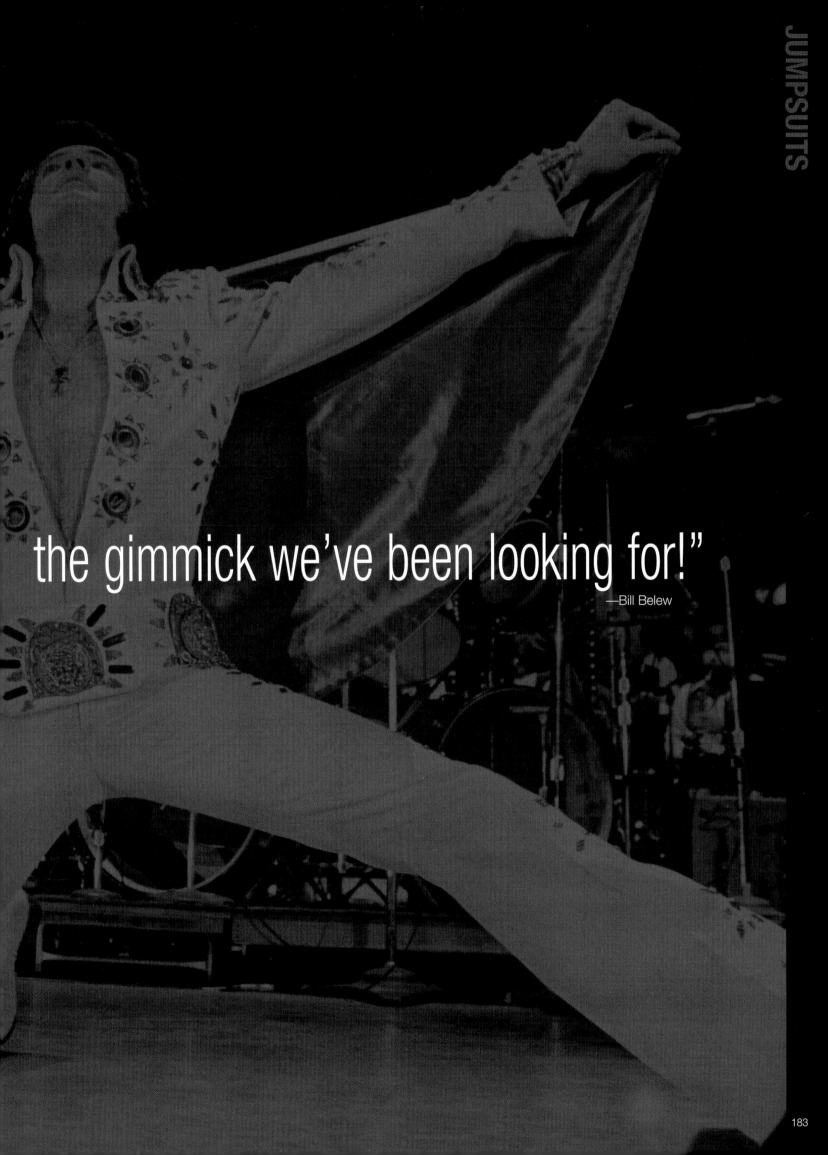

the gimmick we've been looking for!"

—Bill Belew

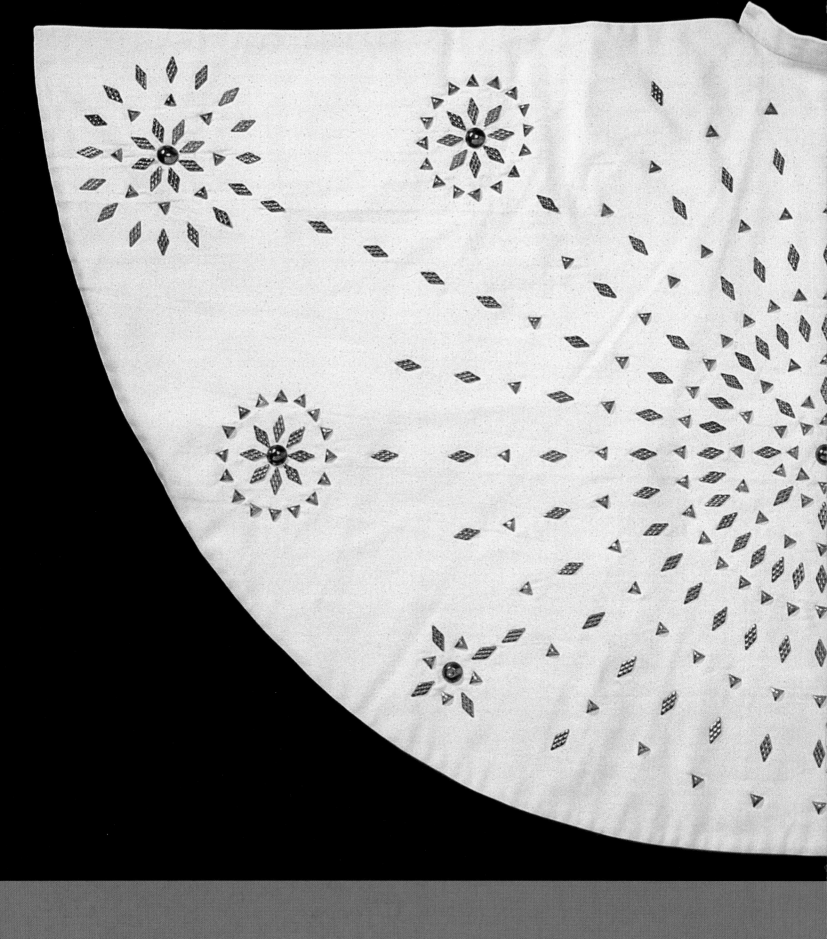

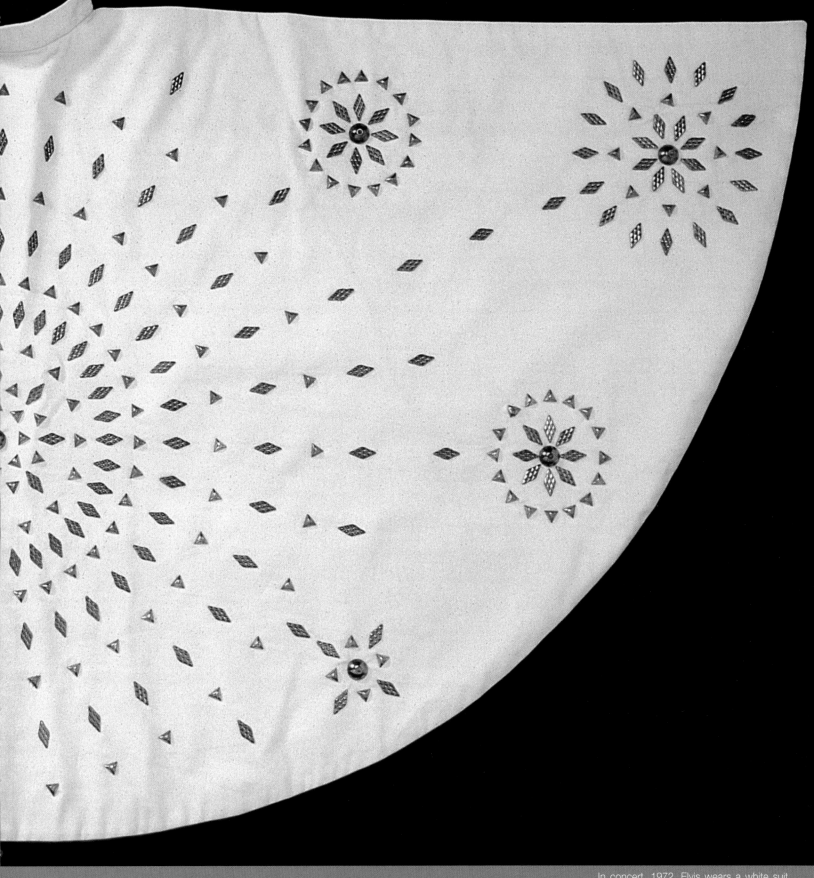

In concert, 1972. Elvis wears a white suit featured in *Elvis on Tour*, with a red lion design on the belt. It's identical in design to the red jumpsuit that is also worn in the movie. This cape, displayed by Elvis on the previous page, was part of a popular suit worn onstage from the end of 1971, which Bill Belew also created in black and red. Elvis wore these suits throughout his well-documented tours the following year.

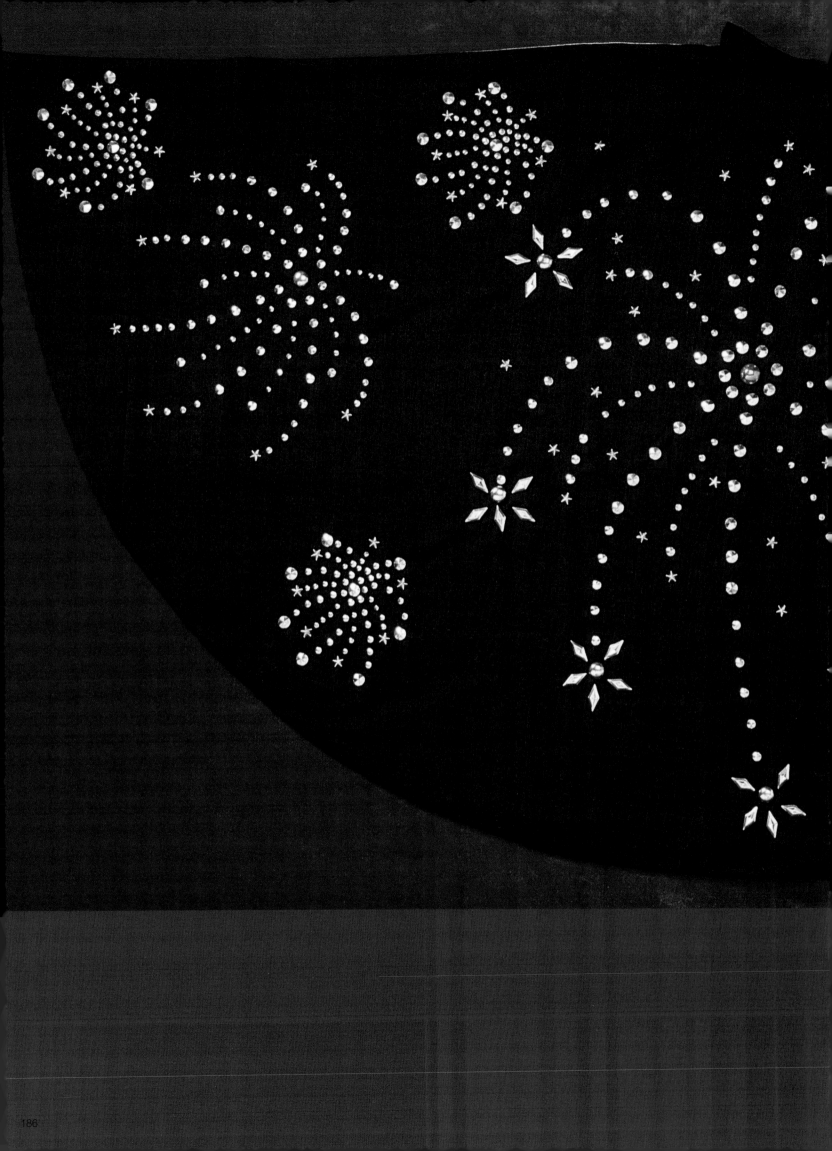

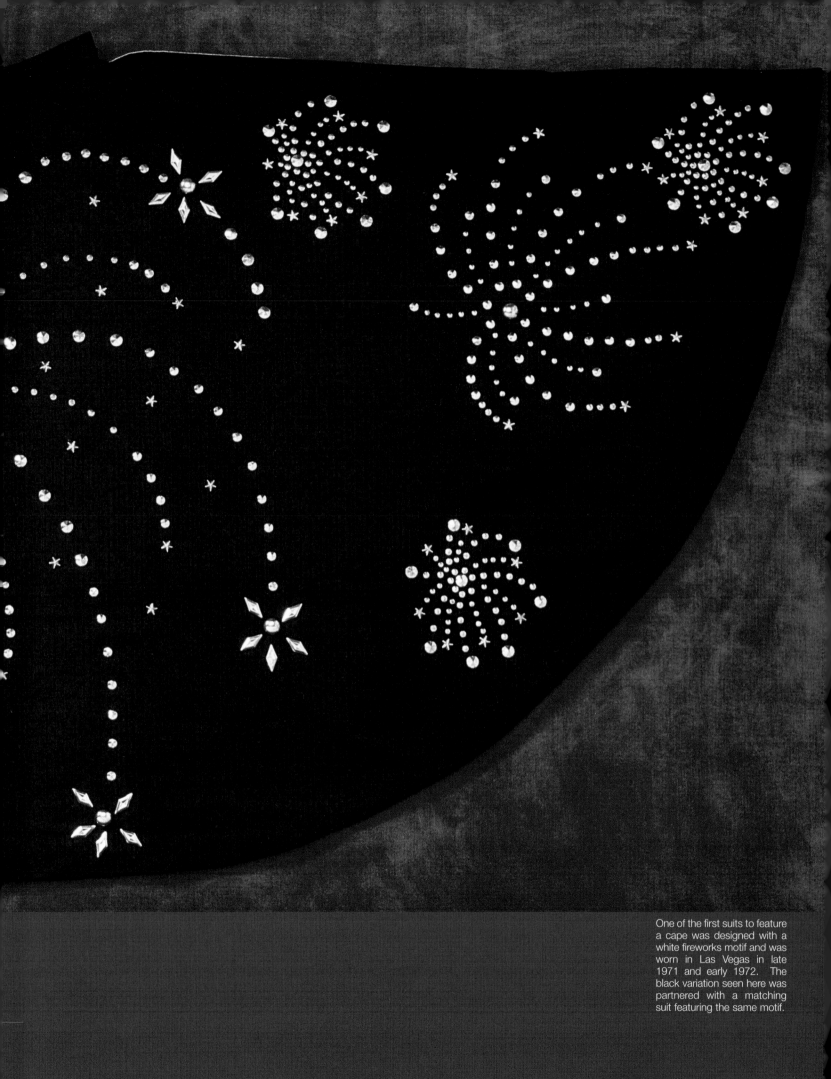

One of the first suits to feature a cape was designed with a white fireworks motif and was worn in Las Vegas in late 1971 and early 1972. The black variation seen here was partnered with a matching suit featuring the same motif.

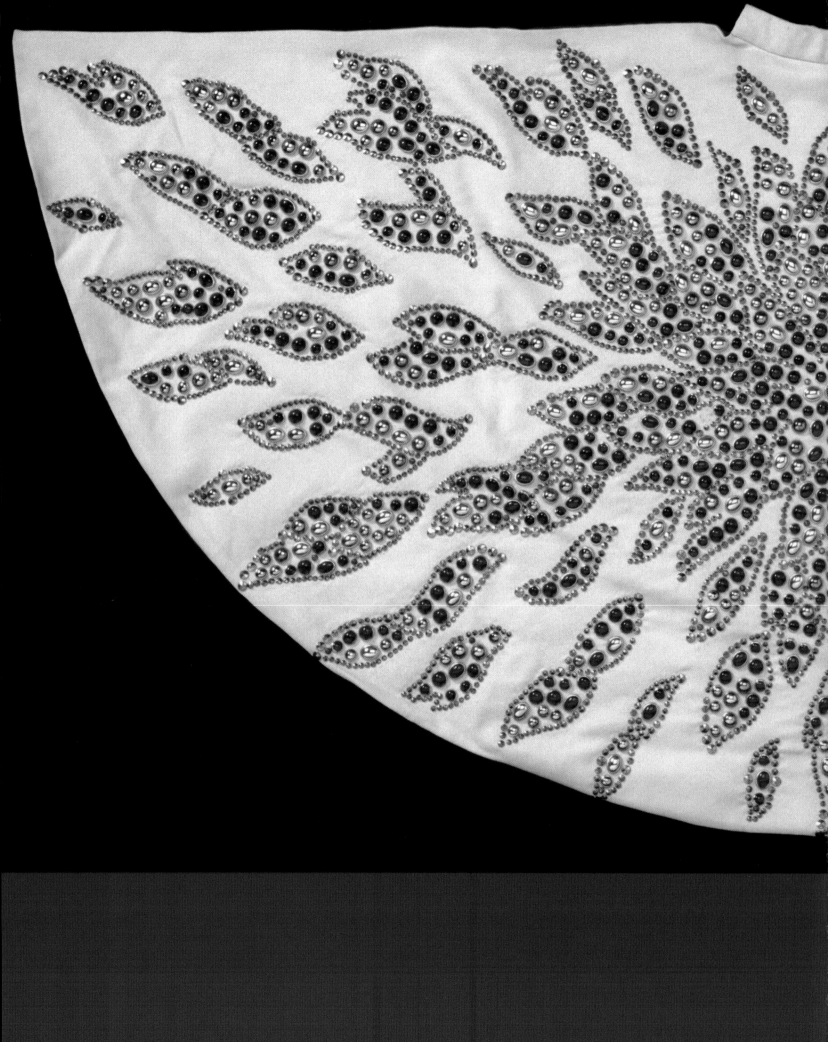

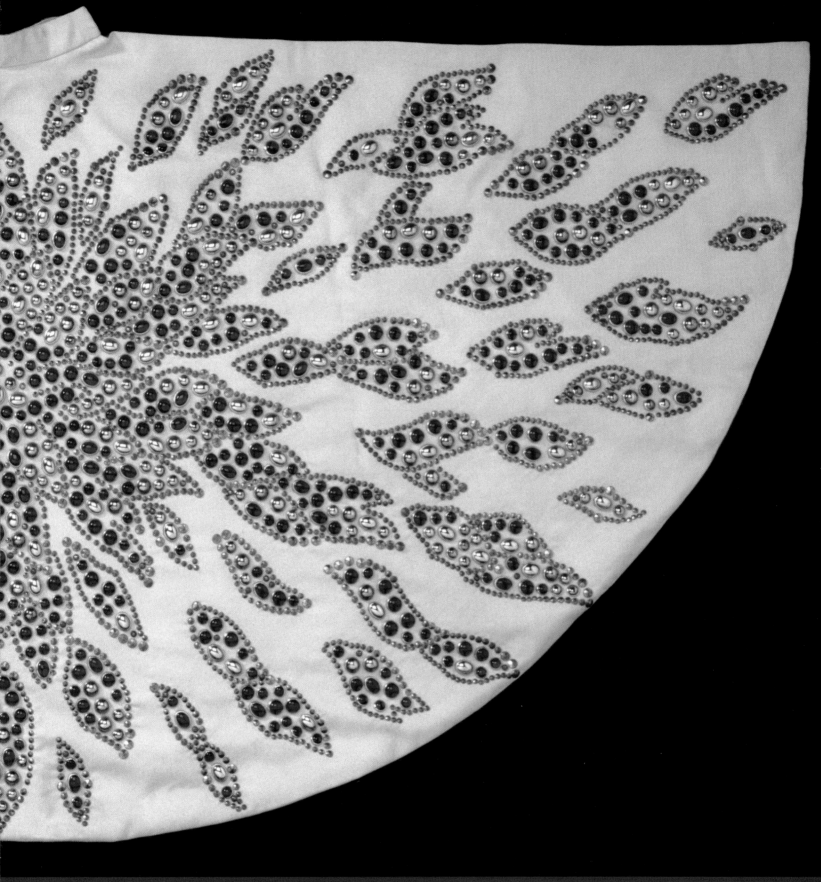

This heavy bejeweled cape matches a suit worn by Elvis between 1973 and 1974. The stagewear of the following tour seasons omitted the use of heavy studwork and capes in favor of embroidered designs.

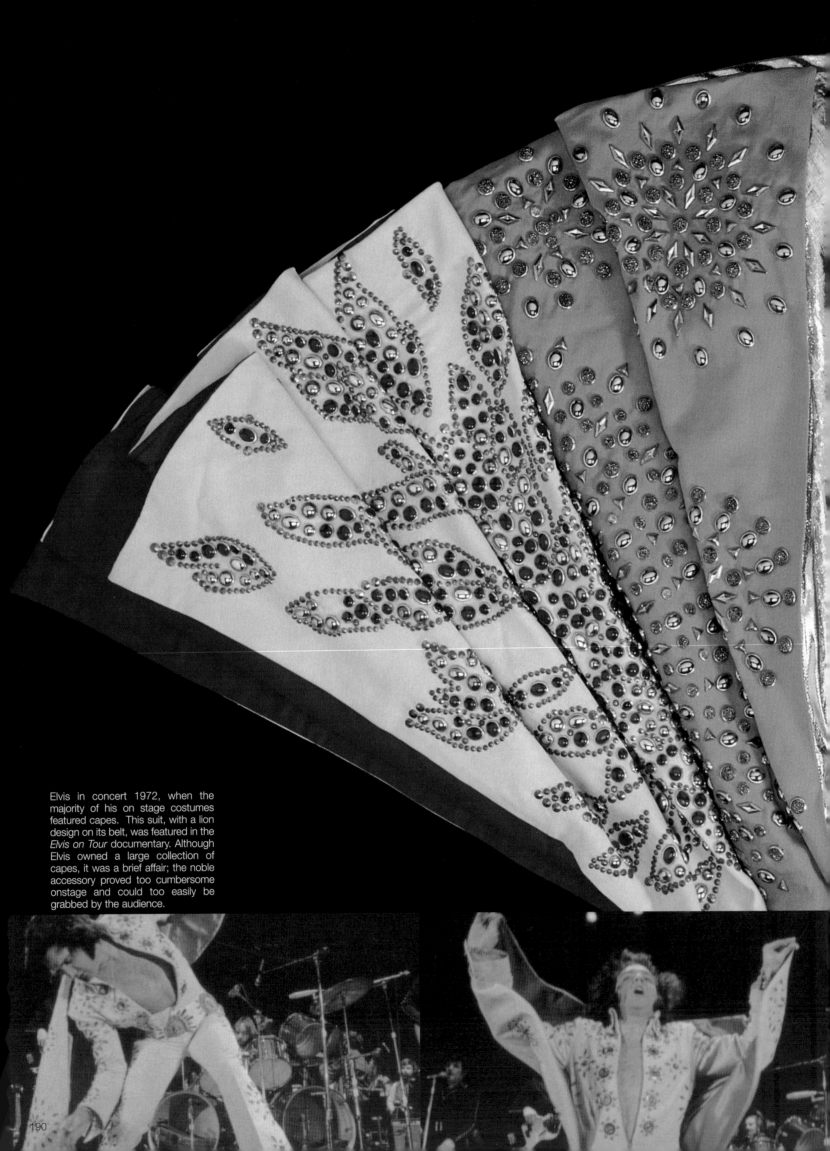

Elvis in concert 1972, when the majority of his on stage costumes featured capes. This suit, with a lion design on its belt, was featured in the *Elvis on Tour* documentary. Although Elvis owned a large collection of capes, it was a brief affair; the noble accessory proved too cumbersome onstage and could too easily be grabbed by the audience.

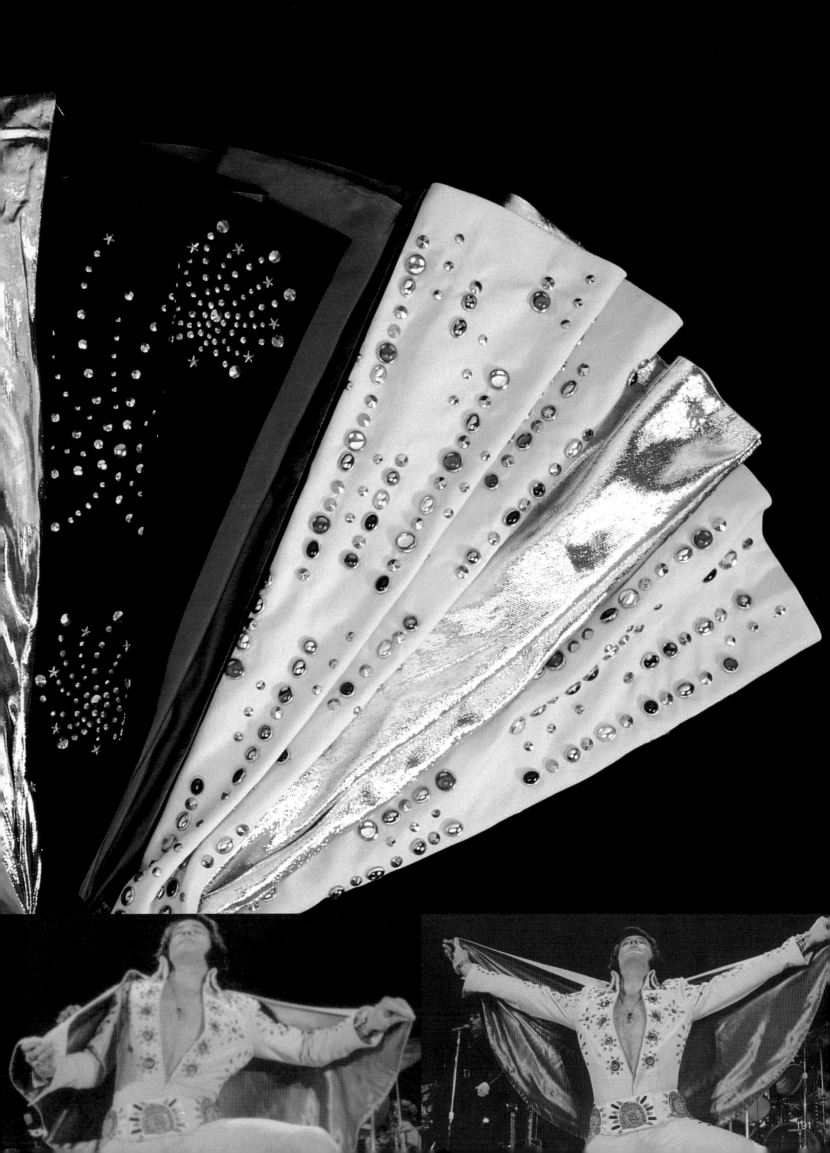

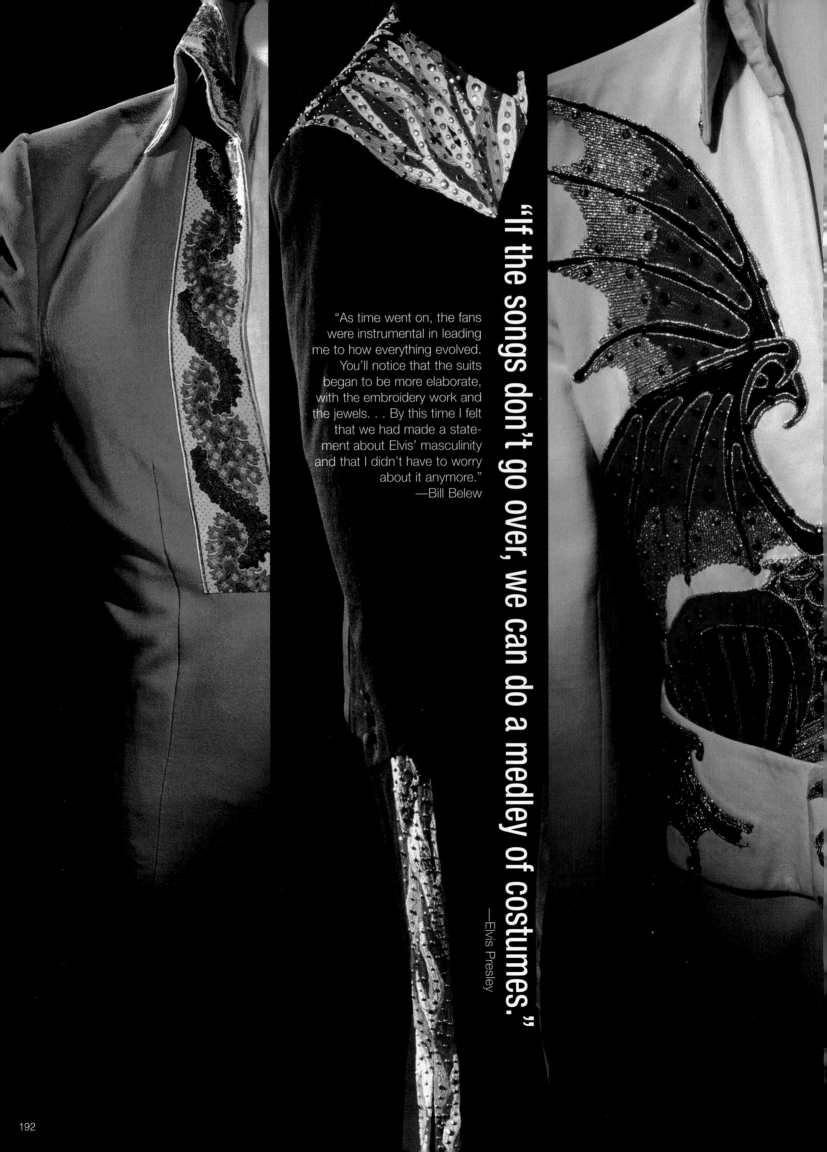

"As time went on, the fans were instrumental in leading me to how everything evolved. You'll notice that the suits began to be more elaborate, with the embroidery work and the jewels. . . By this time I felt that we had made a statement about Elvis' masculinity and that I didn't have to worry about it anymore."
—Bill Belew

"If the songs don't go over, we can do a medley of costumes."
—Elvis Presley

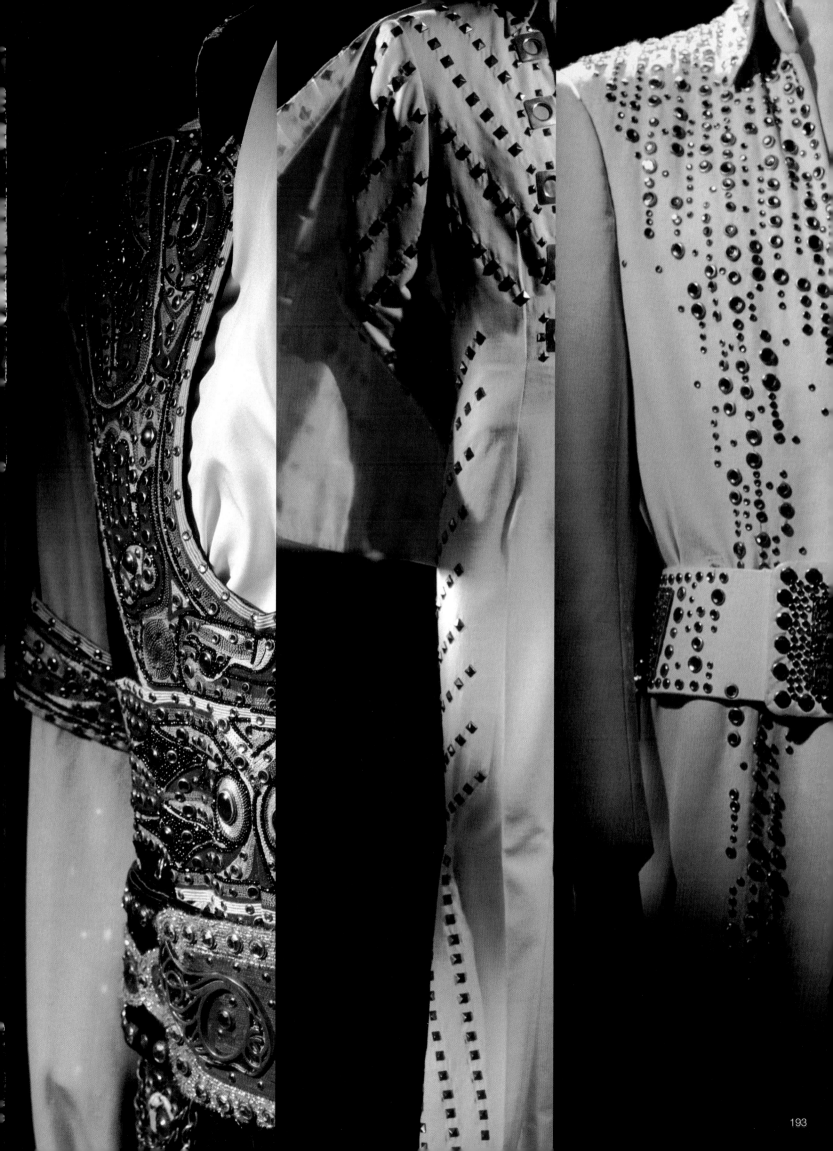

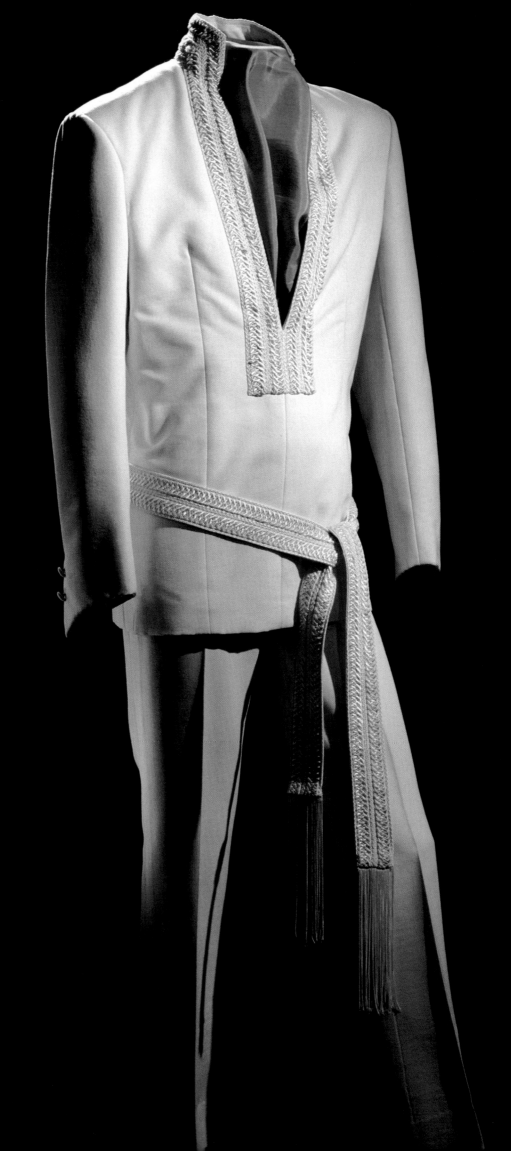

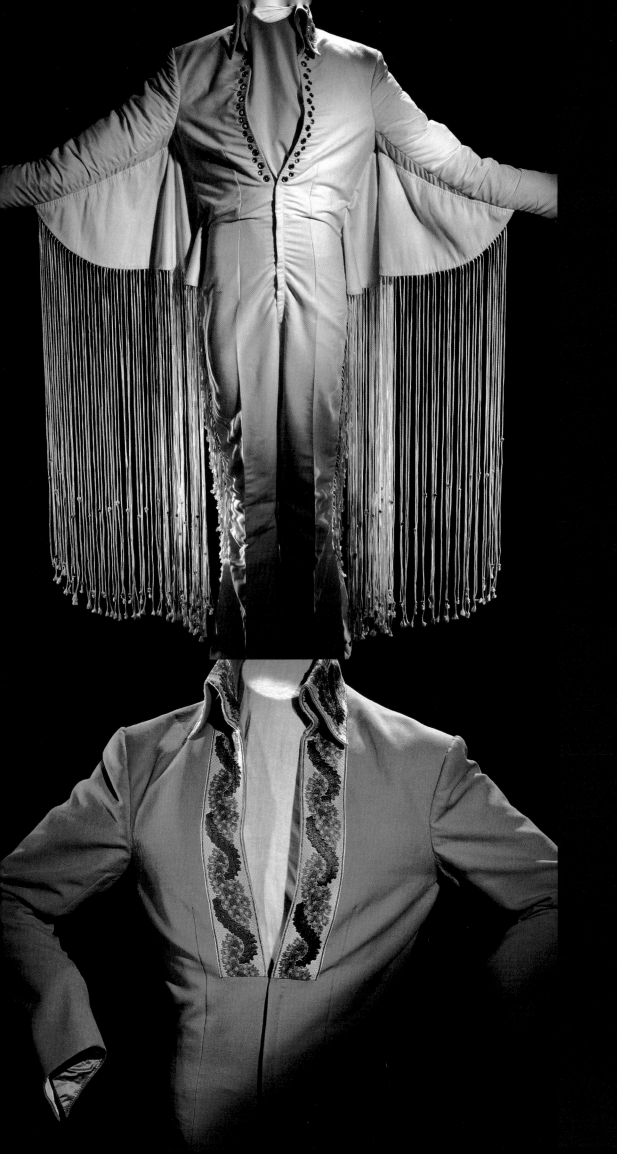

The costumes for Elvis' return to the live concert stage were two-piece ensembles inspired by his passion for karate. Initially worn for his Las Vegas comeback in 1969, the suits couldn't keep up with his onstage moves, prompting the design of the one-piece jumpsuit, which moved with him more fluidly. "Right in front of the audience—ten of them just ripped. They thought it was part of the show!" Elvis told the producers of *Elvis on Tour*.

Elvis wore several variations of this suit. The first, worn in 1970, was featured in the movie *Elvis: That's the Way It Is*. This extravagant piece made its tour debut at the Inglewood Forum in Los Angeles. Elvis looked spectacular in it, with the fringe lashing as he moved. Unfortunately, they tangled all too easily and he was soon forced to abandon this jumpsuit.

Another early feature from 1970 was the embroidered lapel. This blue suit, completed with a white macramé belt, was worn in performances at the International Hotel and at the Houston Astrodome, where he gave six concerts, his first outside Las Vegas. The suit was only recently added to the exhibits at Graceland; it is so slender that it was difficult to find a mannequin it would fit.

195

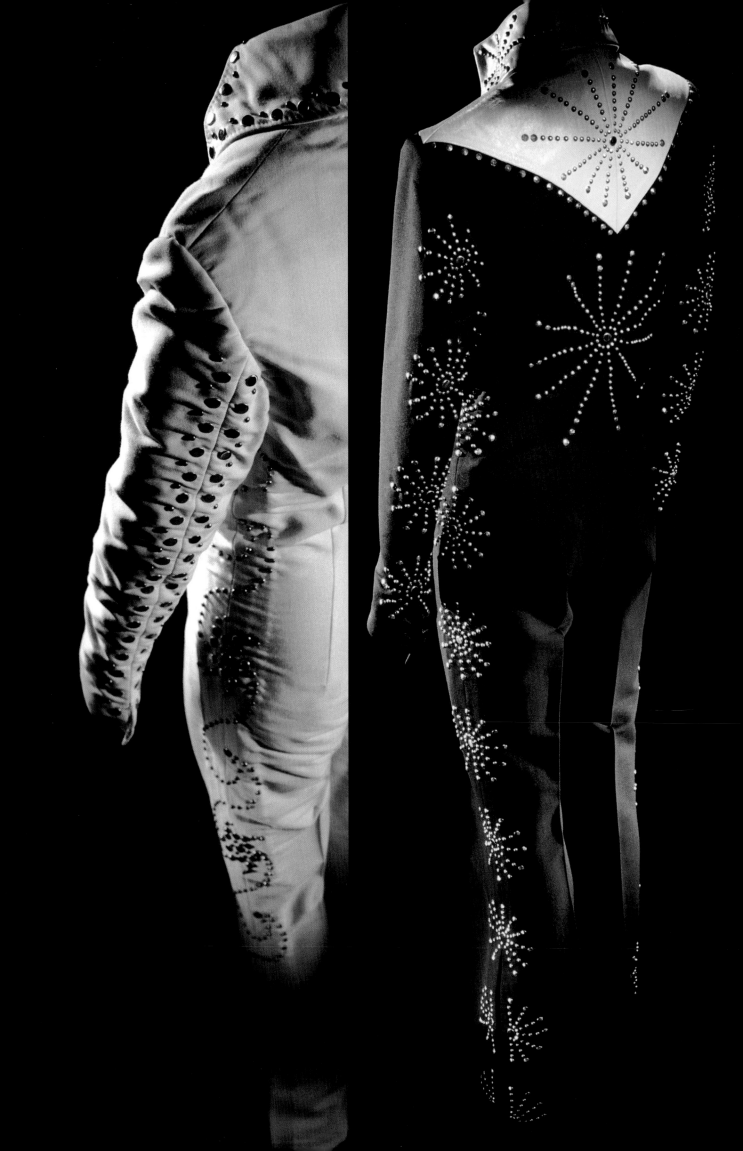

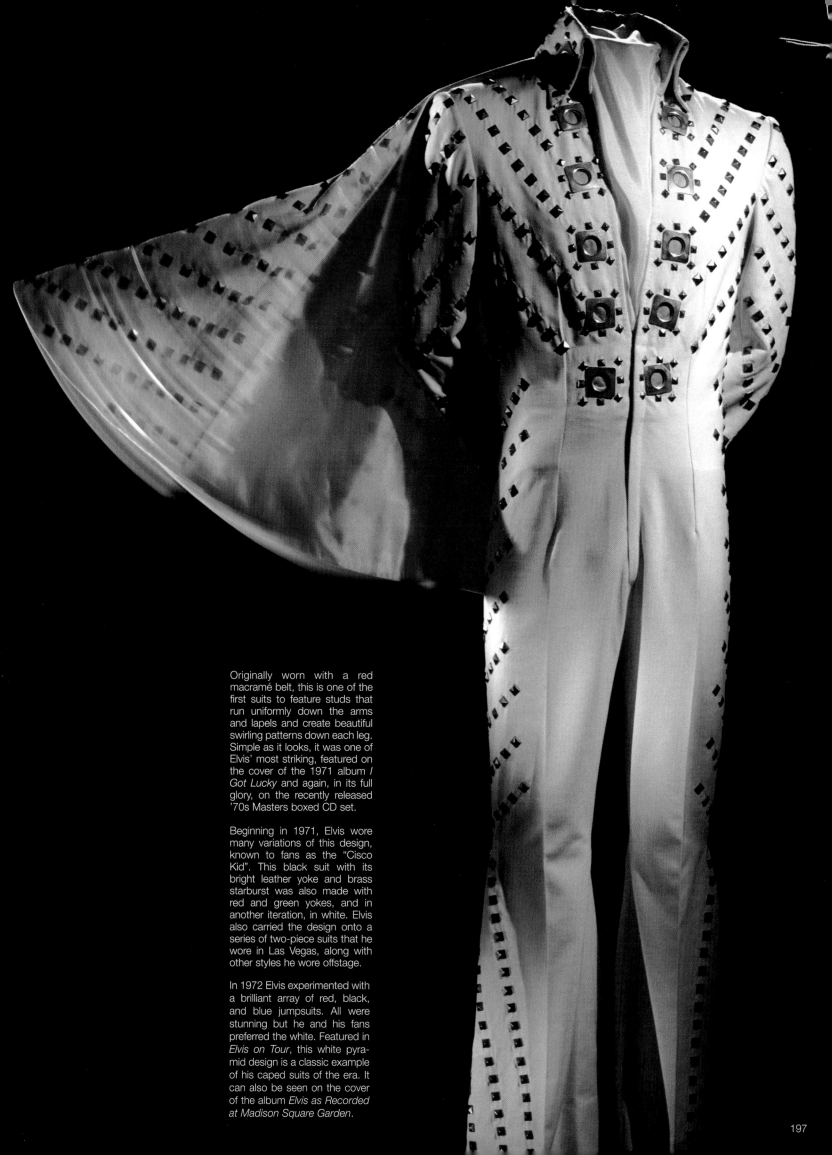

Originally worn with a red macramé belt, this is one of the first suits to feature studs that run uniformly down the arms and lapels and create beautiful swirling patterns down each leg. Simple as it looks, it was one of Elvis' most striking, featured on the cover of the 1971 album *I Got Lucky* and again, in its full glory, on the recently released '70s Masters boxed CD set.

Beginning in 1971, Elvis wore many variations of this design, known to fans as the "Cisco Kid". This black suit with its bright leather yoke and brass starburst was also made with red and green yokes, and in another iteration, in white. Elvis also carried the design onto a series of two-piece suits that he wore in Las Vegas, along with other styles he wore offstage.

In 1972 Elvis experimented with a brilliant array of red, black, and blue jumpsuits. All were stunning but he and his fans preferred the white. Featured in *Elvis on Tour*, this white pyramid design is a classic example of his caped suits of the era. It can also be seen on the cover of the album *Elvis as Recorded at Madison Square Garden*.

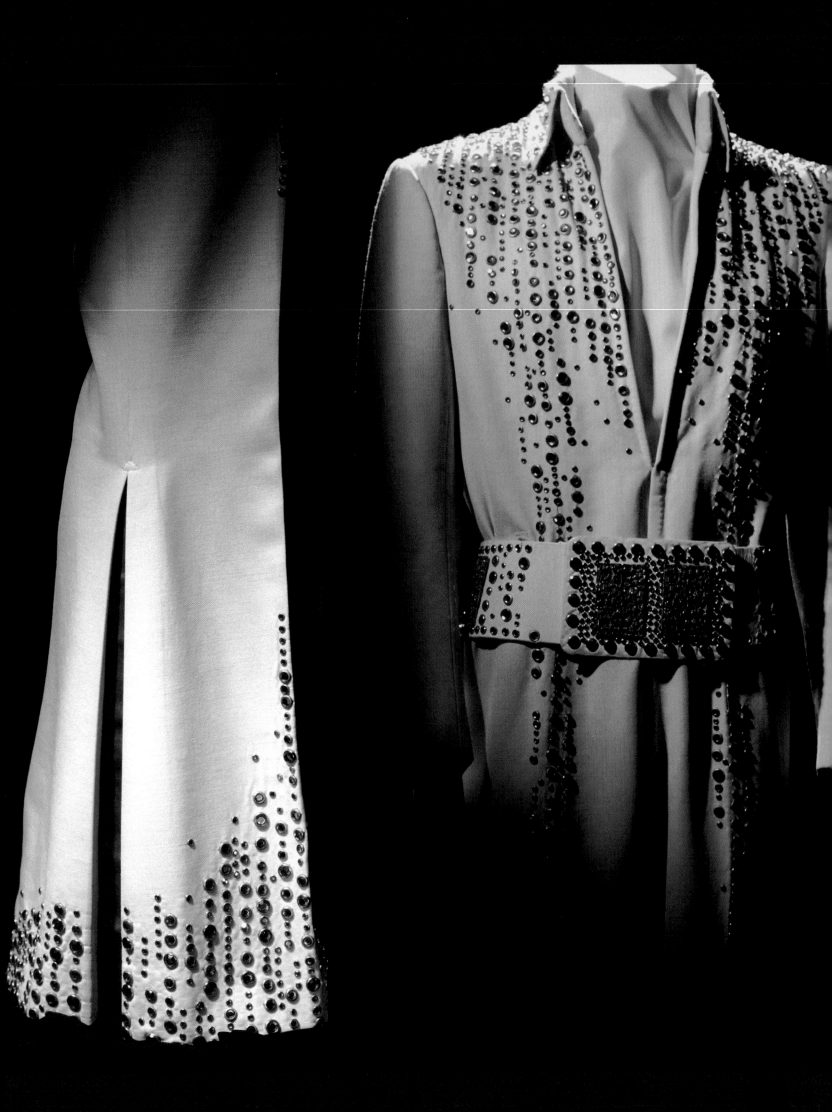

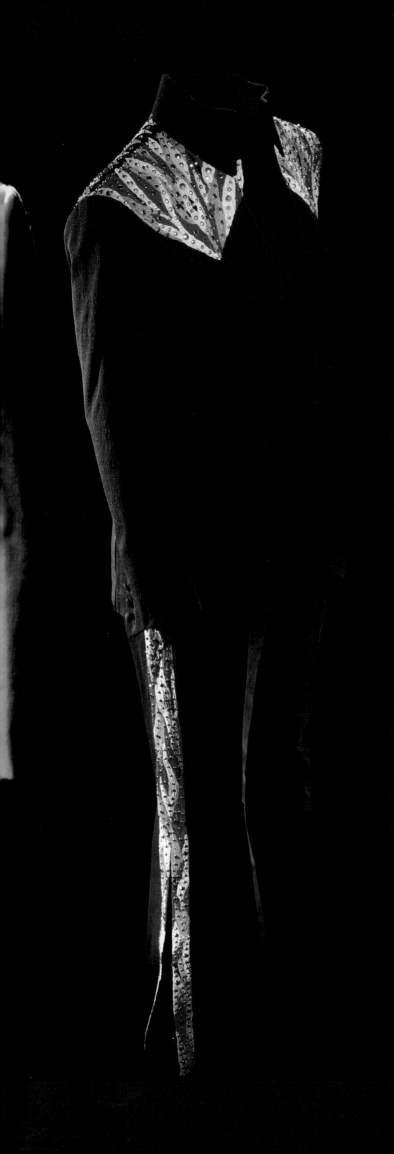

By 1973 most of Elvis' jump-suits were adorned with jewels, making the costumes very heavy, even without the added burden of the cape, which Elvis would stop using by the end of that year. This suit, with shimmering blue stones running down the body, was one of two suits worn by Elvis during a New Year's Eve concert in 1975, when he performed to over 60,000 fans at the Pontiac Stadium in Detroit.

Although famed for his jump-suits, Elvis frequently experimented with two-piece costumes. After his karate-style venture, Elvis introduced a two-piece variation of the "Cisco Kid" design (on the previous page), before wearing a collection of jackets, pants, and puff-sleeved shirts in 1972. This magnificent example, with its contrasting flame embroidery scorching the shoulders and pant legs, is from 1975, when his eighteen-show spring tour was dominated by a collection of such suits. In Las Vegas, other versions included several Western-inspired leather suits and his own karate *gi*.

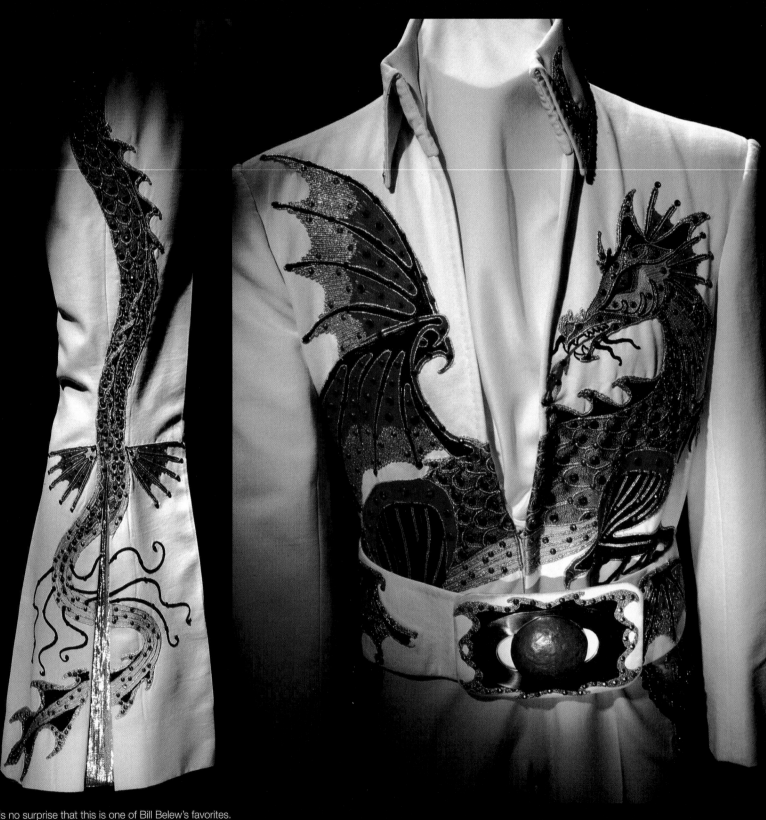

It is no surprise that this is one of Bill Belew's favorites. The intricate embroidery of the dragon design makes this one of the most breathtaking jumpsuits. The tail slinks down to the pants, which are embellished with gold insets. Such embroidered suits were moslty introduced in 1974.

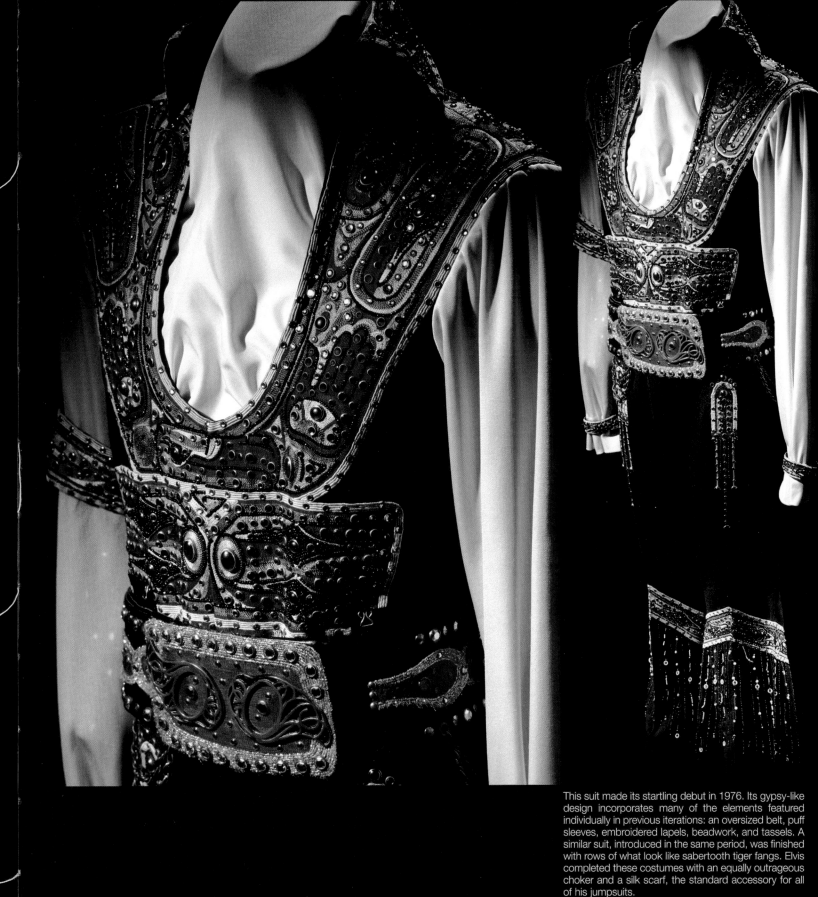

This suit made its startling debut in 1976. Its gypsy-like design incorporates many of the elements featured individually in previous iterations: an oversized belt, puff sleeves, embroidered lapels, beadwork, and tassels. A similar suit, introduced in the same period, was finished with rows of what look like sabertooth tiger fangs. Elvis completed these costumes with an equally outrageous choker and a silk scarf, the standard accessory for all of his jumpsuits.

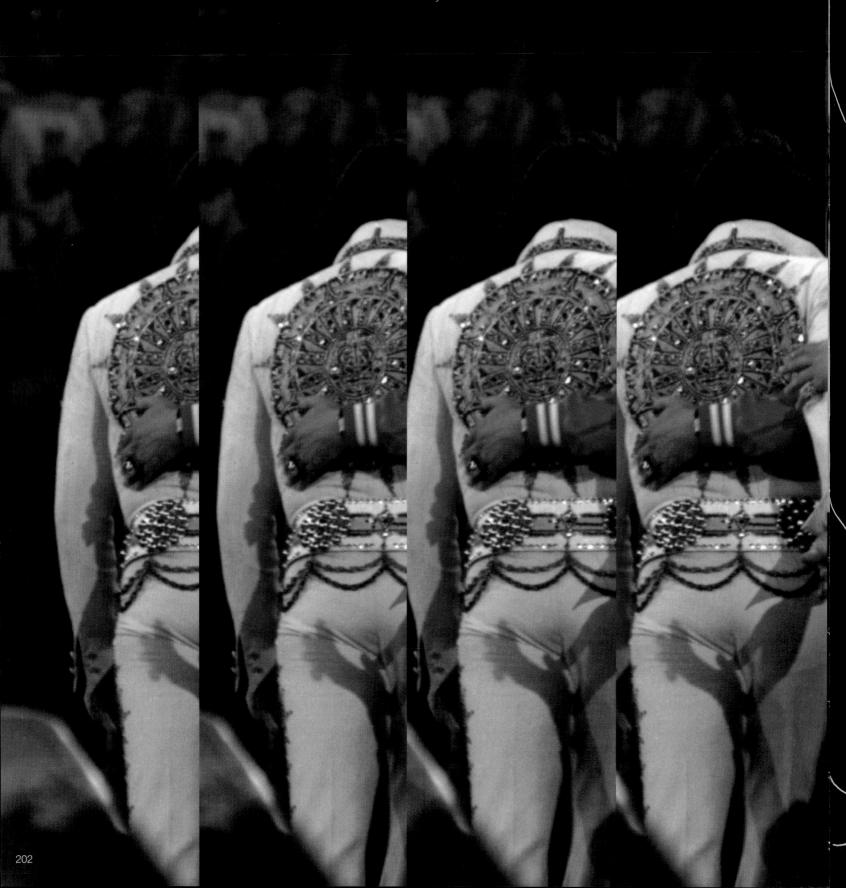

the day
"I learned very early in life that without a song

would never
end."

—Elvis Presley

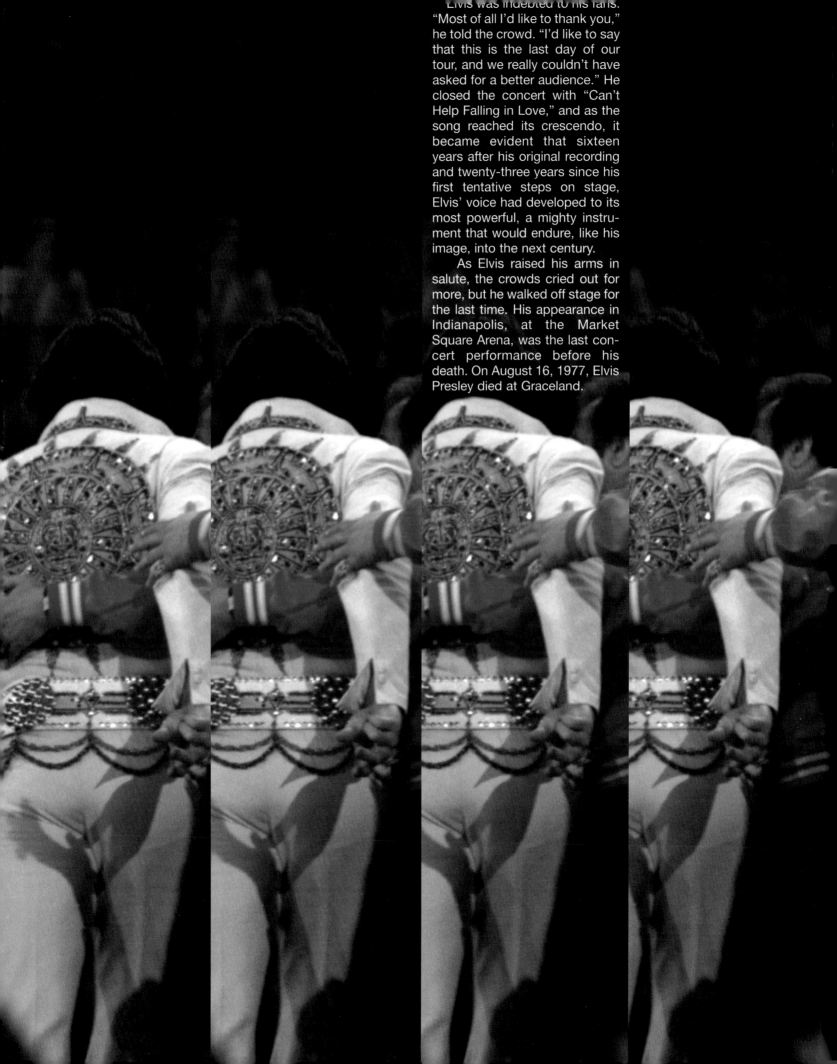

Elvis was indebted to his fans. "Most of all I'd like to thank you," he told the crowd. "I'd like to say that this is the last day of our tour, and we really couldn't have asked for a better audience." He closed the concert with "Can't Help Falling in Love," and as the song reached its crescendo, it became evident that sixteen years after his original recording and twenty-three years since his first tentative steps on stage, Elvis' voice had developed to its most powerful, a mighty instrument that would endure, like his image, into the next century.

As Elvis raised his arms in salute, the crowds cried out for more, but he walked off stage for the last time. His appearance in Indianapolis, at the Market Square Arena, was the last concert performance before his death. On August 16, 1977, Elvis Presley died at Graceland.

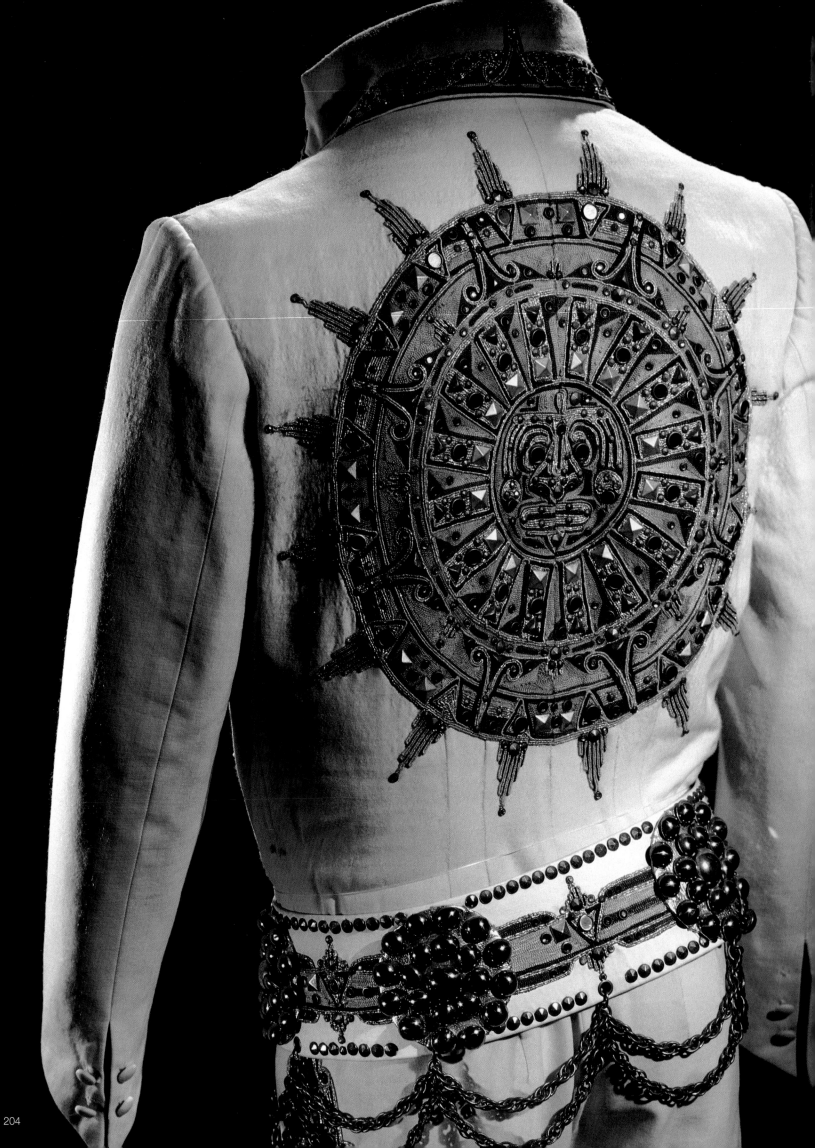

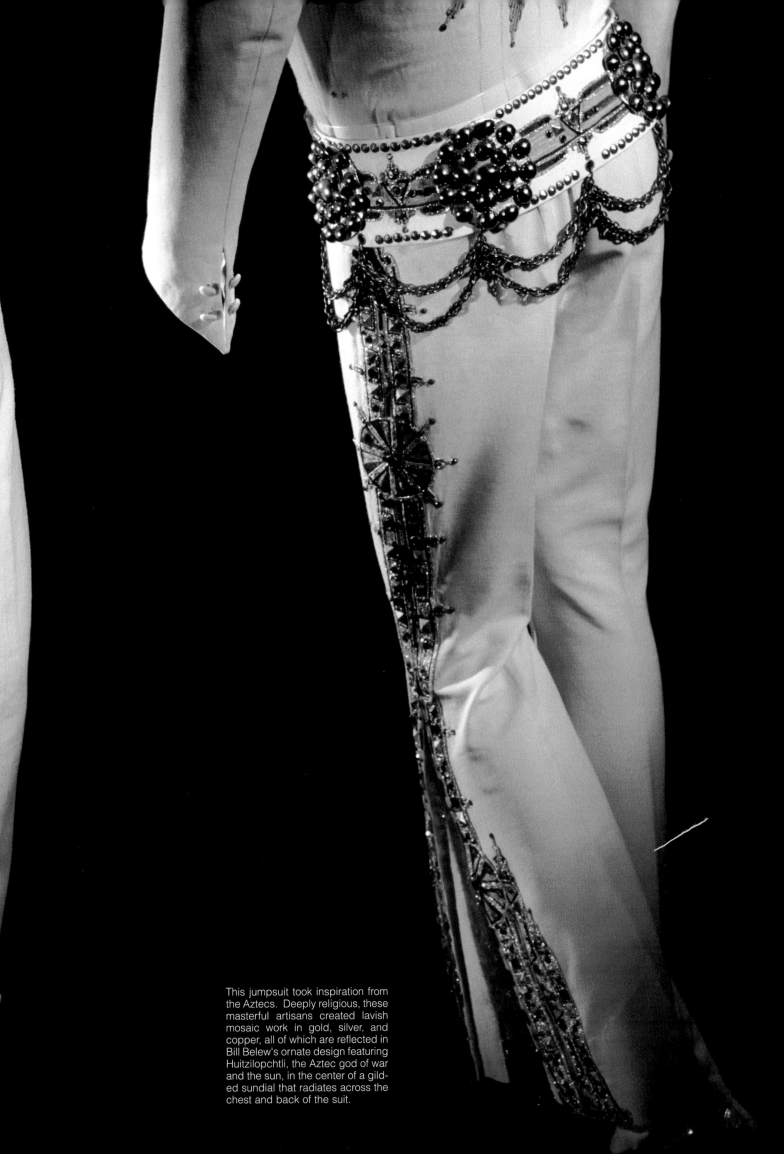

This jumpsuit took inspiration from the Aztecs. Deeply religious, these masterful artisans created lavish mosaic work in gold, silver, and copper, all of which are reflected in Bill Belew's ornate design featuring Huitzilopchtli, the Aztec god of war and the sun, in the center of a gilded sundial that radiates across the chest and back of the suit.

Acknowledgments

Elvis' friends and associates offered many valuable contributions to this book, and I would like to thank the following people for taking the time to talk to me: Scotty Moore, Elvis' very first manager and lead guitarist; Joe Esposito, Memphis Mafia foreman, Elvis' road manager, and best man at Elvis' wedding; Richard Davis, member of the Memphis Mafia, Elvis' Hollywood stand-in, and wardrobe supervisor; Bernard Lansky, known as "Clothier to the King," who still offers an irresistible collection of clothing from the Peabody Hotel in Memphis; Jamie Nudie Mendoza and Bobbie Cohn for their memories of Nudie (Jamie is also working on a museum for her grandfather, and more details are on her fascinating website www.nudies-rodeotailors.com); Marti Devore and her business partner, Leonard Freedman, at Sy Devore Menswear in Studio City—particular thanks to Marti for showing me the family scrapbooks and costume sketches; Emmy Award-winning designer Bob Mackie famed for dressing Cher among many others, but also for designing the stunning wardrobe for the Elvis ballet *Blue Suede Shoes*; and last but by no means least, Bill Belew, a pleasure to talk to. Seeing the wealth of wonderful clothes Bill designed for Elvis took my breath away.

This book would not be in your hands without the following good people at Graceland: Todd Morgan, Pete Davidson, and Carol Butler; the Archives Department, Angie Marchese, La Vonne Gaw, and Sheila James; our helpers for the late-night photo shoots, Andy Pullen, Dee Dee Antle, and Calonda Allen; Kelly Hill and Susan Sherwood for archive photography.

Thanks to Woody Woodliff and Seth Hagee for their wonderful photography and to Paul Guayante for his outstanding art direction. And who knows where I would be without my editor, Ilaria Fusina— my thanks for the late-night cocktails over peanut butter and banana sandwiches.

For inspiration, and for their assistance with this book, my personal thanks go to Darrel Higham, my coauthor on the Eddie Cochran story; and the editors of three excellent and informative Elvis publications: Trevor Cajiao, for *Elvis: The Man and His Music*; Andrew Hearn, for *Essential Elvis*; and Bill Burk, for *Elvis World*. Thanks also to Pat Broeske, Joe McFate, Marty Lacker, George Klein, Butch Polson, Stephen Digby, Alfred Wertheimer, Karl Mundy, Lara Logan, Jason Siemon, Jacen Bruce, Jason Saxton, Clare Haynes, and Trevor Yeardye, for all that I enjoy in this big Elvis world.

Sources

An obsessive collector of books, I thumbed through countless Elvis, and other, publications for this project. Many were just photographic, but my main sources and recommendations include *Elvis and Me,* by Priscilla Beaulieu Presley with Sandra Harmon; *Down at the End of Lonely Street,* by Peter Harry Brown and Pat H. Broeske; *Elvis Day by Day,* by Peter Guaralnick and Ernst Jorgensen; *Elvis' '56,* by Alfred Wertheimer; *Dino: Living High in the Dirty Business of Dreams,* by Nick Tosches; *The Life and Times of Celebrated Costume Designer Edith Head,* by David Chierichetti; *Hillbilly Hollywood,* by Debby Bull; *The Fifties,* by David Halberstam; *How the West Was Worn,* by Holly George Warren and Michelle Freedman; *The Atomic Powered Singer,* by Brian Petersen; *Elvis' Karate Legacy,* by Wayne Carman; *Did Elvis Sing in Your Hometown Too,* by Lee Cotton; *Elvis: Word for Word,* by Jerry Osborne; *Elvis's Man Friday,* by Gene Smith; *A Girls' Guide to Elvis,* by Kim Adelman; *Elvis: The Concert Years,* by Stein Erik Skar; every collaboration between Gerr Rjiff, Trevor Cajiao, and Gordon Minto, with books such as *Shock, Rattle, and Roll* and *60 Million Viewers Can't Be Wrong*, along with the visually stunning publications from Joe Tunzi, which are certainly the best source for concert images.

Finally, from a wealth of vintage magazines I would recommend "Did the Devil Send Elvis Presley?" *True and Strange*, October 1957; "Will the Army Change Elvis?" *Teen*, June 1958; and "Cool Kat, Elvis Presley," *Cool & Hepcats*, October 1958.

This book documents Elvis' wardrobe, as he left it on the day of his death, August 16, 1977. The first of its kind, it offers the ultimate look at Graceland's world-famous collection: the most spectacular garments of one of the great icons, not only of style, but of the twentieth century.

No other artist can boast a following of Elvis' magnitude. His persona has inspired some of the greatest entertainers in music history; his look spurred the onset of rock and roll, and animated countless popular singers in its wake. From U2's Bono in gold lamé to the jumpsuits worn by Britney Spears, the vision is always Elvis'.

From his first release on the Sun Records label through countless gold, platinum, and multiplatinum releases for RCA, to thirty-three movies, and culminating in more than one thousand live concert performances throughout the 1970s, Elvis' life is the ultimate "rags to riches" story. And here we present the riches. Not unlike the rest of us, Elvis' tastes evolved over the decades—there was only so much room in the closet—and he had a penchant for giving things away. As a consequence, much of the clothing from his early career is not part of the inventory at Graceland.

A quarter of a century after his death, what we present here is thanks to the unfailing efforts of the Archives Department, who have preserved and documented every item of clothing in their possession. Many additions have been made to the collection over the years, while existing items travel and are displayed in museums across the country, and beyond. None of these items would be on view if it weren't for the diligence of the Archives team. It is to them that I owe my first debt of gratitude.

Julie Mundy